Photographing Historic Buildings

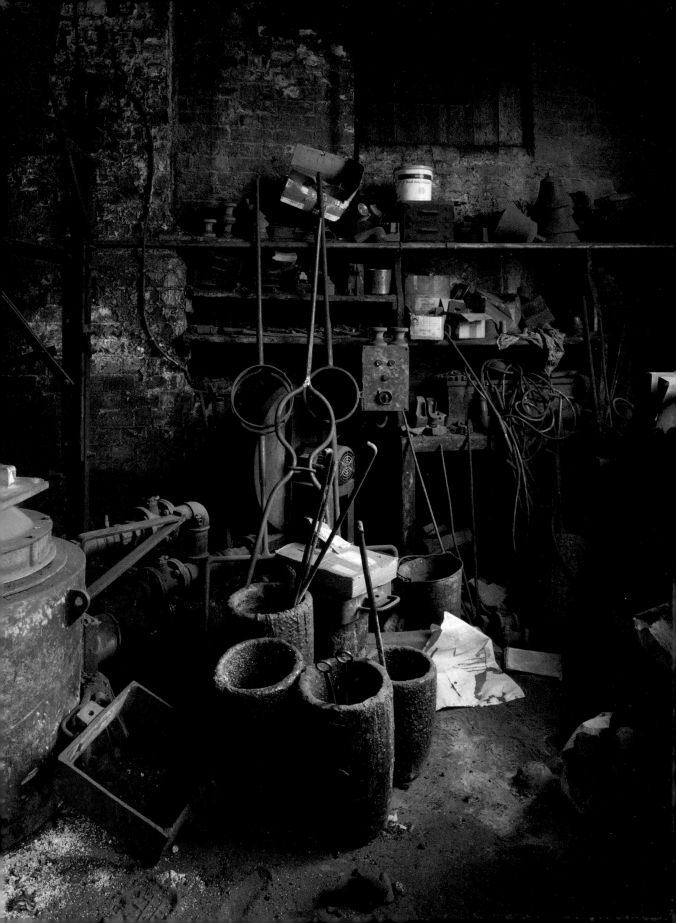

Photographing Historic Buildings

Steve Cole

Published by Historic England,
The Engine House, Fire Fly Avenue, Swindon SN2 2EH

www.HistoricEngland.org.uk

Historic England is a Government service championing England's heritage and
giving expert, constructive advice.

© Historic England 2017

First published 2017

ISBN 978-1-84802-269-0

British Library Cataloguing in Publication data

A CIP catalogue record for this book is available from the British Library.

Historic England holds an unparalleled archive of 12 million photographs, drawings,
reports and publications on England's places. It is one of the largest archives in the UK,
the biggest dedicated to the historic environment, and a priceless resource for anyone
interested in England's buildings, archaeology, landscape and social history. Viewed
collectively, its photographic collections document the changing face of England from the
1850s to the present day. It is a treasure trove that helps us understand and interpret the
past, informs the present and assists with future management and appreciation of the
historic environment.

For more information about images from the Archive, contact:

Archives Services Team, Historic England, The Engine House,
Fire Fly Avenue, Swindon SN2 2EH; telephone (01793) 414600.

Brought to publication by Sarah Enticknap, Publishing, Historic England.

Typeset in 9.5pt Georgia Pro Light
Edited by Jenny Lawson
Indexed by Caroline Jones, Osprey Indexing
Page layout by Andrew Barron
Printed in Malta by Melita Press

Contents

Acknowledgements

I would like firstly to thank all my former colleagues at English Heritage and Historic England for their help, encouragement and advice in the production of this book. In particular, to Terry Buchanan whose book of the same name published in 1984 by the Royal Commission on the Historical Monuments of England was the inspiration for this one and to Paul Backhouse, James O Davies, Steve Baker, John Vallender and all those in the Imaging and Visualisation department whose images are liberally spread throughout publication. Special thanks to Derek Kendall who offered helpful, timely and challenging comment on the first draft.

Additional thanks are due to Robin Taylor and Sarah Enticknap in Historic England Publishing, without whom this could not have happened, to Jenny Lawson for editing the text and to Andrew Barron for his design and layout.

Furthermore, I grateful for the access given to me by all the people who own, live in or care for the many buildings and places that I visited during the production of the book.

About the author

001

Steve Cole has worked as a photographer in the cultural heritage sector for over 40 years. He joined the Royal Commission on the Historical Monuments of England (RCHME) in 1973 as an assistant photographer, where he received his professional training. After obtaining his formal qualification he progressed from the darkroom to taking photographs for the Royal Commission. As a principal photographer he worked on the Royal Commission volumes of *The Country Houses of Northamptonshire* (RCHME, 1996), *Houses of the Gentry 1480–1680* (Yale, 1999) and other publications such as *Early Industrial Housing: the Trinity Area of Frome, Somerset* (RCHME, 1981) and *Cold War: Building for Nuclear Confrontation 1946–1989* (English Heritage, 2003).

In the early 1990s Cole set up and managed a new photographic section for the RCHME in Cambridge, working with his team in East Anglia and across England. His work has appeared in *The Pevsner Buildings of England Series* for Norfolk, Essex, London North and, more recently, the revisions of Bedfordshire, Huntingdon and Peterborough, and Cambridgeshire. He was appointed Head of Photography at English Heritage in 2000, a position he held until his retirement in March 2014. During that time he oversaw the transition from film-based systems to digital image capture and storage media, devising, adapting and instituting new standards and working practices. His work has been reproduced in many English Heritage publications, including *Religion and Place in Leeds* (2007), *English Shops and Shopping: An architectural history* (Yale University Press, 2003), *Carscapes: The Motor Car, Architecture and Landscape in England* (Yale University Press, 2012), *The Hat Industry of Luton and its buildings* (2013) and *Blackpool's Seaside Heritage* (2014), as well as guidebooks for English Heritage properties. His images are now curated by the Historic England Archive.

Cole has lectured on photography of the historic environment at the Departments of Continuing Education of the Universities of Oxford and Cambridge and has been an Associate of the British Institute of Professional Photography since 1988 and a member of the Association for Historical and Fine Art Photography since its foundation in 1985.

Born in London, Cole lived in west and north London before relocating to Cambridgeshire in 1991. Aside from photography, his interests span all periods of architecture and archaeology. He has been Chairman of the Ely and District Archaeological Society for 15 years.

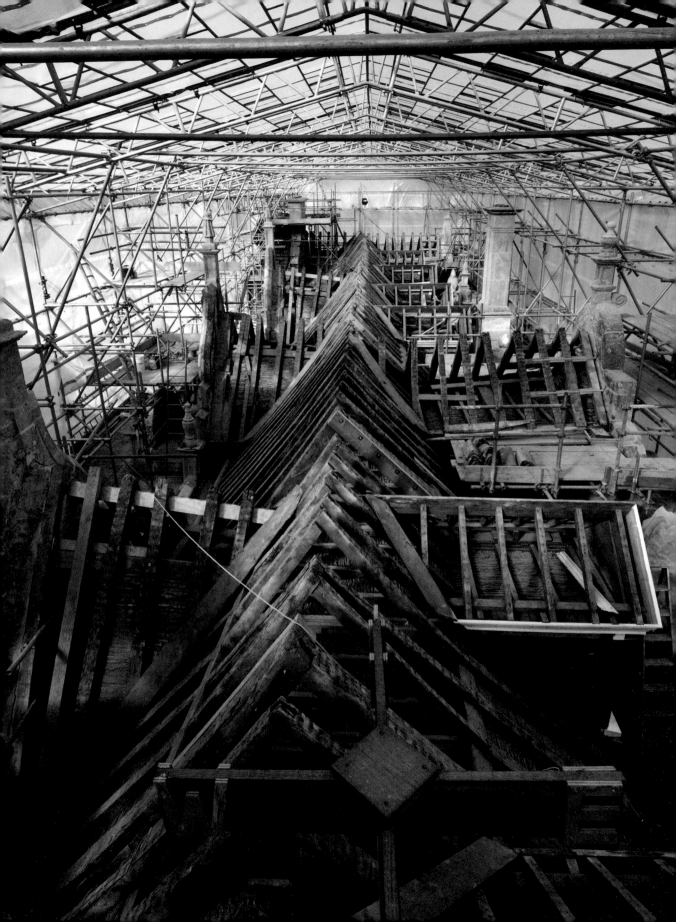

1 | Introduction

The word 'photograph' has Greek roots and roughly translates as 'light drawing'. Yet it is surprising how many people fail to understand the importance of light when taking photographs. As a photographer, or 'drawer with light', one becomes obsessed with how things look and how they change in appearance depending on how the light falls upon them. I will often just stop to look at things to enjoy the way they are lit, whether by natural or artificial means, or even to appreciate the skill of the photographer on advertising hoardings or in printed matter.

While observation in this way can be a great way to pass the time, a better use of time can be made by permanently capturing the effect of the light on what we see by using a camera. The focus of this book is capturing how that light falls on, in and around historic buildings.

Photography has been employed since 1826 to capture and portray our built environment. The oldest known photograph, by Joseph Nicephore Niepce, 'View from the Window at Le Gras', takes an architectural subject. Over time, generations of photographers have used copper sheets, paper, glass, film (plastic) and, more recently, electronic mediums to capture and store the still image. While film may still have many years left as a medium of image capture and storage, current trends indicate that digital capture is the most accessible method of recording the buildings that make up our villages, towns and cities.

Digital capture is a great liberator for the photographer; after the initial cost of the camera, computer and software, the cost of individual images is negligible. This can lead to a scatter-gun approach to image capture. A more measured and thoughtful approach as outlined in the following pages will, I hope, help produce more considered images.

This book will look at what motivates us to take photographs, consider some methods of using the camera to do so successfully and also examine some standards that should be applied to the photographs that we take of buildings in order to ensure that they will be useful documents in the record of the historic environment. Writing about photography tends to be technical, yet I have tried to ensure that this book is as accessible as possible to those with little technical knowledge.

As photographers, light is our primary tool; whether we make use of natural lighting or introduce it from our own light sources, it greatly influences our photographs and our understanding of what we have captured through our lens. Other factors such as viewpoint and technical settings on the camera also play a vital part in the story we want to tell through our photographs.

On the facing page are two views of the Church of St Leodegarius, Ashby St Ledgers, Northamptonshire, taken in 1983 and 2013, which show the remarkable way this building has remained the same. In fact it has probably remained the same for even longer than the 30 years

depicted here. While no change has occurred in the building during that time, the camera and the technology used to capture these two images has changed enormously. In 1983 I used a sheet of 5" × 4" (12.7cm × 10.2cm) black-and-white film and 8 to 10 large flashbulbs to light the interior for the record I was making. The flashbulbs were needed to compensate for the inability of the film to record detail in the dark wood of the pews and roof, as well as record information in the stonework and the wall paintings (002). In 2013

I was able to record all of these elements (in colour) without the need for any additional lighting, using digital technology. The photograph in 2013 is clearly a much better record (003).

Digital technology provides us with the means to create better photographs. Used carefully and stored correctly (as was the case with the old technology) this medium will provide an accessible means to record our historic buildings.

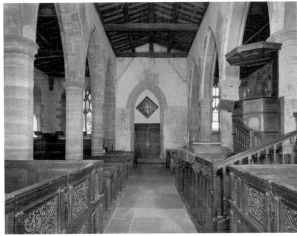

002

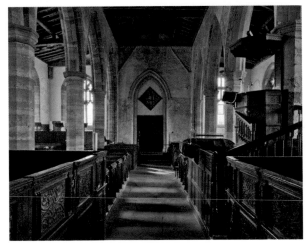

003

Before digital

The development of photography began in the early 1800s. Nicephore Niepce produced a photograph in 1816 but was unable to 'fix' the image to the paper to make it permanent. A solution to this problem wasn't found until January 1839 when, within days of each other, Louis Daguerre and William Henry Fox Talbot both announced their inventions. Daguerre's proposition, the Daguerreotype, produced a single image on a sensitised polished metal plate. Fox Talbot's system produced one negative image from which many positive copies could be made, and as a result his was to prove the more viable of the two competing options.

Niepce, Daguerre and Fox Talbot used architectural subjects for their first images, mainly because the exposure required to capture an image was too long for anything that moved. Soon other photography pioneers started to take photographs of buildings and other artworks using both the Daguerre and Fox Talbot systems.

004

005

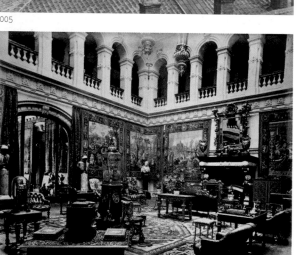

007

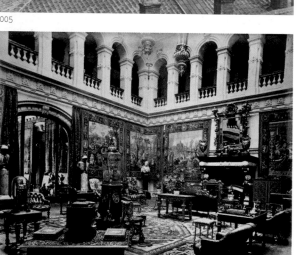

006

004 Fox Talbot's first photograph, the oriel window at Lacock Abbey, Wiltshire.

005 In 1854, only 15 years after the invention of the process, Roger Fenton was producing high-quality images such as this reproduction of Waterloo Bridge in London (since rebuilt).

006 The Carlton Club in Pall Mall, taken in 1872 by Bedford Lemere & Co.

007 An interior view of the Great Hall at Mentmore House, taken in 1880 by Bedford Lemere & Co.

Recordings mediums, cameras and photographers rapidly improved as the 19th century progressed, with sensitive emulsions coated onto paper, glass and, much later, onto plastic bases. This, along with improvement in lens design, made for images that were sharper and improved in contrast and tone.

Soon architects, estate agents and historians were employing photographers and photographic firms to record the new, the saleable and the old for publications and for posterity.

One early photographic firm to reach a level of sophistication and renown was Bedford Lemere & Co, many of whose images were captured on glass plates measuring 12" × 10" (25.4cm × 35.4cm).

Other notable photographers, among them Bill Brandt, also recorded architecture during the Second World War, taking photographs for the National Buildings Record, which was set up to record notable buildings and monuments that were being lost.

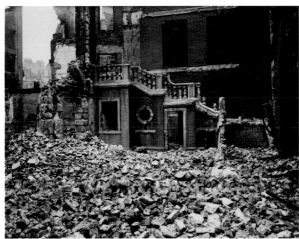
008

009

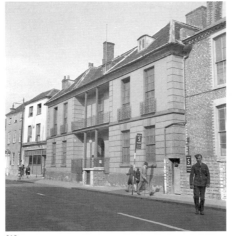
010

008 Bedford Lemere & Co continued producing work of outstanding quality into the 20th century, including recording many buildings damaged by bombing during the Second World War.

009 The Deanery next to Rochester Cathedral.

010 The Regnum Club, 45 South Street, Chichester.

The work of photographers such as Fenton, Lemere, Brandt and countless others helped to improve technical quality and also did much to set recognisable standards in architectural photography. The minimum standard is to achieve a correctly exposed, sharp image, and the next most important quality is that the vertical planes of the building should be represented as vertical in the photograph. This continued a standard that painters and draughtsmen had been adhering to for centuries, but it was important to re-establish it for photography as the new invention could produce very inaccurate representations of buildings. This standard for representing vertical as vertical is one that we should still strive to achieve.

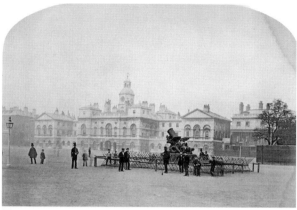
011

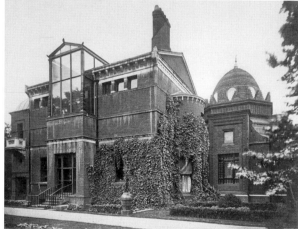
012

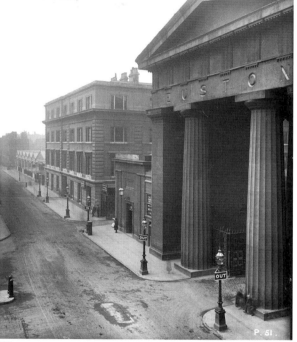
013

011 Horse Guards Parade, London. Taken by Roger Fenton *c* 1865.

012 An exterior view of the Arab Hall at 12 Holland Park Road, London, the home of Lord Frederick Leighton. Taken by Bedford Lemere in 1880.

013 Looking south-west along Drummond Street with Euston Arch in the foreground and booking offices to Euston Station. Taken by Bedford Lemere 1892–95.

The nature of light

Light is electromagnetic energy, part of a spectrum of energy that spans from radio waves to gamma rays. The parts that are visible to the human eye occupy a small part of that spectrum. Light travels away from its source in waves and these waves travel at different frequencies, depending on their energy and colour. In the visible part of the spectrum shorter wavelengths produce blue light and longer wavelengths produce red light. Just beyond, at either end of the spectrum but not visible to the human eye, lie the infrared and ultraviolet parts of the electromagnetic spectrum. The spectrum of visible light can be seen periodically in the form of a rainbow, or when white light is shone through a prism. While our eyes generally receive a mixture of these different wavelengths, the brain usually perceives them as white light.

In photography it is useful to have some perception of the different colours that light can be, and also useful to be able to classify what colour the light is at a given time. This is done using a system developed by William Thomson Kelvin and known as 'colour temperature', expressed in kelvin (K). The light that we might make use of in photography ranges in colour temperature from about 1,700K (candlelight) up to 27,000K (blue sky).

Light at a colour temperature between 5,000 and 5,500K

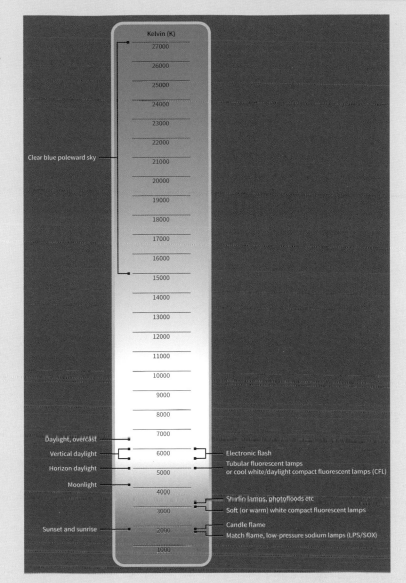

is of particular significance to photographers as it represents the colour of average daylight (measured at noon) and electronic flash light. Digital cameras are calibrated to view both sources neutrally.

The eye is able to compensate for the way things look under these light sources of different colour temperatures and therefore maintain colour consistency between them providing they are

not mixed. Even with mixed colour sources the eye (and the brain) has a pretty good go at compensation for the different colour light. The camera sensor cannot compensate in the same way and sees colours from the different sources as they are: different.

The chart (above) indicates the colour of different light sources in comparison to each other and their colour temperatures.

The capture process

In a digital camera, millions of pixels (short for picture element) are gathered together into an array to form an image. Image sensors are either a charge-coupled device (CCD) or the alternative widely used complementary metal oxide semiconductor (CMOS) sensor, or the less widely used Foveon sensor that is a derivative of the CMOS sensor. Pixels gather information about the scene projected onto the image sensor. Individual pixels only record how much light reaches them and not the characteristics of the light, such as its colour. In order to record colour information, the pixel needs to be shown only one colour of light through a filter. The filters used to record and later reconstruct the image are either red, green or blue. These primary colours of light can be mixed in different quantities to form any other colour of light. A filter array (known as a Bayer filter) with a pattern of red, green and blue filters (RGB) is placed in front of the image sensor to achieve colour information. The pixel needs to record information about the light that reaches it through the filter. It will be only one colour but it needs to record how much of that colour there is, the saturation, and how bright or dark the light is, the luminance. It also needs to record where the light came from by knowing the position of the pixel that recorded it (known as photosite). The light from each of the red, green and blue filtered pixels is then interpreted and processed to form the colour image. (Foveon sensors work differently; *see* http://www.foveon. com/.)

The quality of the image produced by any sensor is determined by the characteristics of the light present at the time of exposure, the capacity of the sensor to capture information in both the light and dark areas of a scene (known as dynamic range), the settings of the camera, how the image is processed and treated during capture and in post-capture, the quality of the camera lens and the skill of the photographer in using the equipment.

Larger image sensors with greater pixel counts will provide more information, but because of the variable factors listed above, it is not quite as simple as more pixels equals more information and therefore a better image. That said, more information will often lead to better tonal graduation and detail in the image.

What motivates picture taking?

There are several key motivators that make us press the shutter release. To create a narrative of the place and to share our experience of it are two of the primary ones. The necessity of making a record is the motivator that forms the focus of this book, but once we get to the site what things go through our mind in the choice of what we will capture onto the image sensor?

Light

How light falls onto any subject, and what light is available at the time of capturing the image are strong motivators to push the shutter release.

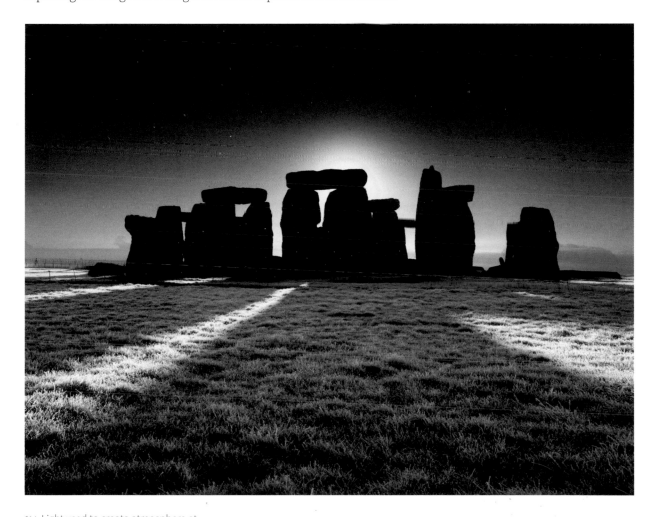

014 Light used to create atmosphere at Stonehenge as the rising sun casts long shadows that lead the eye into the stones, while the colour of the sky produces a feeling of warmth on the frosty morning.

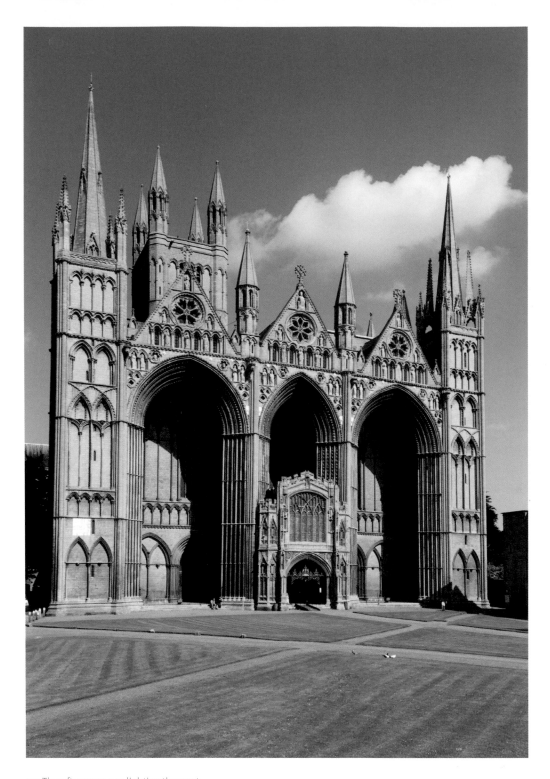

015 The afternoon sun lighting the west front of Peterborough Cathedral gives shape and depth to the arched recesses and decorative stonework.

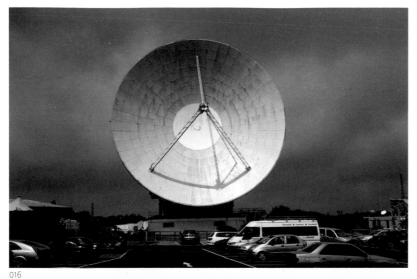

016

016 The sun striking the dish of the Antenna One, 'Arthur', at Goonhilly Satellite Earth Station highlights it against the stormy sky.

017 A strong side light hitting a single elevation of this coal elevator at Didcot Power Station creates a highlight, giving shape and depth to this otherwise minimally toned scene.

018 Light striking the hands of this effigy produces an effect of 'divine' illumination.

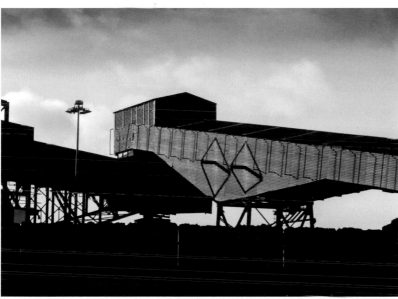

017

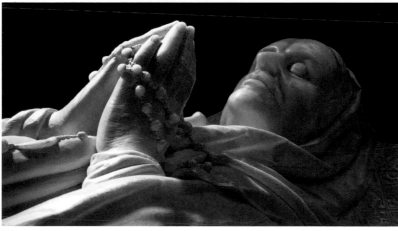

018

MARCIDA·SANGVINEO·LANGVEBAT·FOEMINA·FLVXV
EXCRVCIATA·ANNOS·AD·DVO·LVSTRA·DVOS
IPSA·TAMEN·TANTA·EST·FIDVCIA·VESTIS·IESV
DETVR·AIT·LIMBVM·TANGERE·SANA·FOREM
ATTINGIT·FLVIDVS·STETIT·HVMOR·CEDE·REDEMRTOR
SIC·TANGAM·VT·BENE·STET·QVOD·MALE·CORDE·ELVIT

019

At other times it is the ability to introduce artificial light into a setting that
makes us click.

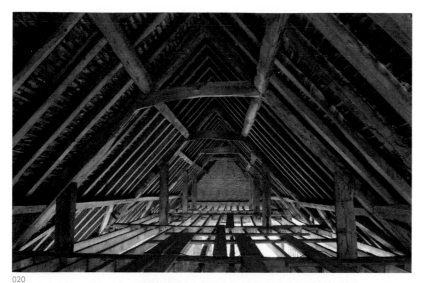

019 A soft light introduced from slightly above and to the left of this stone tablet lights the faces of the figures and gives relief to the shallower areas of the composition.

020 The light filtering through from below is used to illuminate this roof structure. The shadow created on the joists at the base gives a feeling of depth to the photograph.

021 The strong side light from the left falling onto the stacked white moulds in this pottery pattern storeroom gives them shape and tone.

020

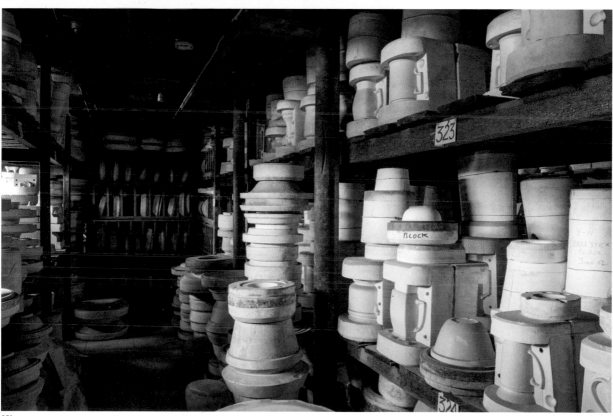

021

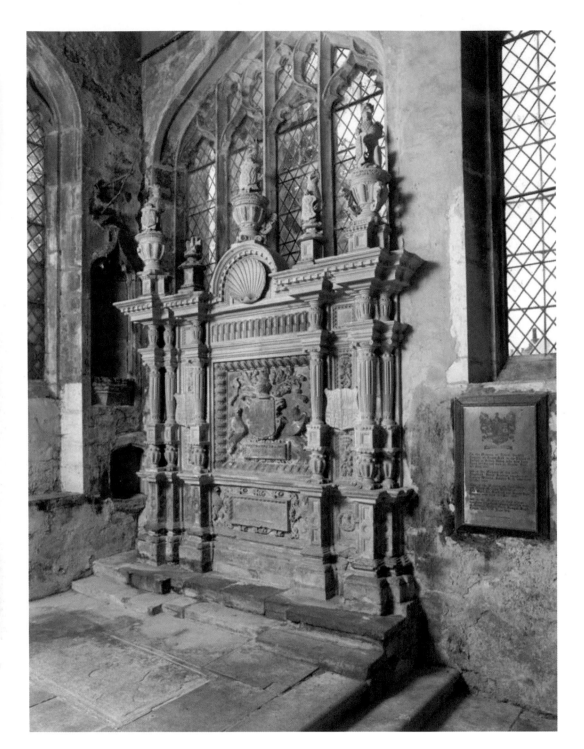

022 The Griffin Monument in All Saints Church, Braybrooke, Northamptonshire is a monument all of one colour. Without a soft bounced light being introduced to the far left of the camera, the carved decoration would be difficult to interpret.

023 Night-time and artificial light combine to produce interesting shapes and shadows at Preston Bus Station, where careful timing has kept a tonal quality in the light in the sky but allowed it to darken sufficiently to separate the concrete shapes of the building and the access ramp.

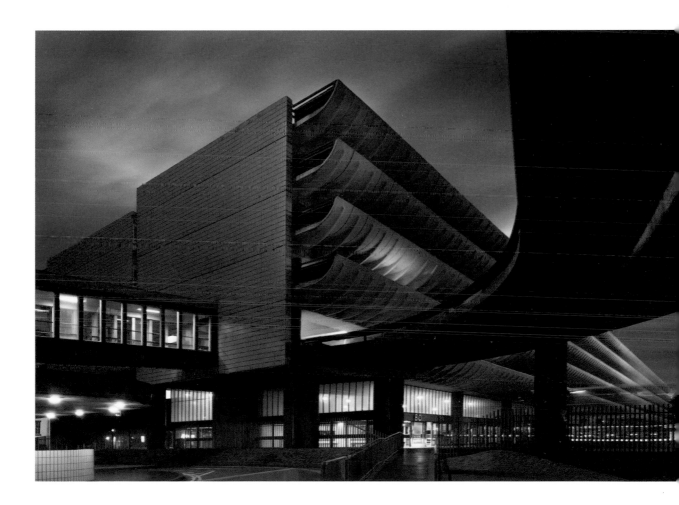

Colour

Muted, bright, unusual, natural or highly coloured things all attract our camera lens.

024 A muted display of colour at Taylors
Bell Foundry, Loughborough.

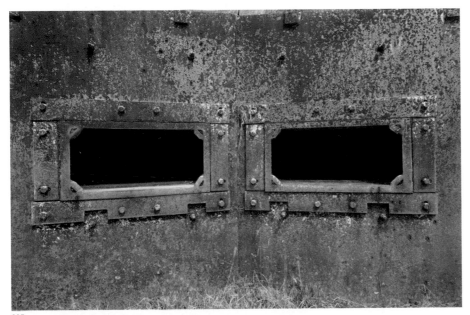

025

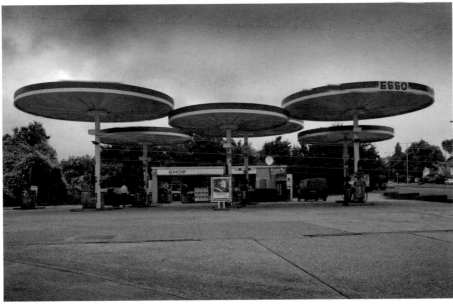

026

025 The beautiful rusty tones of the observation ports to the J10 test rig at the Atomic Weapons Research Establishment, Foulness, Essex.

026 Little accents of colour, such as the red rings on the canopies set against the dark sky and the blue petrol pumps accentuate this 1960s petrol filling station on the outskirts of Leicester.

027 Many colours are precisely positioned in the stencilled exuberance of this organ case in the church of St Nicholas, Great Yarmouth, Norfolk.

028 There is a jumble of colour in this stained glass depicting the mining industry from the church of St Luke, Millom, Cumbria.

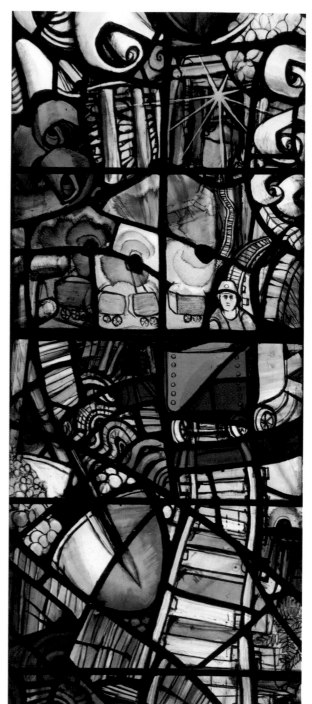

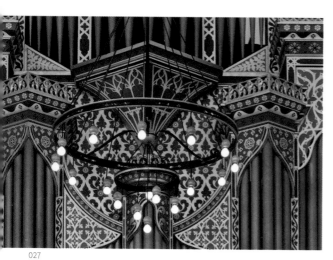

027

028

Black and white

Colour information can be distracting; removing it allows the eye to concentrate on shape and form. In this image of the North Pier and seafront at Blackpool, removing the colour accentuates the curve of the recently updated sea defences (029).

Many digital cameras offer the option to capture in black and white; however, it is better to shoot in colour and convert later in post-production as this will offer many more options in the conversion process that will enable greater control over the tone, contrast and colour (a warm or cold range of tones, for instance) of how the image is presented. For example, in this photograph of the capitals from St John's Church, Wakerley, Northamptonshire, all the information was captured in colour (030) but later removed in post-production (031), keeping options open and allowing greater control.

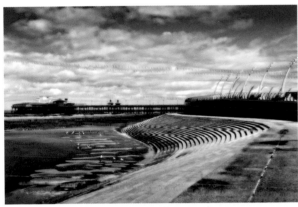

029

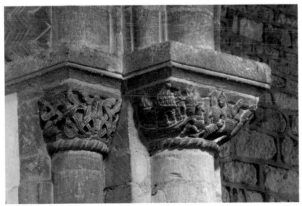

030

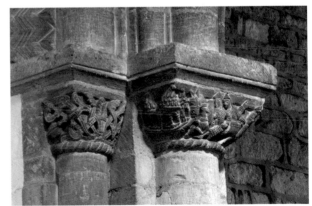

031

Opportunity

Opportunities can be serendipitous or arranged. The latter are the most likely to be motivators for our image making, but take delight in the former when they arise.

032

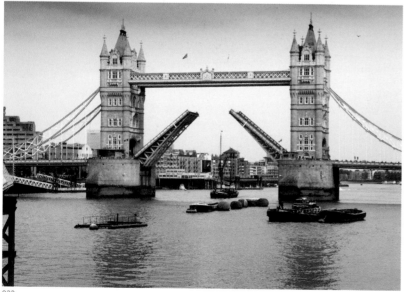

033

032 While not immediately obvious as an opportunistic image, the vast majority of times passing by this building a clear view had been obstructed by vehicles. This time it wasn't and the light was good too.

033 The light may not be perfect, but the opportunity of capturing Tower Bridge open was too good to miss.

034 An arrangement was made to visit the Bowling Green Society at Lewes, East Sussex to photograph the club house while a match was in progress.

035 The roof over Apethorpe Hall with the covering removed during conservation.

036 The restored lookout cabin being lifted on to Eastern Observation tower at the former RAF Barnham, Barnham, Norfolk.

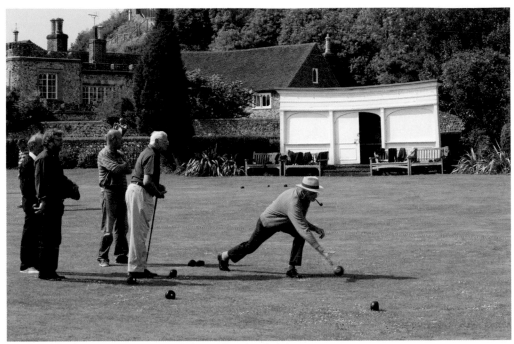

034

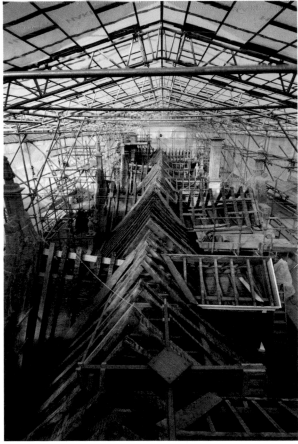

035

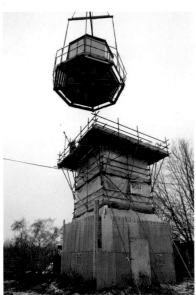

036

Pattern and shape

As well as being attracted to the shape of things we see on buildings, in buildings and around buildings it is also possible to make patterns and shapes in the composition of details of our chosen subject matter.

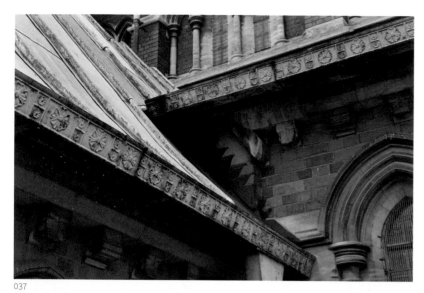
037

037 Strong diagonal lines from the junction of the guttering at St Paul's Church, Fulney, Lincolnshire.

038 The intricacy of the Romanesque in a church doorway in Stuntney.

039 Swirls looking up the stair of Beckford's Tower, Bath.

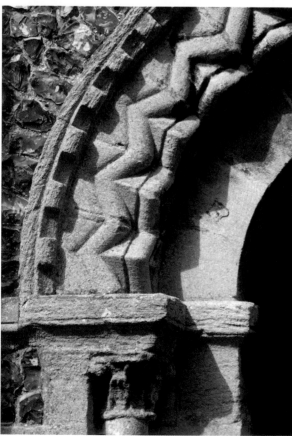
038

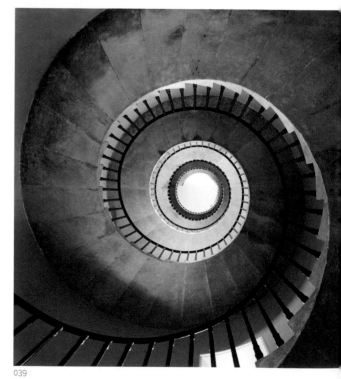
039

040

040 Chevrons from looking up at the Grade II listed William Stone Building at Peterhouse in Cambridge, built in 1964.

041

041 The wonderful shapes of Art Deco exhibited in the former Woolworths building in Nottingham.

Symmetry

Symmetry can be created in different ways: it may be a reflection of what is there, or created in a reflection, or produced in a detail of something larger that might not in itself be symmetrical.

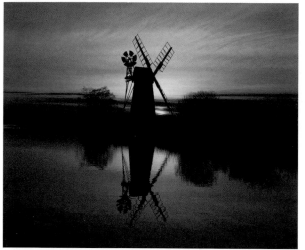

042

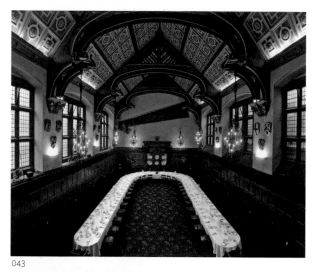

043

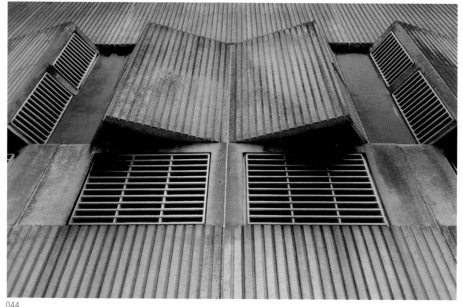

044

042 Symmetry created in the reflection of a wind pump on the Norfolk Broads.

043 Symmetry from the architect and the caterer at Cutlers' Hall, City of London.

044 Symmetry in concrete: a detail of the ventilators in a car park in Blackpool.

Asymmetry

Asymmetrical compositions usually (but not always) place one part of the image in prominence to another.

045

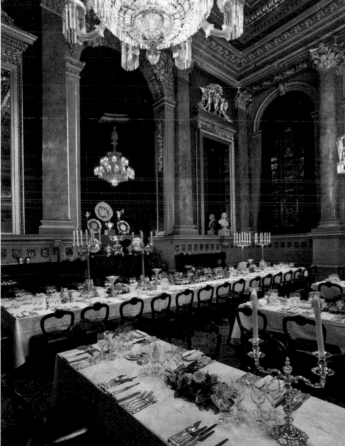

046

047

045 Signage and roof lights at Brixton Market.

046 The grandeur of the room contrasted with its function at Goldsmiths' Hall, City of London.

047 The polychrome font and brickwork of the Church of the Good Shepherd, Arbury, Cambridge.

2 | Practicalities of location photography

Before you pick up your camera and rush out to make your records, it is worth thinking about a few things that will make your journey most worthwhile, both in terms of what you achieve and how you achieve it.

If it is your intention to make a systematic record of a building type, and thereby increase general knowledge of the subject, it is worth checking that this hasn't already been done by someone else. You are unlikely to be the first (or even the twentieth) person to want to record wind pumps on the Norfolk Broads, for instance. Contacting your local archive and the National Archives will provide you with knowledge of what has already been done and also give some indication of what might most usefully be recorded, improved or updated.

Logistics

Owners and occupiers

Many people – but not all – are happy to allow access to their land or property for records to be made. Making contact with the owner or person with responsibility for the site should be your first step. Permissions will often come with caveats or restrictions, some of which may be safety requirements (*see below*). Others may be connected with what the owner or their insurance company wishes to keep private. Reluctant owners can often be persuaded by a full and thorough account of why you want to make a record, along with an explanation of how our historical and architectural knowledge is improved with each individual case study, whether the building is a one-off or typical of a common style. The offer of a set of images can also help! Owners are less likely to respond well to a 'doorstep' approach for permission, and a letter indicating what you intend to do, and why and how, will often lead to a more considered response. Of course, in the end, 'no' means 'no': don't trespass.

The journey

Travelling to and from your chosen site safely is of primary importance. Make sure that you assess the risks by taking the following into consideration:

▶ Will your mode of transport get you there and back? Is your car, motorbike or bike up to it? Are you? What time is the last train or bus?
▶ How will you plan your route? Getting lost could not only waste time but also lead you into areas of risk to you and your equipment. An Ordnance Survey map will help to locate many rural buildings. Technology such as satellite navigation systems (SatNav) or handheld Global Positioning System (GPS) devices will help you get to your destination and navigate around once you are there.
▶ Is the weather going to be suitable for photography at your destination? Check the weather forecast before you leave; although these are

not always accurate, they are usually more so when the indications are adverse. Television and radio broadcasts can be general in their approach, whereas websites tend to offer an hourly breakdown of the weather forecast. Try www.metoffice.gov.uk/weather, www.bbc.co.uk/weather, www.accuweather.com or weatherchannel.com. Most also offer an app for your smartphone.

▶ Are you equipped for changes in the weather and for the terrain in which you will be working? The weather can change rapidly, especially in hilly or mountainous areas. Protect yourself by having the right clothing and safety equipment. Windproof, waterproof and warm garments, suitable footwear and headwear, sunscreen and something to drink will help protect you from the elements and the terrain.

The site

There can be significant risks present on the site itself, which you also need to consider before making your journey:

▶ Is the site isolated? If so, tell someone where you are going, what time you should be back and what to do if you aren't. Take a mobile phone. Some areas may not have network coverage, in which case a torch or whistle may be needed to attract help. Consider if it might be better to visit the site with someone else.

▶ Is the site dilapidated? Some of the most interesting old buildings are in a bad state of repair. Where floors are uneven or unsafe, tread carefully in safety footwear that will prevent sharp objects penetrating your feet. Safety boots conforming to the EN ISO 20345:2007 standard with steel or composite toecap and midsole are the best option. Parts of the building may be unstable and liable to fall. You can mitigate this risk by wearing a hard hat conforming to EN397 and avoiding entering the building in high winds.

▶ Is the site in an unsafe urban area where you might be putting yourself at risk from the unwelcome attention of others? In this case consider visiting the site with someone else and adopting the precautions for isolation as above.

▶ Are there animals on the site? Cows are big and curious creatures, dogs may not be friendly, rats will rarely attack you but can carry diseases that can enter the human body via cuts and grazes. Take suitable precautions depending on the likely risks.

▶ Are there other dangers, such as contamination from industrial processes, gases or radiation? Asbestos may be present, especially in buildings that once housed machinery or processes involving heat. Ensure that you know all these risks and take measures to protect yourself.

Further advice on risk assessment is available from the Health and Safety Executive (HSE) and can be found at http://www.hse.gov.uk/pubns/indg163.pdf

Equipment
Cameras

It seldom takes very long at any meeting of photographers before the discussion turns to equipment and what is good, bad and/or expensive. Indicated below is what is absolutely necessary and what, if you have the funds, would be greatly beneficial.

Digital cameras

Like any camera, the digital camera needs to have several key components. It needs to provide a means of composing an image, to be able to focus light on to a sensor, to expose the image correctly and to save that image as information in a file so that it can be reproduced as an accurate representation of what the photographer saw. This is the very basic specification of what is required in photography, but digital cameras have developed greatly beyond this.

High-end cameras

A select few manufacturers produce cameras that offer not only the best engineering but also the finest image quality. These may be packaged as a complete camera system designed for digital capture, such as those available from Hasselblad and Phase One, or alternatively as digital backs, such as those made by Leaf, Hasselblad, Phase One and others, to replace film (as a retro-fit) for use on existing technical camera systems from Sinar, Linhof or Cambo. These cameras and digital backs offer image capture on much larger sensors, ranging from 24Mp up to 80Mp. The larger size and additional pixels produce exceptional image quality and tonal graduation. Used with high-quality lenses, the information captured using these cameras challenges or in some instances exceeds the quality of capture of medium- and large-format film. All this comes at a price, but the best images will result. Using a digital back with a technical camera – one that offers movements of the front and rear elements, rising, drop, swing and tilt – will provide imaging with perspective control.

The disadvantages of the medium-format digital camera, other than the purchase costs, are that all lenses and accessories are expensive. Other additional costs will include the purchase of computing equipment for the post-production of the captured images. With some file sizes approaching 230Mb, a fast processor, large amounts of RAM and plenty of storage space on the hard drive are essential. The weight and lack of portability of the camera could be an issue for some people, while using a digital back fitted to a plate or technical camera requires careful set-up for best results. Using a technical camera with bellows and a digital back in a setting other than the studio will also present an issue with dust on the sensor.

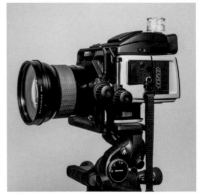

048

DSLR (digital single-lens reflex)

Like the film camera before it, the DSLR camera allows the photographer to see exactly what the camera is seeing, by looking through the same lens that is projecting the image onto the sensor. This is done by placing a pentaprism in front of the shutter, which in turn is placed before the image sensor. The pentaprism sends the rays of light that come through the lens up to an eyepiece for viewing. When the shutter release is pressed, the pentaprism is moved up, away from its position in front of the shutter, which then opens to allow the light to reach the image sensor for the required time selected (known as the shutter speed). After the exposure is made the shutter closes and the pentaprism returns to its position in front of the shutter, once again providing a view through the lens to the eyepiece.

The DSLR offers a flexible camera system by allowing the photographer to change the lens in front of the sensor, to give a wide angle of view or to magnify the image. In addition, the DSLR offers greater control of image-making than many compact cameras. The image quality will very often exceed that of a compact camera, particularly as a result of the 50Mp sensors that are being introduced by some DSLR manufacturers. The level of engineering present in the DSLR allows instant and, if necessary, rapid capture of images without the delay evident in many compact cameras. The range of interchangeable lenses available from the camera manufacturer or third-party manufacturers also offers the greatest opportunity for the best results. Some DSLR cameras provide for the use of two memory cards within the camera body. This facility can be used to extend the storage capacity but can also be usefully configured to provide a back-up of the images as they are taken.

Bridge cameras

These cameras occupy a space between the DSLR and the compact digital camera. They have many of the features for controlling image capture offered by the DSLR, but are physically smaller in size and lighter in weight, mainly due to the fact that they do not offer an optical viewfinder. Composition of images is achieved either by the use of a screen or in some instances an electronic viewfinder that presents an electronic image to an eyepiece. As the name suggests, they offer a bridge between the 'point and shoot' compact camera and the more technically demanding DSLR.

Compact digital cameras

The compact camera has become increasingly sophisticated and is perfectly suitable for recording our historic environment. It can offer high-quality image capture but lacks the versatility of the DSLR. Its small form makes it attractive to carry and easy to use. The more recent models offer

the ability to embed GPS data and applications to simplify the making of panoramic images and moving images (all of which the DSLR camera offers). Some compact cameras are equipped with viewing screens that are articulated to allow them to be viewed at angles or to the side of the camera body. This facility is particularly useful when the camera is used to photograph looking upwards or downwards from a high or low viewpoint, in which instances a viewing screen located on the back of the camera body would be difficult to use.

The complete automation of image capture can be an additional attraction for many, but this should be approached with caution. Ruggedised versions of these cameras are also available, which offer some degree of protection against the elements, dust, knocks and drops. It is best to choose a compact or ruggedised digital camera that allows the fully automatic mode to be turned off so that you can be in full control, to suit the needs of the image you want to capture.

Other capture devices

Mobile phones (049) and tablet computers (050) contain cameras, yet it is unlikely that images of buildings suitable for historical records will be produced using these. Although the cameras within these devices may have the pixel count to record sufficient information, they do not offer the essential refinements to control other elements of image capture, such as the choice of focal length of the lens, the aperture and shutter speed or the ability to synchronise with off-camera lighting such as electronic flash.

Some apps offer control over the aperture, focus point and light metering point for the cameras on such devices, but most are limited to applying 'effects' to the image after capture or providing the function to 'share' what you capture quickly and easily, for example on social media.

049

The very wide-angle view offered by these devices (needed for selfies) can be useful for architectural photography, but it produces an unwelcome distortion of the image as a result of the wide angle combined with the very small lenses used. In addition, the images produced by tablet or mobile phone cameras are designed to be viewed onscreen, at a resolution of just 72 pixels per inch, and they therefore lack the flexibility and resolution to allow for printed reproduction (which requires between 240 and 1,200 dots per inch) at anything but the smallest size. In our digital age, the demand for the printed image is reducing and may disappear altogether in the future, yet at this point in time the flexibility of a higher-quality image with the capacity for printed reproduction should still be your aim.

Photographic apps for smartphones and tablets are being written and improved constantly, as are the cameras and capture technologies. In addition, some tablet and phone manufacturers are producing add-on lenses, plug-in shutter releases and lights to improve their camera offering. It probably won't be long before they will be mounting a credible challenge to devices dedicated to the sole purpose of photography.

050

The shape of things to come

A new technology that is entering photographic use via cameras and mobile phones is 'Light Field'. This revolutionary system of capturing images does away with the need to focus the camera or choose the correct aperture for the appropriate depth of field. The Lytro camera and some mobile phones that use this new technology capture all the rays of light entering the camera at the time of taking the shot. The captured 'Megarays' are then stored and can later be manipulated via software to choose any focal point within the image, at the click of a mouse. More recent development has also allowed for the control of depth of field within the image. At the time of writing, this exciting technology is in its infancy but it is likely to revolutionise photography in the same way that George Eastman's Box Brownie or the first digital camera have done. You can read more at https://www.lytro.com/. If you own an Apple smartphone or tablet you can download an app and manipulate images already taken using the Lytro camera to get an idea of the capabilities that this system offers.

More about the camera

Sensors

Sensor sizes vary greatly, with those in a high-end digital camera being up to twice as large as those in the DSLR, which itself can be more than twice the size of the sensor in a compact digital camera. The categories of 'Dx' and 'Fx' are widely used to describe a sensor size (mainly in DSLR cameras). At an average of 24mm × 16mm, a Dx is a sensor smaller than the image frame size used in 35mm film cameras. Fx is a sensor of about the same size as the image frame size used in a 35mm film camera, generally 36mm × 24mm. Using lenses designed for Fx sensors on a Dx-sized sensor will have the effect of increasing the focal length of the lens due to the smaller size of sensor, but will not adversely affect the quality of the image, only increasing the magnification of the image. Conversely, using lenses designed for a Dx sensor on an Fx-sized sensor will have the effect of decreasing the focal length of the lens due to the lens being designed to work with a smaller sensor. Image quality suffers if you use a Dx lens on an Fx sensor as there is insufficient coverage of the sensor and visible 'cut off' of the image (051).

051

The amount of information gathered by the sensor, whatever its size, is more often expressed by the number of pixels contained within it. The millions of pixels in the array (Mp) offers some guide as to how much information will be gathered at the time of exposure. Any modern digital camera with a pixel count above 10 Mp should provide adequate image quality for printed reproduction at A4 size.

Sensors should be free of dust and dirt, which would otherwise reproduce on the finished image. This can be an issue with image sensors, as the electrical charge within the array tends to attract dust. This is less of a problem with cameras that don't offer the facility to change the lens, such as compact cameras. Changing lenses on a DSLR presents the opportunity for dust to reach the filter in front of the image sensor, so some camera manufacturers offer a system to clean the sensor filter automatically each time the camera is switched on or off. Other systems involving air, chemicals and wiping pads can be used to manually clean the sensor but need to be used with caution, as it is easy to damage. If dust on the sensor filter becomes an issue then the camera will need to be professionally cleaned.

Noise

The image sensor should not produce intrusive noise into the processed image. Noise is unwanted interference and degrading of the image caused by a number of factors during the processing of the image at the time of capture. One of the main causes of noise in images is the result of increasing the sensitivity of the image sensor (increasing the ISO setting)

to obtain images in low levels of light, or indeed shooting in low levels of light. The sensitivity of a sensor – how much it reacts to light – can be increased or decreased electronically. The sensitivity of the sensor is expressed by the use of a standard numerical setting issued by the International Standards Organization (ISO): low numbers – 50, 100, 200 – are considered low sensitivities; high numbers – 1,000, 1,600, 2,500 and upwards – are considered high sensitivity settings. The amount of noise produced at high ISO settings varies greatly depending on the quality of the noise reduction system of the camera manufacturer.

The effect of noise as the sensitivity of the chip is increased is evident in 052 and 053. It is more obvious when the files are reproduced at 100 per cent size (054 and 055). The loss of image quality in the right hand doorway (053 and 055) is purely a result of the additional noise produced at ISO 1,600. The loss of quality is camera dependent as different camera algorithmic systems deal with noise with greater or less efficiency.

Using lower ISO sensitivity settings and turning off any automatic facility on the camera to increase the sensitivity at low light levels will avoid or at least reduce the noise in images.

052

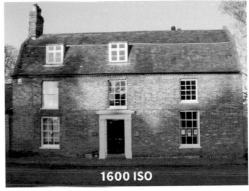

053

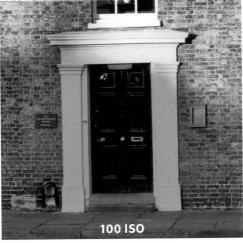

054

055

EXIF

The camera you use should be EXIF (exchangeable image file format) compliant so that appropriate metadata about how and when the image was captured will be embedded into the image. EXIF data record what type of camera and lens are used, what the camera settings are when the image is taken, what colour space is used and how large the file is, so that the image can be accurately described to the computer program that will open it. Most modern cameras will be EXIF compliant. For an accurate time and date this information must have been correctly entered at the initial set up, and re-entered if it should be lost for any reason. In addition, geolocational (GPS) data may also be stored in the EXIF data if the image capture device is able to capture it during exposure, or if it is added subsequently.

Camera Settings

Colour temperature

Colour temperature, in simple terms, is a method of describing the colour characteristics of light, usually either warm (yellowish) or cool (bluish). It is possible to set an exact colour temperature in your white colour balance setting for the colour of the light that is illuminating the scene you are shooting. This is usually done by finding or introducing a white item and photographing it under the light in which you wish to take the photograph (making sure to completely fill the frame in the viewfinder with the white object). The camera sensor will calculate what the colour temperature of the light is and adjust the white balance setting so that the object you are showing it reproduces as a white. The camera does this by producing an adjustment profile. As long as the light illuminating your subject does not change, images made using this setting should record neutrally. Should the light change in colour, another setting of the white balance colour temperature setting will be necessary.

Light

Digital cameras can be set for different colour temperatures (*see above*) of light and this is done using the white balance settings. As the name suggests, this is a setting to render white objects white/neutral when they are illuminated by light sources of different colour temperatures. Options for white balance settings usually include the following:

Auto

The camera will analyse the light falling onto the cell and adjust the white balance setting to produce a neutral white representation. It helps the camera if there is a white or other neutral area within the scene being photographed. Extremes of any particular colour or colours – a green pea on a large purple tablecloth for instance – will confuse the camera and result in an inaccurate reproduction.

Tungsten/incandescent

At this setting, the camera expects to receive light of a colour temperature of between 3,200K and 3,400K, which is the colour temperature that photographic tungsten light bulbs are set to operate at. Domestic incandescent light bulbs usually run at a colour temperature of less than 3,200K and consequently produce images on this white balance setting with a warm (red) cast.

Fluorescent

Fluorescent light has various colour temperatures depending on whether it is provided by a white, warm white, daylight or skywhite lamp, which range in colour temperature from 3,000K to 8,000K. Fluorescent white balance settings tend to be in the region of 4,000–4,500K in this mode. Problematically, fluorescent light also has an extra amount of green light (peak), which the human eye ignores but the cell will see and therefore produce images with a green cast. Using this white balance setting will activate a program to automatically remove this extra green light from your image.

Direct sunlight

This sets the sensor to receive light at a colour temperature of 5,000–5,200K, which is the average colour of the daylight that you will likely be shooting in. While this is less than the 5,500K of the noon sunlight in our colour temperature chart (*see* p 7), camera manufacturers anticipate that most of our photography will not actually take place at noon.

Cloudy

At this setting, the camera is set to receive light that is above the average daylight colour temperature of 5,000–5,500K, to something nearer to 6,000K, which is closer to the average colour of the light on a cloudy/overcast day.

Shade

Light in shaded areas on a sunny day is likely to be of a colour temperature of around 7,000K, resulting in an image that is too warm (red) for a direct sunlight setting. Using this colour balance setting the camera makes adjustments for this warm-coloured light to produce a more neutrally coloured image.

Electronic flash

Light produced from electronic flash has a colour temperature of 5,500K and above, making it bluer than the average for the direct sunlight setting in the camera white colour balance. Setting the camera to the flash white colour balance setting takes account of this blueness and adjusts the image by adding a little warmth.

Mixed light sources

It is important not to mix light sources of different colours within one image as the results will be either too red or too blue (known as colour cast) in different parts of the image, depending on which parts are lit by the different light sources and how the camera is set to receive the light.

In 056 the camera white colour balance is set to a daylight white balance (5,200K); however, the area nearest the camera is illuminated by tungsten light (3,200K). This results in an orange/red appearance in that area due to the lower colour temperature of the tungsten light source. The area beyond the tungsten-lit area, which is illuminated by daylight, reproduces with neutral colours. In 057 the camera white colour balance is set to a tungsten white balance (3,200K) which produces neutral colours to the area nearest the camera lit by tungsten light, but the area beyond appears blue due to the higher colour temperature of the daylight. Mixed light sources of this nature will always result in one area of the image reproducing incorrectly.

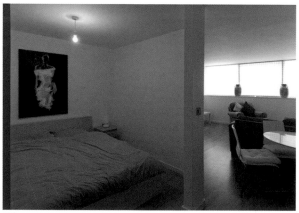

056

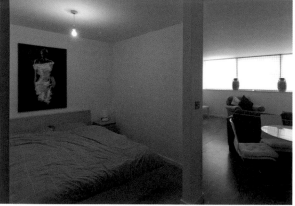

057

Solutions to mixed light sources

There are several ways to overcome the problem of mixed light sources. One is to make the light sources the same colour. The easiest way in the example shown would be to replace the tungsten light source with a bulb producing a daylight colour temperature. Alternatively, the daylight coming through the windows could be adjusted by means of a filter placed over the windows to convert the colour temperature of the daylight to the same as that of the tungsten light. Large rolls of filtering material can be purchased with which to do this, but time and cost can be prohibitive factors. More easily, lighting the tungsten-illuminated part with electronic flash light located away from the camera within the room would produce the same colour balance as the daylight-illuminated part, but this would alter the appearance of the room.

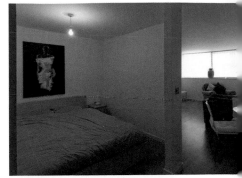

058

Other solutions are available with digital technology: place the camera on a tripod and take the same photograph with the camera set at two different colour temperature settings – in this instance daylight and tungsten. Then, in post-production, crop the two images at the point where the mismatch of colour temperature occurs and stitch them together in a computer program.

059

Alternatively, you could take one image as a RAW file balanced for tungsten light (058) and then convert it differently in the RAW file converter so you end up with two images, one converted for daylight colour temperature (059) and the other converted for tungsten colour temperature (060). Only RAW files offer this kind of flexibility to adjust the data recorded. The two images produced can then be cropped and stitched together in a computer program as described above to produce one image with the correct colour balance in both parts of the image (061).

060

061

Colour space

As the name suggests, colour space is the space in which computers and cameras store the information that describes the colour of an image. There are three main choices of colour space: Adobe RGB 1998, sRGB and CMYK (there are others but these are the most widely used). The size of these spaces – and therefore the colour information that can be contained within them – varies.

Adobe RGB 1998 is a large space with the capability of describing millions of colours (known as a wide gamut). It is an additive colour system which is based on the different amounts of red, green and blue light that are mixed together to produce any colour. Digital cameras and computer screens are RGB devices.

sRGB is a smaller colour space that also describes millions of colours, although fewer than Adobe RGB 1998. This smaller gamut is primarily designed for colour monitors, domestic colour printers and the Internet, and as such is widely used. As with Adobe RGB it is an additive colour system. Many cameras will only offer the sRGB colour space for image capture.

CMYK differs from the RGB and sRGB colour spaces because it is based on a subtractive colour system for colour printing inks. Printed colour images are made up from **C**yan, **M**agenta, **Y**ellow and blac**K** inks. The CMYK colour space is the smallest of the three, designed to accommodate only the colours that can be reproduced on the printed page.

As both sRGB and CMYK limit the number of colours that can be described, it is desirable to capture images in the Adobe RGB 1998 colour space, if it is available on your camera. If required, conversion to either of the other colour spaces can be carried out later in post-production.

Image capture file type

Nearly all cameras will be able to capture images as JPEG (Joint Photographic Experts Group) files. This is not the best file type to use to make photographic records. It is better to use a camera that will capture RAW or TIFF (Tagged Imaged File Format) files. TIFF files offer better quality than JPEG files, and RAW files allow for greater adjustments in post-production.

JPEG file format

The JPEG file is an open format, meaning that it is freely available for use and not owned by any person or company. It is a format that compresses the image by discarding some bits of information (described as 'lossy') and grouping pixels of similar colour, brightness and saturation together

to produce a smaller file. This option is suitable when storage space is restricted or if the image is to be transmitted or viewed via the Internet or an email. It is an excellent format for accessibility, and in spite of the loss of information brought about by its compression (which is why the TIFF file format is favoured), it provides a useful format for viewing, storing and exchanging images.

It is important that JPEG images are not compressed too much; very small file sizes (containing fewer pixels) will degrade the quality of the image. Equally important is that JPEG images must not be repeatedly compressed in post-production, as information is lost each time the file is compressed, resulting in a lower-quality image. It is important to note that merely opening and closing a JPEG image file will not alter its quality in any way. It is only opening the image and saving it as a new JPEG file that will have the effect of further compressing it and degrading the quality of the image. This loss of quality manifests itself as 'jaggies' or jagged edges (also known as aliasing) between different elements of the image due to repeated compression or incorrect reproduction of the image at a size larger than intended at a particular resolution. This is very evident in the reproduction of circular objects within an image due to the inability of the square pixel to create a smooth transition between different areas when there are an insufficient number of them (062).

062

(detail)

JPEG files are currently offered in two formats, JPEG and JPEG 2000. The former is widely used by most camera manufacturers and imaging programs. The latter, which was developed in 2000 as an intended replacement for the JPEG image, has not been widely adopted in spite of it offering many advantages in terms of compression and metadata storage. Few, if any, cameras capture JPEG 2000 files and support among web browsers is limited. The use of this format as storage medium is wider, but at this time it is not recommended due to its limited support.

TIFF file format

The TIFF (Tagged Image File Format Version 6) file is a widely used open format and is accepted as the standard file for archival purposes. The TIFF file is described as lossless (meaning it is uncompressed), and stores all the information captured, hence its relatively large size in comparison to the other widely used and open format of the JPEG image.

TIFF files can be stored in 2-bit, 8-bit, 16-bit or 24-bit depth for each red, green and blue channel. The bit depth is the amount of colour information held within each pixel, used to describe the colour of the light it has captured or is reproducing. 1-bit images would only provide enough information to produce a black and white image. A 24-bit per channel image will provide vast amounts of colour information about the subject, far greater than the human eye can perceive. In fact, 8 bits per channel exceeds what the eye can see, but the additional bit rate above this allows for greater tonal graduation and depth of colour. Increasing bit depth to 24 comes at the price of a file many times the size of an 8-bit file. Additionally, not everybody is able to open a 16- or 24-bit per channel file, so for accessibility the 8-bit per channel file has become the standard archive file. Note: Check with your intended archive for any specific requirements they may have before submitting your files.

RAW file format

The other file format that demands attention is the RAW format. RAW files are widely used by photographers because of the flexibility offered by the format in post-production. Much like a film negative, the RAW file offers the user data as captured by the camera – 'what the pixel saw' – with minimal processing applied. This allows the 'pixel' data to be taken into a computer program for interpretation and processing by the photographer or other competent person. The RAW data can be manipulated in many ways to adjust colour, exposure, saturation and even to bring back detail not readily visible in the shadow and highlight areas of the image. In addition, corrections can be made to compensate for defects in image quality brought about by imperfections in the lens. Many lenses for current and future cameras are or will be designed to make use of the capabilities of the computer to correct distortions in the image produced during the image capture. Like the JPEG and TIFF file formats, RAW files allow for the embedding of EXIF and IPTC metadata.

The use of RAW images as archive files is a source of hot debate. Because the pixel information is retained, many believe that storing the RAW data files is the best and most useful way to archive images, as improvements in computer programs will enable more and better information to be extracted from them in the future. However, this view is not universal. Unlike TIFF and JPEG files, RAW files are not an open

format and they can only be opened by camera-specific programs or by expensive imaging programs such as Adobe Photoshop (which will open most, but not all, current RAW files). Additionally, the camera manufacturers who own the RAW file format change the way they write their RAW files over time, sometimes scrapping earlier formats. So, a 10-year-old RAW file may not be able to be opened in current RAW converter programs. This restriction points the way to TIFF as the file of choice for an archive for the reasons outlined above.

Adobe has tried to standardise RAW file data by the use of a universal open file format known as DNG (digital negative). This file format contains all the data necessary (lossless) for interpretation and conversion to other file types such as TIFF or JPEG. Adobe also offers a free RAW file converter that will convert camera manufacturers' RAW file formats to the DNG format for interpretation via various computer programs. Unlike the TIFF file format, take up of DNG has not been universal.

All RAW files require additional processing in a computer program to get the best from them and to make them accessible to others. This can be time consuming. Those for whom photography is not their primary occupation may wish to consider shooting as a JPEG and saving as a TIFF as a time-saving image production workflow. However, this will fall some way short of the maximum quality and flexibility achievable from using the RAW file format, particularly in terms of colour saturation, dynamic range and colour and optical accuracy.

Using the analogy of film, JPEG files are like 35mm film: they take up less space but lack the quality of larger film sizes when enlarged. TIFF files are like 5" × 4" film used by professional photographers, holding vast quantities of information and capable of a greater degree of enlargement or reduction, being a flexible image. RAW files have the capacity to reproduce at the same or better quality than the TIFF file, but only when looked at with a specific type of viewer (program), otherwise you may just have a blank sheet of film. Storage of RAW files in addition to the TIFF files is a matter of personal choice and storage capacity.

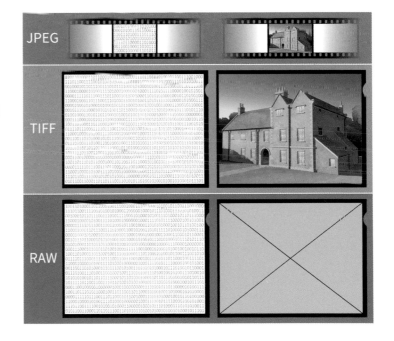

Lenses

Architectural photography is usually about capturing and conveying to the viewer information about large things, be they elevations of buildings or interiors of buildings. A wide-angle lens, which will enable a view of a whole building elevation or most of a room, is therefore necessary to the architectural photographer, as is a long or telephoto lens that will enlarge a detail to make it visible when it is distant from the viewer.

It is often possible to combine the two categories of wide-angle and telephoto lens into one by using a lens of variable focal length or zoom lens. Any study of photographic textbooks will tell you that the quality of a zoom lens is always inferior to that of a lens of fixed focal length. This is indeed true; however, modern zoom lenses offer very acceptable quality and the convenience of being able to vary the focal length will likely outweigh the loss of quality.

Wide-angle lenses

Camera lenses, particularly wide-angle lenses (typically a lens with a shorter focal length than the diagonal measurement of the sensor) have characteristics that produce distortions in the way the image is produced, most notably in the bending of elements of the scene which should be straight. These are reproduced either as bending outwards (barrel distortion) or bending inwards (pin cushion distortion). Using the right software in post-production will enable the removal or reduction of this unwanted effect.

Telephoto or long lens

A telephoto lens is defined as any lens with a focal length greater than the standard lens for the size of the image sensor. The focal length of the standard lens is based on the measurement across the diagonal of the sensor, typically between 50mm and 55mm on an Fx-sized sensor. (Using these focal length lenses on the smaller Dx sensor typically magnifies their focal length ×1.5, making them telephoto.) The effect of this greater focal length is to magnify the image and to narrow the angle of view. Long or telephoto lenses are useful to capture distant or small subjects that cannot be approached.

Zoom Lens

It is useful to have at least two zoom lenses, one of which will zoom in the wide angle to slight telephoto range of between 24mm and 70mm (35mm equivalent) and another in the telephoto range of between 80mm and 400mm (35mm equivalent). The exact range of variation in focal length will be dependent on the size of the sensor in the camera.

Do not use a digital zoom facility on your camera. Unlike a zoom lens – which actually magnifies the image using optical mechanics – the digital zoom crops into the captured image to give the illusion of zooming; however, the resultant file is a portion of the standard file the camera produces, resulting in a reduction of image quality.

Beware zoom lenses that offer a very great range of focal lengths, as these are less likely to provide acceptable image quality throughout the range, even using modern software techniques.

Perspective control lens

Buildings are large objects that do not usually lean backwards, yet this effect is often seen in architectural photography. This is caused by misuse of the camera at the time of taking the photograph. In order to get all of the building into view, especially the uppermost parts, it is necessary to tilt the camera back from a vertical axis. This changes the representation of the relationship or proportion of the parts of a building, making parallel lines appear to converge. This distortion of the perspective within an image makes a building appear as if it is leaning backwards or almost falling over (063). Setting the camera up parallel to the vertical axis of the building results in a correct representation, but there will be too much foreground and the top of the building will be cut off (064).

A perspective control lens eliminates this distortion. The lens, also known as a shift lens (or on some cameras as a perspective control adaptor that allows use with more than one lens), has mechanical movements that allow movement of the lens casing, or the whole lens in the case of an adaptor. Using the mechanical adjustments on the lens barrel/adaptor, it is possible to change the area of view seen in the camera so that areas such as the tops of buildings can be brought into view without the need to tilt the camera from its vertical axis (065). Control of perspective is most precisely achieved if the camera is set up accurately so that it is vertical to the plane being focused on, usually achieved by mounting the camera on a tripod and setting it up carefully by using a spirit level on the camera to ensure level arrangement. The mechanical movements allow use of parts of the image created by the lens that are not normally accessible.

063

064

065

The image created by a camera lens is circular – which is logical really, given that it has been created from a circular piece of glass, and not the rectangular shape we see through our viewfinder or displayed on a camera screen. This circular image is better quality in the middle of the circle and deteriorates towards the outer edges of the circle. The deterioration in the quality affects both sharpness and illumination. Normally the camera uses only the best part of the image in the middle of the circle (066), but there are still parts of the image circle that are usable both above and below and to the left and right of where we normally view.

It will also be necessary to use a small aperture (meaning a higher number) setting to restrict the effects of the loss of image quality as the field of view is moved away from the centre of the circle.

Perspective control lenses (067) usually have the ability to allow a tilt of the lens, as well as a shift up, down or sideways. Using the 'tilt' function gives the ability to change the shape or distort the image and can also be used to increase or decrease the area of sharpness throughout the image. Perspective control lenses are of a fixed focal length, usually in the wide-angle range. These clever optical–mechanical devices are not cheap. In other areas of this book, alternative solutions to controlling perspective are discussed (*see* pp 213–15).

067

066

Tripods

A good, sturdy tripod that extends to at least eye level, preferably higher, with a pan and tilt head is a great investment for a number of reasons:

▶ It keeps the camera still, especially if used in conjunction with a shutter release.
▶ It allows for long exposure times needed in low light levels (often the reality of architectural interiors).
▶ It almost automatically provides the discipline of a considered viewpoint (*see also* pp 64–7).
▶ It presents a very wide span of options for getting the best from your camera.

Recently, new types of tripod with flexible legs have been introduced to the marketplace. Although short, the flexibility of the legs allows the tripod to be fixed to a stable object at a suitable height to make the image. The compact form of these tripods makes them attractive to transport but compromises the choice of viewpoint if dependent on finding a stable object on which to attach it.

Pan and tilt tripod head

The addition of a pan and tilt head to a tripod greatly adds to the ease of using it. Once the camera has been attached, which may be by fixing a screw through into the base of the camera or by using a small plate that is fixed to the camera and then clamped by a mechanical means to the pan and tilt head, the mechanical adjustments that the head provides allow the camera to move freely so that it can be set in the desired position and then locked at the chosen point. The tilt allows for alterations of that position in the vertical and horizontal planes so that the camera may be set square and upright as needed. The pan facilitates circular movement of the camera around 360 degrees. Some provide a 'quick release' for the mounting and unmounting of the camera by use of a camera plate attached to the camera body (068). This camera plate also allows the camera to be mounted vertically and horizontally to the head.

068

Shutter release

Until recently, shutter releases were known as cable releases, as a small button was pressed on the end of a piece of cable that connected to the shutter trigger on the camera. Modern releases still come on the end of a cable, but it is usually now an electronic release system that fires the shutter and not the mechanical movement of the wire. Electronic firing of the shutter has its advantages as other devices can be used to make this happen. Remote firing of the shutter is possible via wireless connection from a far greater distance than a wired connection. The wireless devices can also have additional facilities built into them to fire the shutter at regular intervals or irregular intervals (*see* Communicating with the camera, below). The point of a wired or wireless connection to fire the shutter is that it reduces the possibility of movement of the camera during exposure as there is no physical contact with the camera. This is particularly important for exposures longer than 1/10 second as a blurring of the image may occur due to physical movement of the camera.

Spirit level

A spirit level can be used to make sure that the camera is accurately set up in both the vertical and horizontal planes, to avoid unwanted distortion of the image. This is particularly useful to take full advantage of the perspective control offered by the PC lens or rising front camera movement. The easiest ones to use attach to the hot shoe (flash attachment) on the camera (069) and can be purchased at a moderate price from camera stores or via the Internet.

069

Lens hood

Most lenses designed to work with digital cameras come with a lens hood; this is not coincidence. Lenses are designed to receive light only from defined angles for optimum performance, and the lens hood is the means of achieving this. Bright light reaching the lens from unwanted angles will result in flare and reflections within the lens, reducing image quality. Lens flare can take the form of either a reduction in the contrast and saturation of an image due to unwanted (non-image-forming) light hitting the lens and causing a haze across the image, or alternatively a manifestation of reflections from the within-lens mechanism displaying as a bright line or several bright circles at far and near points within the image. These circles may sometimes reveal themselves as polygonal, reflecting the shape of the iris (aperture) within the lens barrel.

Exposure meter

If this book had been written 20 years ago, it would recommend the use of an exposure meter, even if your camera had one built in. These days, however, unless it is a film camera retrofitted with a digital back (as described above) that is being used, there seems little point in carrying a separate device as all digital cameras have exposure meters built in to them that, of necessity, provide accurate exposure readings due to the small tolerance of digital sensors to overexposure. Even if the built-in exposure meter gets it wrong, it is still possible to check the image exposure using the screen in the camera and, if available, the histogram readout of the image. Information on the histogram and what it tells us follows later (see pp 55–6).

All of the above items (except perhaps the exposure meter) are essential for capturing our images and making records. By contrast, the following items are suggested additions to the photographers' kit, which either improve our image capture or make life easier while on location.

Stepladder

A stepladder could at times fit into the essential category of kit, as it provides a means of raising our viewpoint, thereby making it possible to look over the top of parked cars or hedges or walls. Steps may also allow access to some sites that might otherwise be inaccessible. But beware: working at height introduces an element of risk of either falling or dropping things onto others. It is important to assess this before proceeding.

Notebook

Many years ago photographers would note down each and every exposure and the lighting conditions in which they were taken. This helped to build up a database of information so that exposures could be fairly accurately calculated when the same conditions were encountered at other sites and times. This may still be useful today but my inclusion here is more for accuracy in the description of what is captured in the camera rather than as a database for exposures.

When photographing over a prolonged time or when visiting many different sites it is useful to note down what exactly has been taken on a particular image file. You may well remember that a particular photograph was taken in the Manor House in Anytown, Anyshire, but whether you can be sure it was taken on the ground floor or first floor north-east room in the south-west range is more challenging. Writing it down at the time (or making an audio note as some cameras allow for) will prevent confusion later on.

Torch

A torch is good for several reasons: to look into dark spaces on location; to light a subject so that the camera can be focused; and to give an indication of where to place the light for best effect on your subject matter.

Batteries

It is one of life's strange quirks that batteries will always run out of power just when you need them. It is best to carry spares for your camera, flash gun and torch.

GPS logger

A Global Positioning System (GPS) logger is a helpful device that can be attached to the hot shoe of a DSLR camera (070) or in some cases is built into the camera. This device communicates with satellites in orbit above the earth to provide accurate and detailed information about the location of the camera, which is fed via the cable to the port on the camera body, and is then inserted into the metadata when a photograph is taken. The information gives the latitude and longitude and height of the camera. Some devices will also give heading or the direction the camera was facing, too. Canon, Nikon and Hasselblad all make such GPS devices, and other manufacturers can be found easily on the Internet.

There are also apps for mobile phones that will record your position at any particular time of day. This information can be applied to your image either automatically at the time of shooting – by attaching your mobile phone to the camera – or manually at a later time.

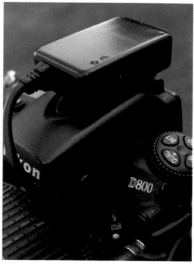

070

This information can be used to revisit the location via computer programs such as Google Earth or Google Maps, to see exactly where the photograph was taken from. It is important to note that the GPS logger records the position of the camera, and not of the subject of the photograph, but unless you are using a telephoto lens it is normally near enough to be able to work out where the subject matter is.

GPS information can be added to the image metadata after the image has been captured, by using computer programs to find the location in the photograph. Examples of programs that provide this facility are Adobe Photoshop Lightroom (http://www.adobe.com/uk/products/photoshop-lightroom.html), Breezebrowser (http://www.breezesys.co.uk/BreezeBrowser/) and ACDsee (http://www.acdsee.com/).

Electronic flash

The power of professional electronic flash units offers great flexibility in the lighting of building interiors and architectural details. Professional units can either run on mains electricity or be powered by large rechargeable battery packs. The output from these units varies but it is generally far greater than any smaller battery-powered flashgun. The units themselves may be single self-contained units or just a flash head that has to be connected to a power pack to receive its charge. Power packs will usually have the capacity to power more than one head, whereas self-contained units will only power themselves. Many flash heads also contain a continuous light source or modelling light so that the effect of the flash light can be assessed before making the exposure with the flash light.

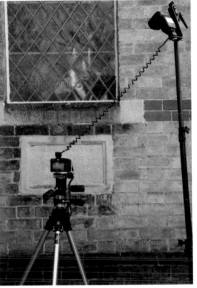

071

More commonly used by amateur photographers is the flashgun, which may be integral to the camera or a separate unit that can be attached to the camera via a sync lead or placed in the camera hot shoe for communication with the camera (071). These flashguns are more easily portable than the professional flash units; however, they do not have the light output of the larger and considerably more expensive flash heads. A flash unit of any sort is much more useful if it can be fired while detached from the camera, which, as we will see later on in the lighting section, is desirable for the light we want to introduce to our subjects.

Detachable flashguns or flash heads need to be triggered either by a lead that plugs into the camera and synchronises the firing of the flash with the opening of the shutter, or alternatively by means of a remote control that will also synchronise shutter and flash. The 'sync' lead allows for operation of the flash some distance from the camera position and may be extended in length by the use of additional lengths of lead. However, a physical link between camera and flash unit must be maintained.

072

073

The flash units may also be triggered via a remote control that can be attached to the camera via a short lead plugged into the 'sync' socket on the camera (072) or alternatively attached to the hot shoe on the top of the camera (073) to achieve synchronisation with the shutter firing. These remote firing devices can be bought in pairs so that one can be attached to the camera as a trigger/sending device while the other is attached to the flash unit (via a small cable) to act as a receiver for the signal sent out by the trigger/sender attached to the camera. These remote triggering units are superior to sync leads as no physical connection is needed between camera and flash unit, allowing greater freedom in where that flash may be positioned. In addition, receivers can be attached to other flashguns or flash heads to fire more than one flash source from the camera trigger/sender, thereby allowing multiple sources of flash light to be introduced into the scene from different positions.

The light produced by any flash source is harsh and will not be suitable for many situations due to the hard shadows produced. The use of flash light bounced from a reflector of some sort produces a softer light and will cover a greater area than using it pointing directly at the subject. Reflectors may be a white wall, a white umbrella or even a white piece of card or paper (074). It does need to be white (or silver) to avoid introducing wrongly coloured light into the subject and distorting the colour reproduction of the image.

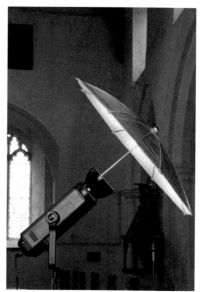

074

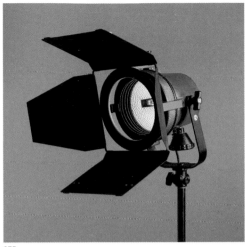

075

Continuous lighting
Tungsten light

Floodlights, spotlights and any other source of electric light usefully light up a scene in front of the camera, which is clearly a major advantage to any photographer. However, this great advantage comes with quite a few disadvantages. The lights need electrical power, which is not always available at many disused or isolated buildings. The lights waste energy by the production of unwanted heat as well as light. With bright tungsten lights (in excess of 500W) this heat is considerable and may be a source of combustion if used without care. The light produced from the tungsten source is very warm in colour compared to daylight therefore cannot be mixed with it without causing a misrepresentation of colour in the image, known as a colour cast (*see* Colour temperature, above). The tungsten bulbs have a short life in comparison to other light sources and are susceptible to breakage if knocked or banged.

LED lights

The light emitting diode (LED) is fairly rapidly taking over as the photographers' choice for a continuous light source. From kitchens to bicycles, the little LEDs appear everywhere, and no less so in the photographic world. The light emitted from a photographic LED light source can often be adjusted for both intensity and colour temperature, which makes them an ideal source of light. They run on low-voltage current and so can be battery powered. Energy wastage via heat generation is minimal and they are also lightweight. In addition, the LED light source is long lasting.

076

While units with a high light output cost considerably more than tungsten lights to buy, they do offer long-term savings in running costs. They are also more robust than tungsten lamps.

Communicating with the camera

Using a digital camera raised up on a pole for a street scene; high up on a tripod looking down on a monument; low to the floor looking up at a ceiling; or capturing a roof space when it is inaccessible or dangerous for a photographer – all these can be achieved with a number of different remote-control methods. A wired connection to a computer (tethered) with suitable software is probably the most reliable. All major camera manufacturers offer software for controlling the camera and firing the shutter remotely. Examples of these are Nikon Camera control, Canon EOS Utility software and Hasleblad Phocus software. Many other non-camera-specific programs also offer remote control of your camera, such as Phase One's Capture One and Adobe Lightroom.

Other remote-control methods include placing a tiny video camera and shutter-triggering device in the hot shoe of the camera, which sends a view from the camera position to a receiving device with a screen showing what the video camera is seeing. However, this is not necessarily what the camera will capture in terms of field of view.

A number of apps now exist for controlling your camera via a smart phone or tablet computer, using a wired or wireless connection. The utility of these varies from merely firing the shutter to full remote control of the camera. The best of these will provide you with a view of what the camera is actually seeing (live view) so that the shot can be composed before taking.

Useful links

http://www.phaseone.com/en/Imaging-Software/Capture-One.aspx

http://www.canon.co.uk/Support/Camera_Software/#EOSUti

http://cpn.canon-europe.com/content/product/accessories/lc5.do

http://camranger.com/

http://www.zesty.co.jp/en/zgr/

http://dslrdashboard.info/

Additional aids

The histogram

Many cameras offer a histogram of the scene you are shooting or have just shot. The histogram is a graphical representation of all the different brightness levels (tones) in your photograph and it provides a quick and easy way to assess the exposure.

The histogram presents the different brightness levels (tones) from left to right along the x axis, with black at the far left and white at the far right. In between these two are the midtones. Each level denotes a change in brightness that is discernible by the eye. The number of these changes to alter the brightness from black to white along the x axis is 256 where 0 is black and 255 is white. The y axis indicates the amount of any one brightness level (tone) within the scene; that is, how many pixels are receiving that colour and brightness. So, the higher up the block rises, the more of that brightness level is contained within your image; more pixels are receiving it. If a correctly exposed 'normal' scene is photographed, the range of brightness levels should spread from the left to the right of the x axis. The amounts displayed up the y axis will vary with whatever is being photographed. For instance, if the scene contains a greater proportion of dark tones, then expect to see a higher display of blocks to the left of the histogram; if light tones, then more blocks will appear on the right. Some cameras provide histogram information for each of the red, green and blue channels being recorded by the sensor, sometimes overlain and at other times displayed separately.

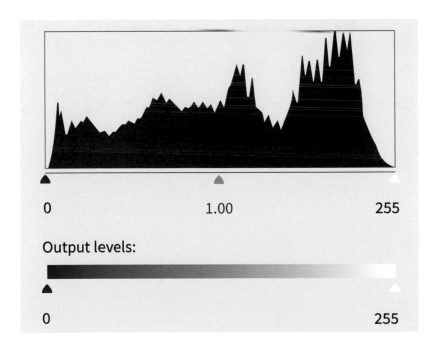

Output levels:

Interpreting the histogram

If the scene being photographed has a normal range of tones but the histogram displays nearly all of the blocks to the right and fails to reach completely across the x axis to the left side, this indicates that the image is over-exposed (077). If the opposite is being displayed, with most of the blocks to the left with none to the far right of the x axis, the image is underexposed (079). A histogram that displays a complete range of brightness levels across the x axis indicates a correctly exposed image (078). The high peaks displayed to the right in the over-exposed image and to the left of the under-exposed image indicate what is known as 'clipping'. Clipping is exhibited in an image as a loss of information where several different brightness levels have combined together to form either white or black without any tonal differentiation. Armed with this information, it is possible to assess the exposure of the image and make an adjustment for more or less exposure to spread the levels completely along the x axis.

A histogram that does not display a full range of brightness levels across the x axis will be lacking in contrast because the image will not contain either a complete black or complete white brightness (tone). Lack of contrast is also evident in a histogram that displays a full range of brightness levels along the x axis but the blocks for any level do not extend far up the y axis because there is no great difference in any of the brightness levels (tones) contained within the image. This lack of contrast can be rectified later in post-production if required.

Histograms with high peaks at either end of the x axis will be of high contrast. They may indicate clipping of both the highlights and the shadows because the range of brightness exceeds what the sensor can capture.

Understanding the histogram display will not only help you to get the exposure right at the time of capture but also provide information to make an informed decision about which brightness levels are important and need to be kept and which can be sacrificed and the information lost. Understanding the histogram is also vital for making adjustments to the image in post-production.

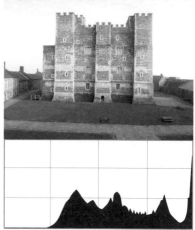

077

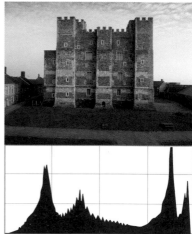

078

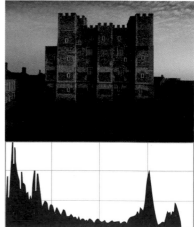

079

Colour accuracy at the point of capture

Digital cameras are actually pretty good at getting the colour right at the point of capture, to within a few kelvin. For even more accurate colour reproduction and easy adjustment during post-production, it is useful to include a known standard, which may be grey or, for more accurate measurements, a card containing many standard colours, at the time of taking the photograph.

The image below was captured by the camera without colour correction (080), but with a standard grey reference point (at right) included in the photograph. In the post-production process this shot was used to take readings from the reference point and corrected for colour (081).
Note the shift of colour as the program places equal amounts of red, green and blue light into the image, which are reflected from the grey standard. Once the adjustment was made, the readings were stored in the computer. The correction can then be applied to all images taken under the same lighting conditions in order to achieve the same colour balance (082).

080

081

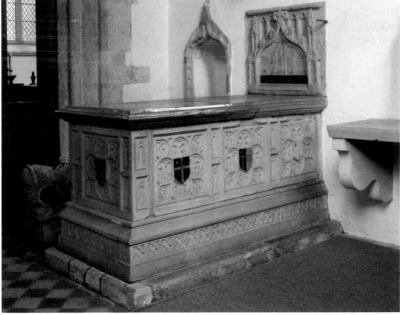

082

Introducing a colour patch is essential when photographing subjects or scenes that deviate from the normal range of colours a camera might expect to see, as the camera will not be able to work out what is neutral and create a correctly balanced image. For example, the strong blue surround of the painted depiction of the coastline within a Battery Observation post (083) would make it impossible for the camera's colour program to assess what the correct colour of the painted scene should be, and wall paintings and plaster contain a narrow range of colours (084). The inclusion of a standard set helps to provide a basis for measurement. It is also necessary when a very high degree of accuracy is required, for example when photographing paintings and other artworks (085).

Measuring the colour of the patches in a computer program allows for a comparison to be made with the known standard. Any deficiencies identified can be corrected by the application of a colour profile created from the measurements.

See http://xritephoto.com/ph_product_overview.aspx?ID=1192

or

http://shop.colourconfidence.com/section.php/10055/1/input-profiling

or

http://motion.kodak.com/motion/Products/Lab_And_Post_Production/Control_Tools/KODAK_Color_Separation_Guides_and_Gray_Scales/default.htm

083

084

085

Depth of field

Depth of field is the term for describing how much of your photograph is in focus, in front of and behind the object that is focused on. How much of your photograph is in focus is determined by a number of elements.

We get more in focus by using small apertures (higher numbers, F:8, F:11, F:16) and less by using wide apertures (lower numbers, F:2, F:4, F:5.6).

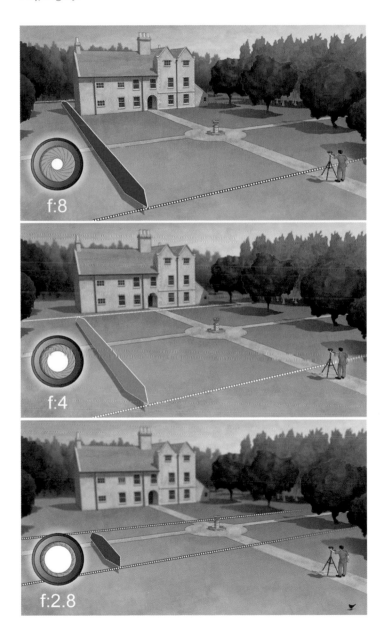

086

087

We also get more in focus by using wide-angle lenses and less in focus using telephoto lenses. The amount is also dependent on how near or far the object focused on is from the camera. For maximum depth of field, with more things in focus, use a wide-angle lens and a small aperture and a distant object focused on. For a minimum depth of field, less things in focus, use a telephoto lens with a wide aperture focused on a near object.

For example, both the above images were taken using the same lens and the viewpoint focused on the head at the front. One image was shot using an aperture of F:2.8 producing a shallow depth of field with mainly the head in sharp focus (086). The other image was shot using an aperture of F:18 producing great depth of field with both the head and the vase recorded in sharp focus (087).

088

089

Using a telephoto lens and a wide aperture gives a shallow or minimal depth of field, which may be used to isolate an object such as the end of a row of theatre seats (088), whereas using a wide-angle lens and a small aperture gives great or maximum depth of field, used to capture an entire room in sharp focus (089).

In the photography of historic buildings it is best to aim for more of the image in focus than less, so we opt for the use of smaller apertures. The use of a smaller aperture to increase depth of field will also affect the exposure, as all exposures are based on how much light is shown to the light-sensitive cell (controlled by aperture) and for how long it is shown to the cell (controlled by shutter speed). As less light is shown to the light-sensitive cell by the use of a smaller aperture, in order to achieve the same exposure it is necessary to show the cell the light for longer by using a slower shutter speed. Use of a slower shutter speed will often require a means of keeping the camera still: a tripod is good for doing this!

3 | Composition considerations

Viewpoint

Put simply, viewpoint is the distance, angle and height from the subject matter. Where the camera is placed in relation to the subject matter is hugely important for a number of reasons: it will determine the appearance of the building or part of a building; it will either provide a truthful rendition of the subject matter or distort it; and it will dictate the understanding of the subject matter and its surroundings to the viewer of the photograph. It would be disingenuous to say that it is possible to completely remove the photographer's bias, intent or emotion from the choice of viewpoint. The story we want to tell about what we see may well outweigh all other considerations. Whether an object looks good or bad is influenced either by what we feel about it or what we want others to feel. Your choice of viewpoint should start with two questions: what do I want to say about this building or subject and where can I best say that from? For example, the proportions of the vast airship hangars at Cardington in Bedfordshire are much better explained by showing more than one elevation (090).

Choosing a viewpoint is always a compromise between where the camera can actually be placed and where it ideally should be placed, in order to show what we want to of the subject matter. This compromise is due to a number of factors: limitations of the equipment in use, the illumination of the subject, environmental constraints and safety considerations.

090

All of the above factors influence our decisions on viewpoint, and limit how much control we have over this. How the subject is illuminated, either naturally or by light we introduce, can be under our control either by choosing the time of day we take our photograph or by choosing where we introduce our light into the scene. Equipment can also be tailored to suit our needs, although more often than not the equipment to hand and budget will limit our choice. Environmental considerations are more difficult to overcome. The height of a wall or hedge or the width of a room or passageway cannot be easily changed.

These photographs of the rotunda of Ickworth House, Suffolk show one taken from a near viewpoint using a wide-angle lens (091) and one taken from a more distant viewpoint using a longer focal-length lens (092). The near viewpoint has failed to capture any information about the roof and distorted the proportions of the circular shape of the building. The more distant viewpoint produces an image without distortion, reproducing the building and its roof in the correct proportions. For exterior viewpoints, a position distant from the building taken with a standard or slightly telephoto lens will always give a more truthful and less distorted image than one taken close up with a wide-angle lens.

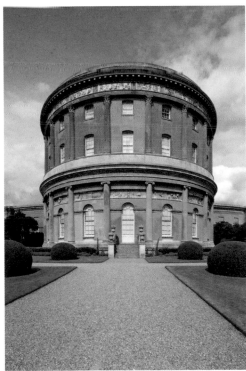

091

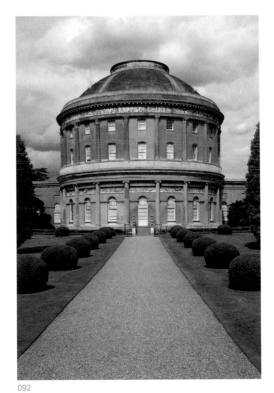

092

The choice of viewpoint for an exterior is particularly important because it can convey a considerable amount of information. Besides the obvious matters such as building materials and constructional information, additional information about the layout of the interior may also be evident either from the arrangement of windows on an elevation or the number and position of chimneys at roof level.

This is shown in the following photographs. A viewpoint close to the subject using a wide-angle lens distorts the proportions of this group of houses, misrepresenting the sizes of the windows and doorways. It also obscures information about the positioning of the chimneys and dormer windows (093). A more distant viewpoint using a longer focal length lens more accurately portrays the proportions and relationship of the group,

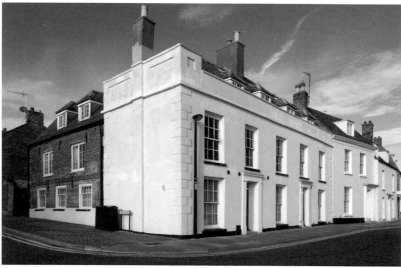

093

094

shows the arrangement of the dormer windows and chimneys
and more honestly shows the proportions of the windows and doors
(094). This more distant viewpoint also gives additional information
about the location of the buildings.

Many buildings have beautifully symmetrical elevations; others
present an asymmetrical front. This is important information to show.
A view taken straight on, parallel to the elevation, will be the best way
of doing so. For example, in a photograph of the south elevation of
Chatsworth House, Derbyshire, taken from a straight-on view, the
symmetry is emphasised (095), whereas a straight-on view of a London
house shows its asymmetry, and raises many questions about
its design and construction (096).

095

096

Locational information

Generally speaking, buildings do not stand alone, and the photographer needs to convey this. They should be placed in context with their environment, be that urban, domestic, rural or industrial. More distant viewpoints are better at doing this than ones close up to the building. A series of photographs showing the context of several buildings may be necessary to explain their connection or separation, particularly on industrial sites or other sites where a process is or has been in operation. Sometimes this can only be done with an aerial viewpoint.

097

097 The former mill at Brierfield, Lancashire dominates the town landscape.

098 The remains of Mohopehead Mine in Northumberland are placed in context from this raised viewpoint overlooking the valley.

098

099

099 Littleport signal box is shown next to the railway lines with the level crossing gates beyond giving an indication of its purpose and its location relative to the nearby road.

100 Surprising things often lurk behind historic buildings! A more distant viewpoint tells more about the building and its surroundings, as this photograph of the former Unitarian Chapel in Southwark shows.

100

Viewpoint isn't just about distance from the subject; it's also about height. Raising our viewpoint is often necessary to achieve the best photograph. It's one way of reducing the need to tilt the camera off its vertical axis, thereby minimising distortion of the perspective in the captured image.

A raised viewpoint can be achieved by using a stepladder (101) or standing on a wall or gaining access to a window on an upper floor near to the subject matter. A camera raised high using a telescopic pole can also be useful when taking details of buildings (102).

101

102

A high viewpoint can minimise the presence of parked cars and/or
pedestrians in towns and cities (103). At other times it can be useful to
show roofing materials and construction. An aerial viewpoint obtained
from a camera mounted on a remotely controlled drone was
the only way to capture the arrangement of multiple courtyards at
Apethorpe Hall in Northamptonshire (104).

103

104

Interiors

Interior viewpoints offer less opportunity for using a standard lens. The nature of domestic interiors will automatically dictate the use of a wide-angle lens to enable the capture of more than a small part of a room. As with exteriors, more information about the size and shape of a room will be provided when more than one wall is shown, and photographs taken from the corner and middle provide sufficient visual references for the viewer to orientate themselves with the room (105, 106).

The height of an interior viewpoint needs careful consideration.

105

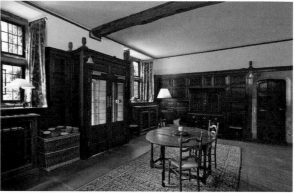

106

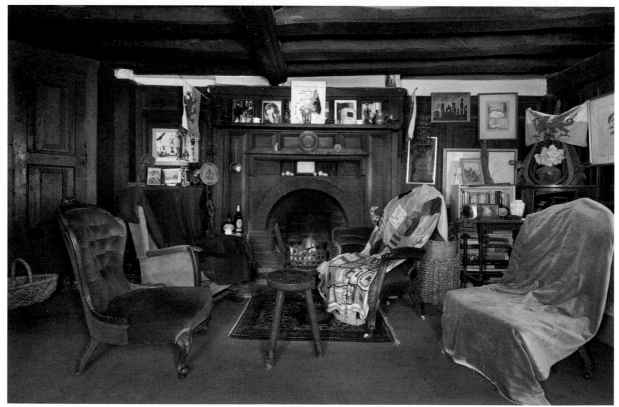

107

High viewpoints in a timber-framed cottage will provide much information about the floor but little about the joists and beams in the ceiling, so often a viewpoint lower than normal eye level will be necessary to give correct proportionality to the space (107).

A viewpoint showing two sides (108) gives more information about the fenestration and roof of this reconstructed World War I soldiers' hut in Staffordshire, but the view from one end of the hut (109) gives more information about the layout and contents. Careful consideration of what needs to be shown is essential in the choice of viewpoint.

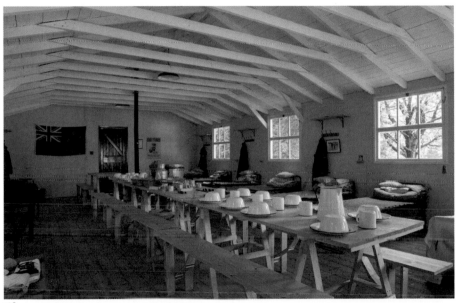

108

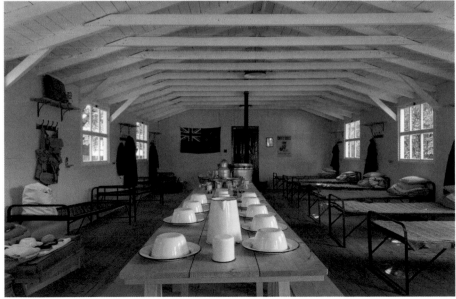

109

110

111

112

113

114

To give greater information about how a building is laid out and how rooms relate to each other, choose a viewpoint that offers a view into an adjacent room via the doorway (110). If the door itself is important, then an additional view with the door closed can be taken. Additional information can also be given about the room that is showing through the doorway (111).

The relationship between connecting rooms should be explored through a series of photographs. The general view sets the scene showing the doorways (112); a closer view with the doors open provides a narrative to the adjoining room (113); and a view from that room back to the original room confirms the relationship and position of the adjoining room (114).

For larger interiors – in ecclesiastical or industrial buildings, for instance – using extreme wide-angle lenses will distort the proportions of the space, emphasising near objects and diminishing distant ones. Not using the widest-angle lens may produce a more accurate representation of the recorded space.

Careful consideration is required for details of buildings, too. Choosing the correct height, often lower than eye level, will reveal additional detail lost from the higher viewpoint, such as the decoration beneath the shelf of a fireplace (115) or the faces and rose decoration on the cant at the base of a font (116).

115

116

Timing
Seasonality

There is another element to consider when timing a visit to any site (providing it is not under immediate threat). The weather and the time of day are important, but so is the time of year. These two photographs of Ely Cathedral show just how much more can be revealed of the building and its surroundings from this viewpoint when it photographed in February (117) as opposed to May (118). Both were taken at a similar time of day but the verdant spring growth of leaves reduces the visibility of the cathedral building dramatically.

117

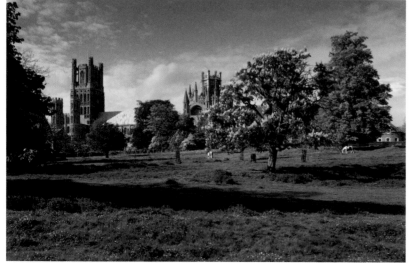

118

Opportunity

Timing of a different kind also has a dramatic effect in any site where a process or particular activity takes place. These photographs of the control tower, hangar and engine maintenance facility at RAF Coltishall in Norfolk were taken in February and August of the same year.

In February (119–121) the personnel, activity and technology required to keep the aircraft in the air are evident: the radar screens and staff inside the tower with the aircraft out on the apron beyond, and the aircraft in the hangar with the sheer clutter of the engine maintenance facility. The base closed in April and by August (122–124) everything had been cleared away, leaving a sterile environment with the meaning and vitality of the buildings lost.

119

122

120

123

121

124

Panoramic views

Digital technology has greatly simplified the process of making panoramas. Computer programs can make comparisons of the pixel information in several different images and successfully match like pixels to combine ('stitch') the images and produce a panoramic view. However, some care needs to be taken to help the computer program ensure a successful outcome.

Mounting the camera on a tripod and setting it and the camera to be level in both the horizontal and vertical planes will prevent distortion of the perspective. Avoid using the widest-of-angle lens to limit distortion of the image. Make images that overlap each other by about 30 per cent, to give the program plenty of pixels to compare. When making exposures, set the camera to manual exposure to ensure a consistent exposure over the batch of images being captured. Avoid making panoramas (unless using specialist lenses and software; *see* 360-degree photography, below) that have objects near to the camera lens, as the difference in the way the camera records these in each image will be great and probably beyond the ability of the software to compensate and create a successful panorama.

The resultant stitched image may require cropping to remove uneven image boundaries. Once produced, the panoramic image is very useful in conveying buildings in their environment and gives a good feeling of what it is like to be on the site. For example, using three images taken at Ashby St Ledgers in Northamptonshire (125–127) and stitching them together, it was possible to connect the church in its landscape with the Manor House (128).

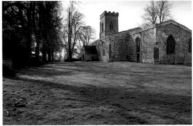
125

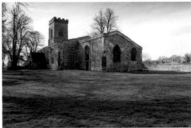
126

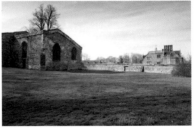
127

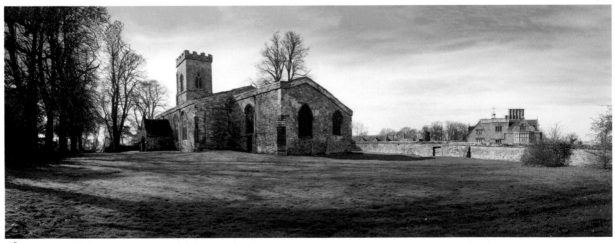
128

Stitching images can also be used in the vertical axis. The tall interior of the Olde Trip to Jerusalem public house in Nottingham would be impossible to capture in its entirety without doing so. More information on the stitching of images can be found in the post-production section (*see* pp 216–21).

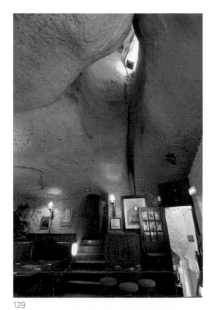

129

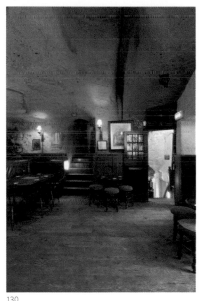

130

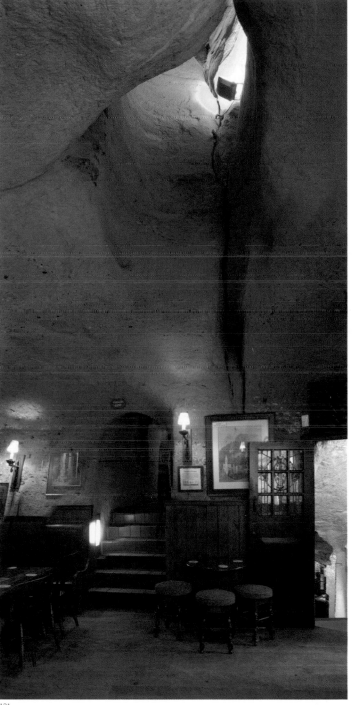

131

360-degree photography

For even greater ability to create a photograph that fully shows a site, specialist software can be used to create a 360-degree panoramic image. To create a 360-degree panoramic image, proceed as above for panoramas, making images that cover views of a scene in a circular motion, ensuring not to vary your viewpoint. This will result in a minimum of six images (as below). If it is an interior 360-degree panorama that is being taken, consistency of viewpoint is so critical that it will be necessary to mount the camera on a special mount that enables its rotation on the nodal point of the lens in order to avoid even minimal changes of viewpoint that will result in changes in the way different objects appear in relation to each other and cause stitching problems.

Capturing sufficient data is easier if a fisheye or other extreme wide-angle lens is used. Doing so enables information at the top and bottom of the vertical views to be recorded, which will overlap sufficiently with the views of the floor and the ceiling that need to be taken with the camera either pointing upwards or downwards respectively.

A typical set of images produced from a fisheye lens for a 360-degree panorama showing all four sides of the room plus views looking up at the ceiling and down at the floor is shown below. Note how the special camera mount used for rotating the camera about the nodal point of the

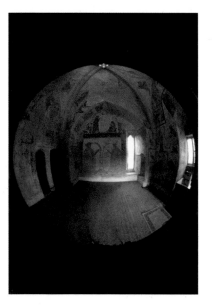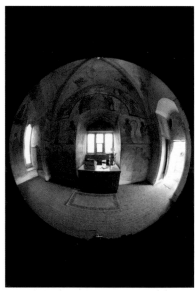

132

lens is visible in the view looking down. The information in the area of the subject obscured by the mount can usually be gathered by the stitching program from the vertical views, or alternatively covered up in post-production either by cloning information from surrounding areas, or perhaps by inserting the name and copyright information here.

Once enough images have been taken to capture the view in 360 degrees, the images need to be imported into a specialist stitching software. Options include PTGui (www.ptgui.com) or Microsoft ICE, which is available as a free download from http://research.microsoft.com/en-us/um/redmond/groups/ivm/ice/. The software will stitch together all the images to produce the 360-degree image. Once produced it can be viewed either by uploading to a website to share with others (for example via https://www.photosynth.net) or output from the stitching program into a format that can be viewed via freely available players such as Apple QuickTime player or Windows Media Player.

Capturing 360-degree panoramas for the web can be done very cheaply (although not necessarily at the best quality) using a portable device such as a telephone or tablet computer and using an app. Various free or low cost options are available. *See* https://occipital.com/360/app or http://www.photat.com/ or more options via the Apple App Store or Google Play.

Scale

An indication of scale in buildings is mainly evident in the architectural features of the doorways and windows that most people will recognise as standard sizes. However, when these features are not present or are other than a standard size, it is necessary to introduce a known standard into the image. For instance, it would be difficult to know just how big the pipes of a wind tunnel plant really are without the addition of the human figure standing on the bridge (133).

The inclusion of a colour patch as a colour control also adds a measured scale to an image of a watercolour drawing (134). Including a scale measurement like this allows the artwork to be reproduced at its original size.

134

133

Explaining function

Explaining the function of things found in historic buildings, such as the oven in a kitchen at an RAF base (135, 136), is assisted by maintaining a consistent viewpoint and taking two or more views of the subject in its different operation conditions. The eye has the same visual references of the surroundings in both shots and therefore the brain is able to easily recognise it as the same object with the differences serving to explain its function. There are other less technical ways of explaining function, like including a donkey in a donkey wheel (137).

135

136

137

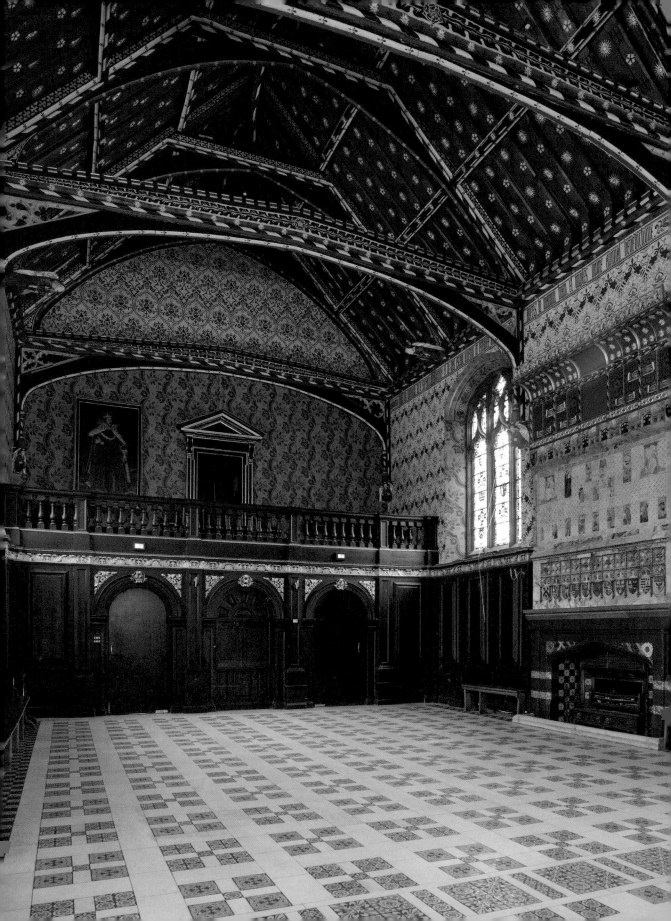

4 | Light

Lighting exteriors

Planning our photography to take advantage of the sun requires prior knowledge of how the building is orientated. This can be discovered either by using a map or alternatively by using one of several websites that offer either a bird's-eye view or a street-level view of the building of interest. These website options offer the best preview of the site as it is possible to spot large trees or other tall obstructions that will cast shadows on to parts of the building at particular times of day. Google Maps offers a great service with Street View.

There are times when the shadows cast by bright sunlight should be avoided. For example when maximum detail in all areas is needed, perhaps for the production of a drawing from the image or to reveal what the timber framing is like beneath a jetty or the stonework detail in a deep recess. A soft overcast light will be best on these occasions, with the sun behind the camera. This may also be your best choice if time is limited and you wish to record all sides of the building in one visit. Remember though, shooting in flat light makes for images lacking in shape, depth and texture.

There are also times when a light coming towards the camera casting shadows in the direction of the lens can be used to emphasise shallow relief or to create a feeling of depth. If possible, avoid actually showing the sun in shot and shield the lens from direct sunlight to avoid unwanted highlights in the image caused by internal reflections within the lens.

138 A soft sunlight coming towards the lens is used here to give shape and depth to the stairs. Tight cropping avoids any direct sunlight entering the lens.

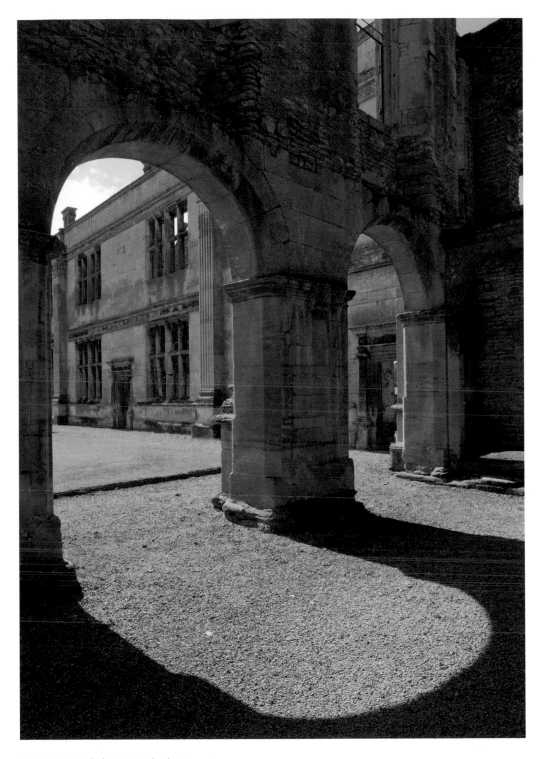

139 A strong sunlight casting shadows towards the lens gives a feeling of depth to the image and balances the arch of the arcade.

Using natural light for exteriors

Discussion has already taken place in the previous chapter about how light and its source and direction will influence our choice of viewpoint. Our use of natural light may vary depending on what we want to achieve and how much time we have to obtain our image. Strong sunlight produces strong shadows, which we can make use of to give shape, depth and texture to our images. A raking light across an elevation can reveal much in the way a building has developed: changes in the brickwork, blocked openings and straight joints will be revealed with a raking light. Indeed, a raking light from left or right of an elevation will often reveal or disguise different features.

With the sun shining it is necessary to plan our photography for the result we want to achieve and to consider where the light will be coming from at any particular time of day. East elevations with raking light need to be photographed early in the morning or late in the morning.

140 A bright light from a light cloudy sky provides enough illumination to give relief to the decorative panels while maintaining some detail beneath the overhang of the eave.

141 A dull day with a flat light provides the maximum detail beneath the jetty and roof overhang of this Wealden House (part of the Weald and Downland Museum).

142 The lettering on this elevation is barely discernible when photographed in a flat light but clearly visible when taken with a raking light from the left shining across the building (143).

140

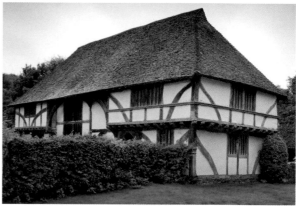

141

142

143

Don't forget that this will extend during summer months when the sun rises earlier and sets later. For south elevations with a raking light, early morning or early evening during the months of April and September will be the best times. For west elevations with raking light, early afternoon and late evening during the same calendar range. North elevations are more problematic due to the lack of sunlight reaching north faces during many months of the year. When light does fall on north-facing parts of a building it will be raking across in the early morning and early evening.

The low raking sunlight in the winter months (November–March) can be particularly problematic for architectural photography in towns because of the shadows cast on the subject from surrounding buildings. On the other hand, low winter light is wonderful for recording lumps and bumps in the ground: buildings and structures that used to be, namely archaeology, such as the remains of the deserted medieval village at Wharram Percy, North Yorkshire.

144 The raking light to the right of the tower emphasises its circular shape and picks out the decorative details.

145

Working with the sun

St Martin's Church, Witcham, Cambridgeshire, photographed from the south-east at 2-hourly intervals over a period of 12 hours during August (146). Note how the sun moves from east to west casting greatly differing light on the subject. (All times are BST.)

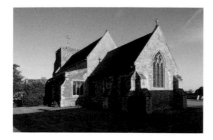

At 07.00 the sun is too low and fails to illuminate even one elevations without intrusive shadows.

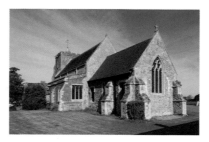

By 09.00 the sun is high enough to illuminate the east elevation completely and is just skimming along the south elevation.

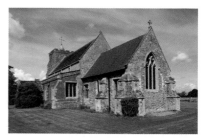

At 11.00, with the sun almost immediately behind the camera, both the south and east elevations are lit evenly, with the effect of flattening the building.

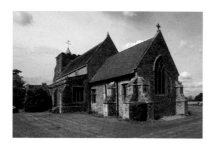

At 13.00, with the sun due south, there is better shape and contrast.

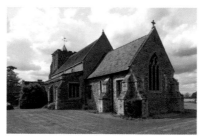

At 15.00 the lighting offers good shape and contrast but the shadows on the south side are beginning to intrude into the chancel elevations.

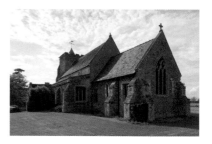

At 17.00 little useful light is shining on the south elevation of the chancel.

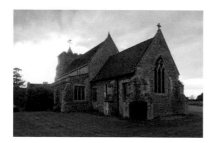

By 19.00 the sun is shining directly into the lens and not lighting either the south or east elevations.

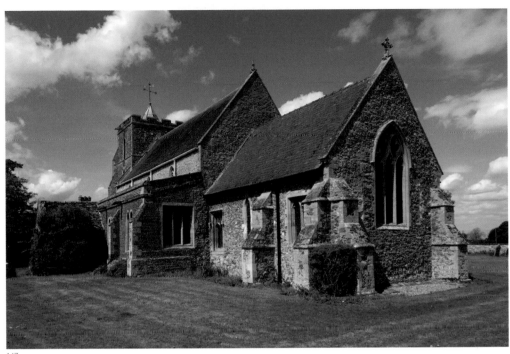

147

The most opportune time to capture maximum information about St Martin's Church from this angle is 12.30 (147). The light on the two elevations is different enough to give shape and depth to the structure; at 11.00 it is too even on both elevations, flattening the subject, and at 13.00 the light has gone completely from the east elevations. The 13.00 light gives shape and depth to the structure but lacks the quality of the 12.30 light falling obliquely across the east elevations to pick out the archaeology of the remains of a former window at the east end and to show the break in the brick plinth to the south aisle. Here and at many other churches the light between 12.15 and 12.45 will provide the right conditions for this kind of information gathering. The time is variable depending on the exact orientation of the church in its east–west axis. Within an hour the same opportunities for oblique light on the west elevation will exist.

148 The dappled sunlight falling on the pump in this image has its attractions but is generally distracting and not beneficial to showing the form and function of the object.

Lighting interiors

Choosing when to photograph is also a significant consideration in interior photography. As with exteriors, the rotation of the sunlight around the building during the day can either assist or hinder image making. Bright sunlight entering a room or building interior will, depending on the time of day or year, create highlights either on the floor or walls of the space being recorded. This can be used to create mood but will distract the eye in record making. It is arguable whether these highlights and consequent shadow areas add or detract from a view, but they will certainly limit the capture of detail in an image.

A bright, soft, hazy light is best for capturing interiors without too much distraction. Many interiors can be captured using only the available light within the space. For some large interiors, such as Test Cell 4 at Pystock National Gas Turbine Testing Establishment (149), this might be the only way to capture them, as to light them would be beyond the means of most non-professional lighting equipment. The starting point should always be the available light. The cell in a digital camera is sensitive enough to record in very low light and provided the camera is kept still (by the use of a tripod or other firm supporting surface) a surprising amount of detail can be captured. This works for views looking away from the light sources, such as windows and doorways. Very long exposures may introduce noise into the image with a resulting loss of quality. The quality of the image produced will depend on the internal noise reduction system of the camera at the time of shooting, or alternatively the use of noise reduction filters in post-production.

149

As with exterior light, in order to achieve shape, depth and texture, the light source needs to be away from the camera, achieved by either choosing a viewpoint where the natural light source is to the left or right or by placing introduced light sources off the camera to positions either above, left or right.

150

150 A light placed to the left of the camera and bounced from a reflector produces a soft illumination of the room but also gives sufficient light to cast shadows in the white painted panelling. The light entering through the window is controlled to the desired level by use of the shutter speed. The aperture for the flash exposure element of the overall exposure determined what the shutter speed for the window could be.

151 Choosing a time of day without direct sunlight shining through the windows, and using flash light bounced from an umbrella placed above and behind the camera to create a soft light, the lighting of the room helps to pick out the plasterwork of the ceiling.

151

152 Flash light reflected from a source placed to the far right of the camera casts shadows along the wall to bring out the archaeology of the openings and blocked openings.

153 This large interior space is lit by natural light from windows to the left of the camera and additional flash light to the right of the camera reflected up into the roof and towards the dark wood of the screen at the far end.

Very often the available lighting of interior spaces or objects is uneven and produces a range of brightness levels that exceeds the capacity or range of the charge-coupled device (CCD) in the camera, such as a figure on a monument located in front of a window, where the available light from the window illuminates the wrong side of the monument and also causes flare around the window (154). When this situation occurs action needs to be taken to reduce the range of brightness levels so that they fall within an acceptable range for the CCD to capture. The method of correction involves controlling the brightness of the highlighted areas by using the correct exposure for those areas. Doing so will lose information in the shadow areas. This loss is regained by introducing additional light into those areas either by use of artificial lighting or reflecting light into the dark areas to bring them back into range.

The use of tungsten or fluorescent light will work in these situations and has the advantage of showing how the light is affecting the scene, but it will create difficulties with clashes of colour temperature (*see* Colour temperature, chapter 2) between the daylight coming in and the light being introduced. The best light source for lighting the shadows without clashes in the colour of the light is electronic flash as it is very close to

154

155

daylight in its colour temperature. Unlike the continuous light source of tungsten or fluorescent sources, the effect of this introduced flash light is not visible before exposure but becomes so when the image is shown on the camera screen after exposure.

Balancing light coming in through a window with light introduced from a flash gun requires dealing with the two sources separately. In order to successfully effect this separate treatment it will be necessary to set the camera controls to manual.

The exposure for the introduced light of the flash gun will be controlled by the aperture setting on the camera. This is because flash light is very short in duration, typically 1/800 second or shorter, and will be unaffected by the shutter speed element of the exposure because the maximum flash synchronisation speed of the camera will be much slower.

In the final image (155), electronic flash has been introduced to light the figure from the correct direction, with the exposure for the flash based on the lens aperture setting. The exposure for the window has been controlled by use of shutter speed and set to a short enough interval to eliminate the flare but correctly expose for the daylight coming through the glass based on the aperture determined for the flash light.

Determining the aperture for flash exposure using a guide number

Almost all modern flash guns are fitted with sensors that measure the light that is bounced back from the subject matter and adjust the output from the flash to correct for overexposure (and, to a lesser extent, underexposure if the flash gun is powerful enough). With the right connection between flash and camera this information may also be integrated into the exposure metering system in the camera. This automated exposure adjustment works best when the flash is mounted on the camera. For most of our image making, using the flash in this position is undesirable due to the harsh shadows and flattening effect that light from this position produces.

Flash guns also come with a guide number indicating the output at a given sensitivity setting of the sensor, expressed by the use of ISO numbers. The calculation for the correct aperture when using flash is made by using the guide number of the flash gun and dividing this by the distance that the gun is from the subject. For instance, if we have a flash gun with a guide number of 50 when using an ISO sensitivity rating of 100 ISO and our subject is 10 metres from the gun, the aperture will be

156

157

GN 50 divided by 10 (distance from subject) = F:5. Calculating the correct aperture setting by using the guide number overcomes the sometimes-too-clever technology of integrated systems that try to dictate camera settings which may not suit the image being captured.

For the most accurate measurement of the light falling on the subject generated by the electronic flash gun, readings can be taken by using a flash meter (like an exposure meter but able to record the light produced during the short duration of the flash). The aperture reading indicated by the flash meter can be applied as the setting for the aperture part of the exposure. Flash meters can be purchased from around £60.

Using a digital camera, it is possible to use the TIAS (try it and see) method of flash exposure determination, in which case the correct aperture for the flash can be established by trying a couple of exposures at different apertures to assess the correct setting. If the flash-lit area is too dark, use a larger aperture (lower number) to let more light fall on to the CCD. If too light, use a smaller aperture (higher number) to reduce the amount of light falling on to the CCD.

Once the aperture for the flash exposure is established, the exposure of the daylight-illuminated parts of the image will be controlled by using the shutter speed to expose the daylight parts correctly. As stated above, the shutter speed will not affect the flash exposure, only the daylight exposure. Using the TIAS method, keep the aperture as already assessed for the flash exposure and adjust the shutter speed until a suitable balance between the two is reached in the test shots. Remember not to reduce the exposure for the daylight too much as this will result in an unnatural result; windows should still appear as highlights.

A black marble tomb placed against the east wall of the chancel poses particular difficulties with flare and shadow with the available light (156). These can be overcome using electronic flash to light the monument from two sources, high up to the left of the monument and low down to the right of the monument. To achieve the final image (157), the exposure for the tomb was based on using the correct aperture setting for the flash lights and the exposure for the window was based on the correct shutter speed calculated to correctly expose for the daylight coming through, in combination with the aperture determined for the flash light.

Using only introduced (artificial) light

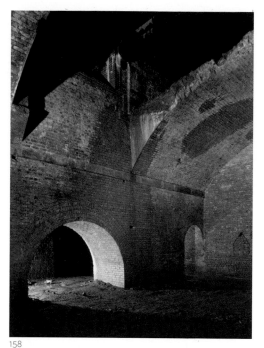

158

159

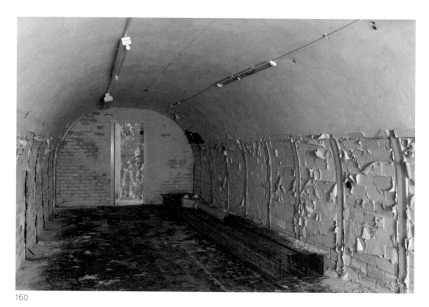

160

158 These large, underground spaces were lit using flash light from the camera position and with additional lighting from behind the arches to illuminate the arches themselves and the wall beyond. The highlights of the arches give shape and depth to the scene and separate the different areas.

159 Light to the right of the camera provides modelling to the moulded surround of the doorway, while a light at the end of the passage sending light towards the camera gives both depth to the image and shows the curved shape of the passage.

160 Flash light to the right of the camera places an oblique light along the wall of the room, giving contrast to the light-coloured walls. Placing another flash light beyond the far doorway gives a point of interest to the image and reveals the chalk face of the underground area into which the room is inserted.

Lighting architectural details or features

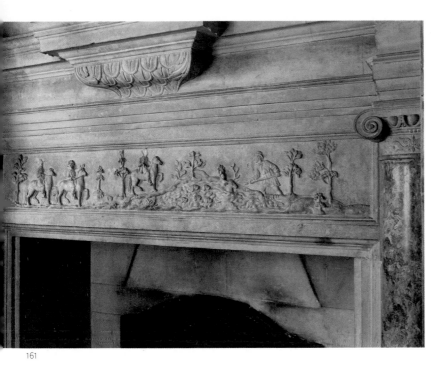

161

162

163

161 With a viewpoint limited by the remains of a framework of a protective cover, the relief of the frieze on a chimneypiece is brought out by a light to the left of the camera casting shadows forward towards the lens.

162 Lighting this ventilation duct required very careful positioning of the light source. The monochromatic nature of the subject matter meant that only one face of the subject should receive the light, casting shadow on to the other face to give relief and shape to the vent and the curved nature of the tunnel. An electric light bounced from the opposite corner of the room away to the right of the camera was used to achieve this.

163 Light coming towards the camera emphasises the relief decoration of this ceiling.

Introducing highlights and shadows

Subjects that are all of one tone need to have shadows or highlights introduced into them in order for the viewer to be able to interpret the content. Shadows can be introduced using either direct or bounced light depending on the depth of relief or impression of the subject matter. Shallower incision or protrusion will normally require a more direct light source placed at an oblique angle to the subject. Lighting from an oblique angle will cause uneven illumination across the subject, with points closer to the light source receiving a greater amount of light than points further away. This unevenness in illumination can be corrected in post-production by the 'burning in' of the brighter areas and the 'dodging' of the less bright areas (*see* Post-production, chapter 7).

165 Soft shadows produced from a bounced light source above and to the right of the camera are more suitable for the greater relief of the figures on this overmantle.

165

164 Graffiti carved into a white painted wall would be almost invisible without the very oblique light placed across it using a direct flash light source placed to the left of the camera. This introduces hard shadows into the whitewashed stonework and makes the image legible.

164

166

167

166 This black wooden overmantel needed highlights and shadows. They are produced here by using a large, reflected light source placed away to the right of the camera and at the same angle to the subject as the camera viewpoint. As the angle of incidence of the light equals its reflection, the white of the light is reflected into the camera from the wood, and highlights are created. Shadows are created in any surface not in the same plane as the highlight reflecting surface.

167 The same subject but lit from the camera angle. The overall effect is to flatten the subject matter and, while some detail is recorded in areas lost in the above image, overall the result is less legible and less interesting.

5 | The subjects

Staircases

Staircases present a challenge to the photographer for a number of reasons. Many are small and tightly curving; others large and grand architectural statements. Nearly all will need some form of supplementary lighting in order to show the shape, direction of travel and construction. A full record of a staircase includes views to show shape, direction of travel, cheeks, risers, treads, balusters and newel posts.

168

169

168, 169 The grand and domestic staircase gives the photographer more scope for a general viewpoint, with either a ground or upper floor position presenting information about the construction and direction of the staircase.

170

170 A view looking straight up the staircase tends to give too much prominence to the treads and risers and insufficient information about the balusters and cheeks. More than one shot may be required at different levels to tell the complete story; however, a view from the side will usually give information about the newel post, cheeks and balusters.

171 Photographs from mid-landing levels facing towards windows will require light to be introduced from camera level and probably from above and below it. Flash light using an aperture and shutter speed combination to allow suitable exposure for both elements will need to be adopted (see Lighting interiors, chapter 4).

172 Many staircases are lit by a large window. This is helpful if a viewpoint can be obtained with this light source behind the camera. Here the curve of the stair and the first floor are lit by a large window to the right and above the camera.

171

172

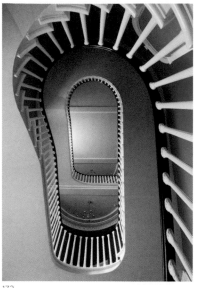

173

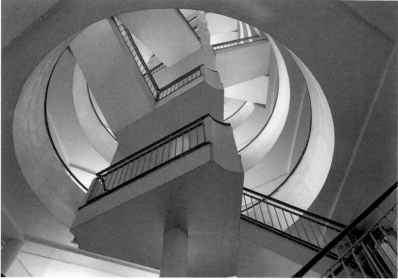

174

175

176

173 Frequently, staircases will need to have lighting introduced from more than one level in order to avoid large areas of shadow. Here, lights were placed on each floor, giving detailed information about the balustrade and the ceiling at the top of the staircase.

175 Looking down will also provide good information about direction and construction of staircases.

174 Looking up within the turret, or the space within which the staircase is placed, provides much information about the staircase and its construction, particularly if it rises through a great height.

176 In this instance, more information is available from being able to see the underside of the treads.

177

178

A small staircase within a turret can be particularly difficult to capture because both viewpoint and the placing of lighting equipment are severely limited. Two options normally present themselves: looking at a section of the staircase as it rises with the light coming from above on the staircase (177) or, alternatively, looking down the staircase from above with the light coming from behind the camera (178). The former of these offers a better relief and texture to the turret and treads.

179 This spiral staircase is much easier to photograph, and provides the opportunity to show maximum information. The direction of travel, the treads, risers, cheeks, balusters and newel post are all seen from a single viewpoint.

179

Information in the detail

180

181

182

Details of the newel post or balustrade provide good evidence for dating purposes.

103

184

185

186

Details can be taken to show the cheeks and balusters from the side of the staircase, either at ground level or from on the staircase itself looking across from one flight to the other. In some instances, with the right lighting, good information can be provided about the underside of the tread.

Plasterwork and ceilings

Plasterwork is very frequently painted all one colour, resulting in a very limited range of tones in a photograph. Lighting and/or viewpoint need to be used to enhance this range of tones or contrast. Choosing a viewpoint with the light, either natural or introduced, coming towards the camera will give deeper shadows and emphasise the shape of any decoration. Placing an oblique light across details such as cornices, friezes and so forth will achieve the same result.

187

187 Strong light coming towards the lens emphasises the shallow relief of the plasterwork in this ceiling.

188 Ceilings lit naturally rarely have even illumination, as the light falls away from the light source. Additional light will need to be introduced to even things up, or the darker areas can be shaded in post-production.

188

189

189 Soft light from high up near the ceiling gives relief to the plasterwork and shape to the pendant.

190 The plaster coat of arms is lit by natural light. The soft illumination lacks sufficient shadow to make the shapes and lettering easily readable.

191 The same detail with light introduced from the top produces shadows which give depth to the decoration and produce a more legible image.

190

191

192

193

194

192 A central viewpoint and very careful setting up of the camera (using a level to ensure that it is parallel with the face of the ceiling and a flat, even light reflected from a wide area around the camera) enable the capture of the design of this Adam-type ceiling. Experimentation and careful positioning of the lighting was necessary to avoid reflections in the painted cartouches. Lying on the floor beneath the camera to compose the shot is never easy. The use of a remote viewing and control device would make for a more comfortable working arrangement

193 Using an iPad to control the camera while photographing a ceiling and the resultant image (194).

195

196

195 An off-centre viewpoint for this detail, with light coming from the far right, gives shape and depth to the plasterwork.

196 A central viewpoint with a soft natural light coming from the left is sufficient to produce shape and texture to both the ceiling and cornice plasterwork.

Historical markers

Dates may appear in many different places in and around a building, frequently high up in a gable but also at ground level in foundation stones. They may not actually be a true indication of the date of a building or part of a building; some date stones will have been reused from another building or applicable to just one small part of the building. Much will depend on the style of the lettering and the surrounding detail to prove their veracity or otherwise, so it is important to give some context when recording them.

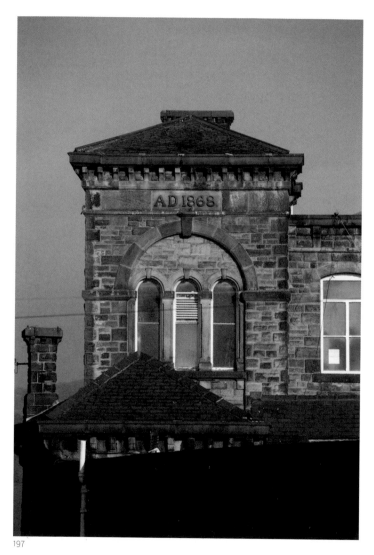

197

198

199

200

201

202

203

204

Roof spaces or attics

The roof or attic level of a building is often the least altered part of the structure and much can be learned from photography at this level. Lighting is always necessary, unless the covering is missing, and access is often difficult. Generally off-centre views will reveal more of the construction, particularly if the roof is wind-braced.

205

206

205 This roof space was too dangerous to enter, but there was room to raise a camera with an attached flash gun and shoot from the floor below to capture the simple roof structure and smoke hood of wattle and daub construction. Remote viewing from the camera was not possible at this time and, as the space was completely dark, trial and error was used in raising the camera and light up into the space several times and repeating the shot until all the required features were shown.

206 Access for the camera, lighting equipment and the photographer to this attic floor facilitated this view showing the divided space. A light to the left and slightly above the camera picks out the niche in the wall to the left of the chimneystack, and placing a light in the other part of the roof shows the continuation of the roof and avoids the black space that would otherwise have resulted if it were not lit.

207

207 Up in the roof space of this house an oblique view looking across from one side to the other reveals much constructional detail. Two lights to the right of the camera and one to the left bring out the pegged braces and tie beams, as well as showing the wind braces on the far side.

208 A detail using raking light reveals the 'carpenter's mark' on the brace and principal rafter.

208

Industrial subjects

209 Many industrial buildings are in locations close to a canal or railway, or sometimes both. Views showing the location are always significant to telling the story of a building's past.

An elevated viewpoint will reveal much about the processes that take place in the building, whether it is a bell foundry (210) or a jet-engine research establishment (211).

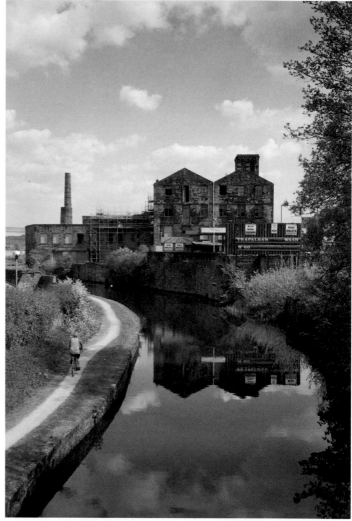

209

210

211

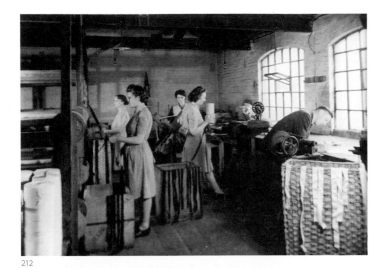

212

213

212, 213 While on location it sometimes happens that you come across images taken at the site at earlier dates. It is always useful to copy these, especially if the date of the original is known. If possible (and with permission), include them in the record. Taking a view from the same or similar viewpoint allows comparisons to be made; it is always interesting to see what has changed and what has remained.

214, 215 Photography of industrial buildings is greatly enhanced by recording them while the machinery is still in place, and even better if they are still used for their original purpose. The inclusion of humans in the photographs helps to explain how things work.

214

215

Recording industrial process – hat blocks

As already discussed (*see* Timing, chapter 3), it is desirable to photograph any building in which a process takes place during the time that the process is still taking place, as this greatly enhances the meaning of what is recorded. As a photographer recording a process it is vital to have someone explain that process to you first, so that you understand which areas are the significant ones to record.

Here at a hat block makers in Luton, a series of images indicates what goes on and what is produced by the process.

Hat blocks are the equivalent of moulds for the making or shaping of hats. The blocks may be made of wood, for small production runs, or alternatively, from aluminium when a greater volume of production is required.

The shape for a hat block is first produced in plaster of Paris, around which an oily sand is compacted in a 'box' to produce the outline shape of the hat as a space in the sand. Into this, molten aluminium is poured, during the stage known as the sand-casting process. This series of images follows that process.

216 Setting the scene.

217 The plaster mould is placed in the casting box.

218 The top and bottom sections of the casting box.

219 The sand is rammed into the casting box.

220 The maker's pattern plate and the impression of it in the sand.

221 The two parts of the sand mould are placed together.

222 The furnace (right).

223 Aluminium ingots inserted into furnace to melt.

224 Molten aluminium is stirred to make ready for pouring.

225 The molten metal is ladled from the furnace to pouring ladle.

226 The molten metal is poured into the boxes housing the sand mould.

227 The casting box is opened.

228 The casting for part of the block is removed.

Still images taken at particular chosen points are not the only way of recording a process; indeed these days this is probably not the best format to use when nearly all digital cameras offer the opportunity to make a record with moving images via video. Many DSLR cameras produce broadcast-quality footage and are increasingly used in major film and television productions due to the film-like quality of the video files produced. However, be warned that video production requires more skill than merely pointing the camera at the process taking place. Do seize the opportunity to take moving images, but be prepared for a lot of post-production work to arrive at something good.

229 Another section for the block is removed.

230 Aluminium components from the casting session are displayed.

231 It is always good to include the person who has been carrying out the process in your photographs.

Bridges

Due to their very nature, it is difficult to photograph bridges from within the area that they span, as this viewpoint is difficult to access safely. A straight-on view, although informative, may not necessarily provide the most information about the constructional details such as piers, arches and cutwaters, and so forth.

232 A bridge spanning the street between two buildings photographed from straight on gives information about its location, height above ground and also an indication that it is identical on both sides (as seen by the light coming through the windows on the other side).

233

232

234

233 A viewpoint from the riverbank shows the underside of the bridge, its cutwaters and a datestone of 1795. The continuation of the spans and cutwaters beyond the river indicates either frequent flooding or silting up.

234 This bridge over the M1 motorway could only safely be photographed from the side. This view provides maximum information about the terminals on each side of the bridge, the central pier and the decoration of the concrete upstand.

235

236

237

238

235 This view gives appropriate information about what the bridge is spanning and its construction, but obfuscates the cast ironwork of the balustrade.

236 A view from the bank may obscure what the bridge spans, yet it does reveal more of the form and structure of the balustrade and decorative details.

237, 238 Purpose and construction explained with viewpoints showing rail and road bridges

Places of worship

Religious buildings such as cathedrals, churches, synagogues, chapels and mosques present great opportunities to the architectural photographer and are among the most frequently photographed historic buildings. Their size, complexity and significance are all elements that need to be portrayed, which may require taking many images to create a complete record or a few just to capture the essence of the building, or even just a single, defining image.

239

240

241

The photographers have chosen to visit these two sites at very different times of day.

242

242 Early evening light has been used to capture the mosque with its illuminated dome and minaret. Additional flash lighting has been used to lighten the building and separate it from the sky, which is not yet fully dark.

243 Early morning with the light in the east and just skirting along the south elevation picks out the decorative brickwork.

243

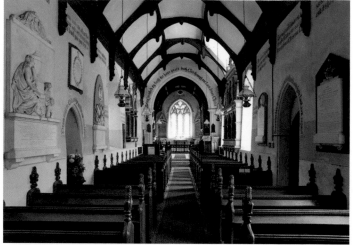

244

245

246

244 Looking east in this parish church from a central viewpoint illustrates the abundance of wall memorials.

245 This photograph of the simplicity of a Friends Meeting House from a low viewpoint reveals the timber structure supporting the gallery.

246 A view from within the aisle with a strong light from left of the camera illustrates the arcade piers of different forms of the south aisle and also the complete arch of the arcade in the north aisle beyond.

247

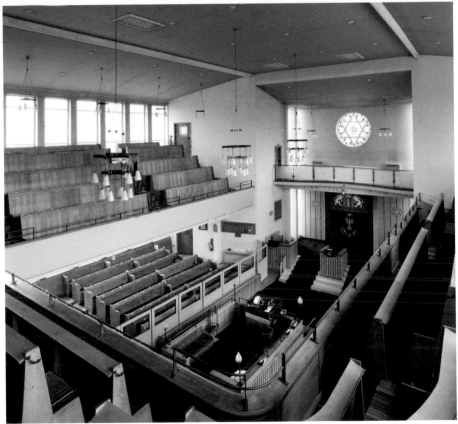

248

247, 248 The large capacity of both these synagogues is evident in these views from the galleries.

249

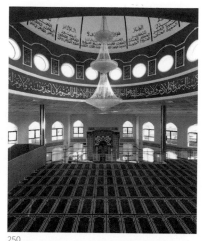

250

249 The natural lighting of the chancel framed by the shadow of the chancel arch gives drama to this church interior.

250 All the essential elements of a mosque – dome, prayer mat, lighting and mirab – are shown in this interior taken from the gallery.

251 This interior of a chapel taken from the gallery shows the roof structure and the semicircular arrangement of the seating around the pulpit.

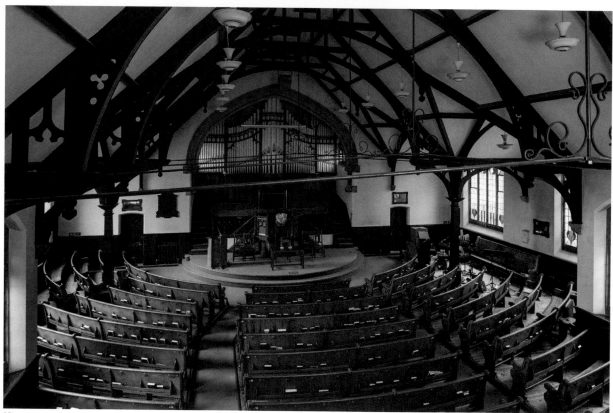

251

Roofs and ceilings

252 Roof timbers can be monochromatic when photographed with available light, and light coming from clerestory windows can flare into the lens.

253 Lighting with direct flash light produces shadows and tonal variation and the use of shorter shutter speeds will enable control of the available light via the clerestory.

254 Direct flash light from two sources to the left of the camera – with one in front of the crown post and the other behind it fired straight up into the timbers – creates shadows to give separation to the rafters and shape to the crown post. An off-centre viewpoint allows all four braces of the crown post to be seen.

255 Soft flash light reflected from a source in front of the camera provides an even illumination to this painted decoration of a chancel ceiling. Slight shadow coming towards the camera gives shape to the moulded timbers.

252

253

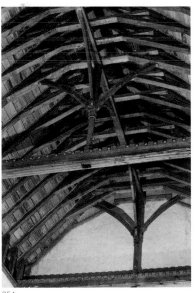

254

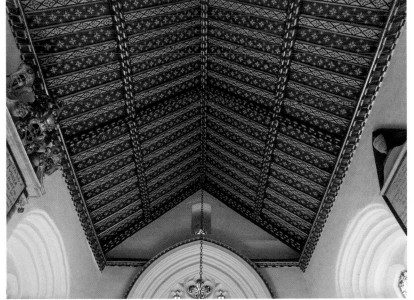

255

Tombs

Tombs should be photographed from more than one side if possible, as this will give an indication of the size and depth of the tomb. Additional views may be required of the sides and top of the tomb in order to show decoration and inscriptions, which will require suitable lighting conditions to bring out the detail.

256 A simple tomb chest with a single-sided inscription and stone slab atop, taken with available light coming from two directions: light coming towards the camera from the window picking out the coat of arms on the top stone and light from a window to the right lighting the inscription. Cropping out the window light source removes a distracting highlight.

257 A tomb chest with an effigy, photographed from an angle to show the inscription and heraldic devices. It is naturally lit from above by the window to the right. A reflector placed to the right of the camera 'tops-up' the light falling on the inscription, ensuring it is readable.

258 A table tomb from a viewpoint just high enough to show the entire table, but low enough to show the balusters and mouldings to the base.

256

258

257

Tombs with effigies will require an additional view from above in order to show the figures resting on the top. A tall pair of steps and a wide-angle lens will help to show the figures in their entirety and achieve a suitable viewpoint for doing so.

259

260

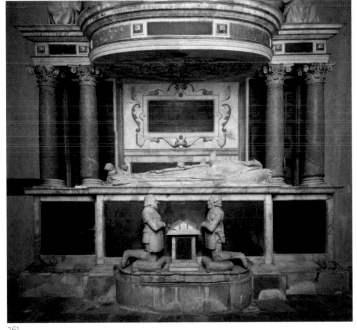
261

262

259 A general view locates the monument, showing its shape and proportions.

260 A straight-on detail shows the heraldic entablature.

261 Effigies and dedicatory inscriptions.

262 An elevated view looking down shows the effigies in relation to each other.

Wall monuments

Always assess the quality of light falling onto a wall monument and adjust it if necessary to ensure that it is providing relief and shape to the subject. If possible, the light should come in towards the faces of the main figures so that they are lit and not in shadow. The light should also ideally come from above, unless you are deliberately seeking a dramatic 'Dracula' effect. Sometimes, placing a light obliquely across the face of the monument will make inscriptions that have lost their infill to the lettering legible, as a result of the introduction of shadows. However, this technique should be used with caution, to avoid creating unusual shadows across the rest of the monument. A separate image of the inscription using the oblique light should be taken if the effect detracts from the understanding of the rest of the composition.

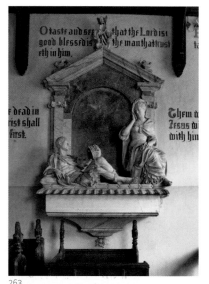

263

264

265

266

263 The available light falling across the monument is perfectly suited to providing information about its shape, offering relief and depth to the figures and other elements of carving.

264 Here, an oblique light from above left has helped to make the inscription more readable by creating shadows in parts of the lettering where the infill has disappeared.

265 The available light falling on the monument fails to provide suitable highlight and shadow, resulting in a flat image.

266 Light introduced from above and to the right of the monument provides the necessary highlight and shadow to make the figures and shape of the monument legible.

Fonts

These may be photographed with or without their covers. Many covers are considerably later in date than the fonts they rest on. One shot with and one without the cover will serve all needs. Fonts should be photographed so as to reveal their shape and if possible the shape of the bowl within the top, although this might be determined to be of lesser importance than the decoration at the base of the font, in which case a lower viewpoint should be used. An angle should be chosen to present two sides of a square font to the camera and several sides of a hexagonal or octagonal font. Round fonts should be lit from one side to indicate the curvature.

267

268

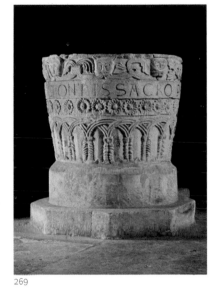
269

267 The font should have had the flowers removed before photography as they are too dominant and distracting, and obscure information about form and decoration.

268 The font has been photographed with its contemporary accessories.

269 The font has been isolated from its background by the use of a black curtain in order to focus the eye on its shape and decoration. Although round, in this instance the font has been lit from both sides in order to present the maximum information about its decoration.

Font covers

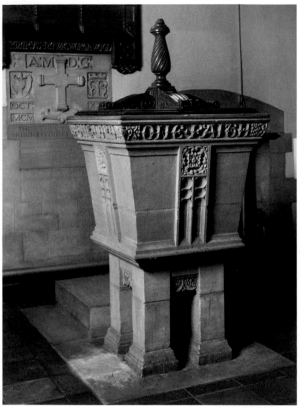

270

271

272

273

270, 271 Both fonts have been photographed with their contemporary covers.

272, 273 This font and cover are clearly from different dates. More information about the font is provided without the cover (272) as damage to the bowl on the far side can be seen when the cover is removed. A complete record of this font would require many shots to record the different carvings on each face and the heads at the angles. If making a complete record, a shot showing the font with its cover (273) should be included.

Location of fonts

Fonts have their own areas within some churches, known as a baptistery. Photographs which place the font within the context of the baptistery better reflect the original ideas of the architect.

274

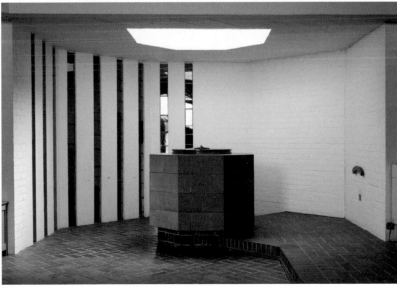

275

274 Font screen and stained glass.

275 Font with top lighting and raised tiled plinth.

Pulpits, minbars and bimahs

As with fonts, it is desirable to show the shape of the pulpit, minbar or bimah, and also its position. Many have been moved to a new space or altered in size as fashion and religious ceremonies have changed over time. Details that indicate this, such as an unhappy junction with the floor, stand or wall, or a different style of stair, should be recorded.

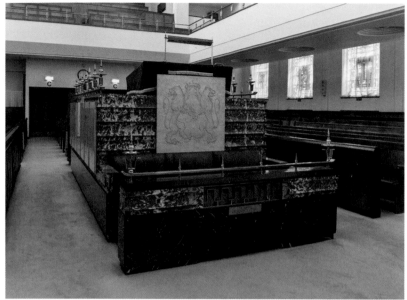

276

276 This bimah, located in the centre of the synagogue, is shown from an angle that reveals its size and shape.

277 A light placed to the left of the subject gives shape to both the base and the wood structure of the pulpit.

278 The clutter of the chairs and the hanging and fire extinguisher beyond should all have been removed prior to photography, so that the decoration and shape of the pulpit and its stand can be seen without interference or distraction.

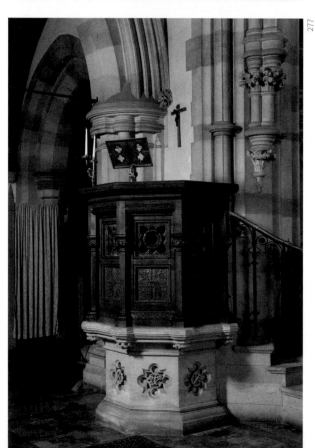

277

278

279

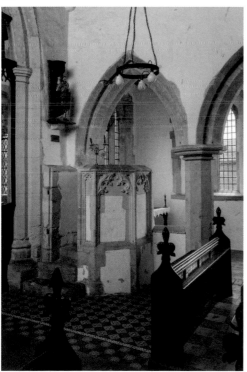

281

280

279 This viewpoint within a mosque shows more than one side of the minbar, and provides information about its shape, size and location close to the mihrab beyond.

280 Pulpits often consist of several components. Here, the reading desk, stair, altar rail and sounding board have been included.

281 This stone pulpit needed a careful choice of viewpoint to overcome the height of the nearby benches. In addition, two lights were required to reveal the recess for the former door and also the tracery carving on the two main faces, while a third light was used to illuminate the south aisle beyond.

Metalwork

There are two categories of metalwork: shiny and dull. Both types can be tackled in either of two ways: with raking light with a viewpoint straight on to the subject so as to put shadows into the incised areas; or photographed from an angle using the technique of 'angle of incidence equals the angle of reflection', which will introduce highlights into the subject. In the latter, the incised areas will interrupt the reflections of the light and become visible. A large, reflected light source will create a larger reflection than a small point source of light.

282

283

282 The brass lectern has been lit with multiple light sources to provide highlights in the shiny surface, in addition to using the available light to give an even illumination.

283 The black lectern was lit with a large reflected light source to provide a highlight on the front face, giving shape and picking out the pierced metalwork.

284 Using natural light, highlights are reflected from this detail of a black painted metal chancel screen.

285 Natural light and a wide aperture (to produce a shallow depth of field) help to isolate this lectern from its surroundings and reduce the definition of any reflected highlights.

284

285

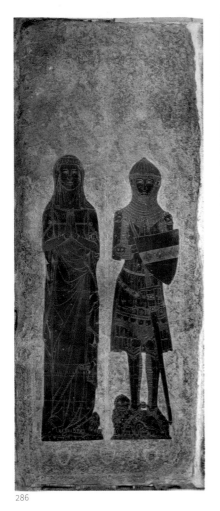

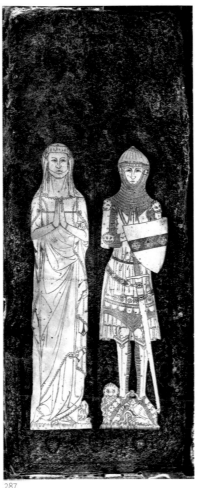

286

287

286, 287 Photograph of a brass (286) converted to black and white, then reversed to create a negative that gives the appearance of a drawing (287).

Brasses are best photographed square-on with the whole slab into which they are mounted included in the shot, because many slabs have indentations where parts of the monument that are now missing would once have been. The overhead viewpoint can be difficult to achieve without a ladder, but complete monuments can be photographed in sections and stitched together (*see* Post-production, chapter 7). Brasses may be more easily interpreted by the use of some post-production techniques. Here, the original image has been converted to black and white and then inverted to create a negative, which gives the appearance of a drawing. The contrast of the image has also been greatly increased. While this does not produce quite the same result as making a brass rubbing (which would produce black figures), it is a useful alternative, especially given that rubbing brasses is no longer favoured due to the damage to the fabric of the brass that can result.

Gravestones

As with brasses, ledgers and gravestones are best photographed from above and as square on as possible in order to make the inscriptions easy to read. Raking light across the stone will help to bring out the inscription. A special technique using light from all sides of the subject has also been developed, which is of particular use when photographing gravestones. This 'peripheral lighting' is a low raking light that casts shadows into the subject from all four sides. It gives an unnatural appearance but provides more information about the detail of the object.

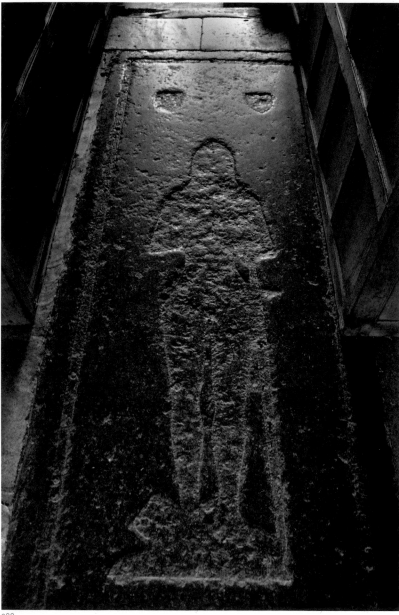

288

288 An oblique view of a chancel floor with the light coming towards the camera shows perfectly the indent for the brass that originally stood in place in this bed for a memorial.

289

290

291

289 An oblique view of this ledger stone does not serve well, as it is difficult to read the inscription, which is the information of primary importance to be conveyed to the viewer.

290 A vertical view looking straight down on the stone – although somewhat more difficult to achieve – presents the stone and its inscription as a printed page, allowing for easier reading. As with brasses, the overhead viewpoint can be difficult to achieve without a ladder, but complete monuments can be photographed in sections and stitched together (*see* Post-production, chapter 7).

291 Using the camera screen enables easier composition in situations where looking into the viewfinder is difficult. (Many compact cameras only offer a screen and no viewfinder.) The screen comes into its own in these situations; some also have the ability to tilt at an angle of 90 degrees or more to the camera or even articulate to the side of the camera, which is even better for viewing at high or low viewpoints. DSLRs offer a 'live view' for the same display (*see* Communicating with the camera, chapter 2).

Woodwork

A significant number of religious interiors consist of wooden objects: pulpits, screens, lecterns and pews, for example. The wood is frequently dark and benefits greatly from the input of some additional lighting to bring both it and its surroundings into a manageable dynamic range, and to give it shadow and highlight.

292

292 A soft, reflected flash light was used to give an even illumination to the chancel screen, pulpit and lectern with a speed/aperture combination to balance with the light in the chancel beyond.

293 Misericords are notoriously difficult to photograph due to the tight space in which they are located within the stalls. If possible, choose a bright day for the maximum available light, mount the camera on a tripod that can facilitate a low viewpoint and carefully align it with the misericord. Invest in a wide-angle lens and consider using a live view remote control for the most comfortable setting up of the shot. Artificial lighting is difficult in these circumstances, but small flash units bounced from a reflector above may assist if natural light is unsuitable.

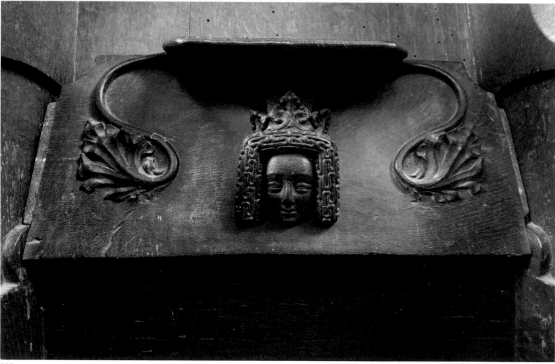

293

294

294 A soft, reflected flash light was used to give an even illumination to the bimah and ark from almost directly behind and above the camera. The straight-on view emphasises the symmetry of the arrangement.

295

296

295, 296 Two flash lighting techniques used for this bench end: 'angle of incidence equals the angle of reflection', giving highlight and shadow (295); an oblique light with a straight-on viewpoint provides the same (296). Note that the angled view provides more information about the bench, whereas the straight-on view may suit better if a comparison of a group of bench ends is being made.

297

298

299

300

297 These choir stalls are lifted using a large reflected light source to the right of the camera, creating highlights in the dark wood using the 'angle of incidence equals the angle of reflection' technique.

298 Simple elegance, using natural light, composed to avoid any flare from the window above and to the right.

299 A reading desk is lit to reflect the bounced light aimed at it, using the same technique as with the choir stalls above. Care has been taken not to place much light on the stalls behind, in order to clearly distinguish between the desk and the stalls.

300 A detail of the lock and door furniture lit with a bounced light source slightly above and to the left of the camera. The result gives a flavour of the craftsmanship of this Victorian door.

Stained glass

Stained glass is a challenging but greatly rewarding subject to photograph.
Its vibrant, rich colours and high contrast are always attractive. It is often
easier to appreciate the subject matter in a photograph rather than *in situ*,
due to the large size of many windows.

Stained glass presents several challenges for the photographer.
Unlike most photography where light is reflected from the subject into
the camera, the light we want to capture when photographing stained
glass is transmitted through the glass itself. The transmitted light can
contain a range of luminance that very often exceeds the range or levels
of luminance that the light-sensitive cell can accommodate. The resultant
image will lack information in either the highlight or the shadow areas.

304

301

302

303

Exposure

Standard average light metering in the camera will almost always result in overexposure of the image due to the meter taking into account the area surrounding the window and indicating an exposure to produce some detail within this area. To record the light transmitted through the glass at the correct exposure it is necessary to ignore the surrounding frame or tracery and base the exposure solely on the light coming through the stained glass. The required exposure will normally be less than that indicated by the camera's internal metering system.

Reducing the exposure sufficiently will allow detail to be retained in the highlight areas of the glass. The shadow or dark areas will lose some of the detail. Recovering the detail in the shadow or dark areas can be more easily achieved during post-production than recovery of the highlight areas.

305

306

305 The image shows the camera-metered exposure which has resulted in overexposure of the highlight areas.

306 An adjusted exposure. Reducing exposure by 1.5 stops, by increasing the shutter speed, retains information in the highlight areas of the figures and faces.

307–310 Four identically composed but differently exposed images of the same window.

307 An image exposed one stop over the indicated exposure by the camera, containing information in the shadow areas but losing it in the highlight areas.

308 Image exposed at 0.5 stop over the indicated exposure, containing less information in the shadow areas but gaining it in the highlight areas.

309 Image exposed as indicated by camera exposure, containing less information in the shadow areas but gaining it in the highlight areas.

310 Image exposed at one stop less than indicated exposure, containing information in the highlight areas but losing much of it the shadow areas.

311 The HDR image derived from all four differently exposed images, containing detail in both the shadow and the highlight areas.

Stained glass is a subject where High Dynamic Range (HDR) photography can be used to tackle the extreme subject brightness range in the glass. This requires a series of images to be taken with the camera mounted on a tripod or other firm support to keep it still. The images are taken with a range of different exposures to ensure that all the detail is recorded in the highlight and shadow areas. These might normally be within a range of up to a stop less and a stop more than the indicated exposure from the camera light reading.

These differently exposed images are then blended together in a computer program to produce a single image that combines the information contained in the dark areas of the overexposed image with the information contained in the light areas of the underexposed image, thereby containing detail across the whole brightness range.

307

308

309

310

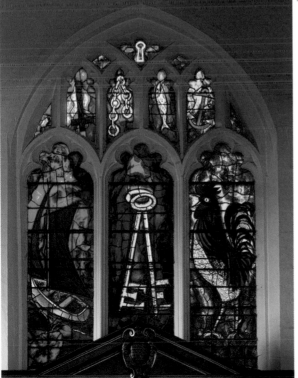

311

Depending on the size and position of the window, an accurate reading of the highlight areas may be obtained using the spot meter mode available in some camera metering systems. The reading obtained from the highlight area will need to be increased (usually by two stops) to make the highlight appear as a highlight in the image. Remember, the camera meter thinks the highlight is a grey.

Another useful feature available on some digital cameras is 'blinking highlights'. When this option is turned on, highlight areas within the recorded image may blink when played back on the camera digital screen. The areas that blink or flash black to white are indicating that they do not contain any detail due to the exposure they have received being beyond the capacity of the camera sensor.

312 An image with overexposed highlights.

313 Black highlight areas denoting lack of detail in a 'blinking highlight' display. To bring the highlights back within the capacity of the sensor it will be necessary to retake the photograph giving less exposure. When the highlights no longer blink, detail will have been retained within them.

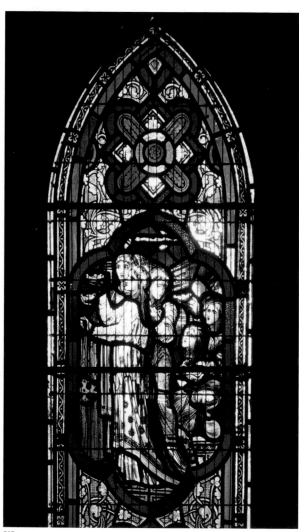

312

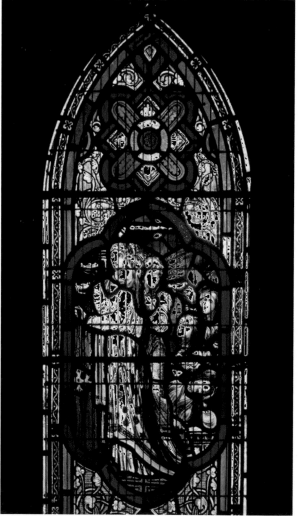

313

Lighting

The photography of stained glass should not be undertaken with a direct
axial sunlight source, as this may illuminate the glass unevenly, especially
in the winter months when the sun is low in the sky (314, 315).

Direct axial sunlight will also cast shadows onto the glass if the window is
protected by a wire mesh on the outside (as is sometimes the case) (316).
A soft, even light from a bright yet overcast sky should be the aim for
stained glass photography, and a camera white balance setting of cloudy
usually produces a more accurate colour rendition.

314

315

316

6 | Understanding photographic surveys

Photographic surveys of buildings – many threatened with demolition or alteration – have been carried out both professionally and by keen enthusiasts almost since the invention of photography. Some adopt a structured approach to this important work, while others adopt a more random or haphazard approach. In order to encourage more people to adopt the former, and to set some minimum standards, Historic England has published guidance on the recording of historic buildings. *Understanding Historic Buildings – a guide to good recording practice* offers information and advice on all forms of building recording (available as a downloadable pdf at https://historicengland.org.uk/images-books/publications/understanding-historic-buildings/). Within this document, different levels of recording are outlined, ranging in completeness from a single photograph of the exterior of a building (level 1) to a record that includes drawings and plans produced from a survey of the building, a full photographic survey and a written account that describes the building and provides a historical background from research undertaken (level 4).

The photographic element required for the different levels of recording also varies depending on the importance of the particular building and the purpose of the record. Section 4.4.7 of the document states that:

> Photography is generally the most efficient way of presenting the appearance of a building, and can also be used to record much of the detailed evidence on which an analysis of historic development is based. It is also a powerful analytical tool in its own right, highlighting the relationships between elements of a building and sometimes bringing to light evidence which is barely registered by the naked eye.

Photographic recording rarely captures every part of a building, unless of course the building is being taken down and then being reconstructed, in which case very detailed and methodical recording of every face of every wall will be necessary. The Historic England guidelines focus more on recording for the purpose of understanding and analysing the standing structure.

Standards for photographic surveys

Historic England gives the following guidelines for photographic levels of recording:

1 A general view or views of the building (in its wider setting or landscape, if 2 (below) is also to be adopted).
2 The building's external appearance. Typically a series of oblique views will show all external elevations of the building, and give an overall impression of its size and shape. Where individual elevations include complex historical information, it may also be appropriate to take views at right angles to the plane of the elevation.
3 Further views may be desirable to reflect the original design intentions of the builder or architect, where these are known from documentary sources or can be inferred from the building or its setting.
4 The overall appearance of the principal rooms and circulation areas. The approach will be similar to that outlined in 2.
5 Any external or internal detail, structural or decorative, which is relevant to the building's design, development or use, with scale where appropriate.
6 Any machinery or other plant, or evidence for its former existence.
7 Any dates or other inscriptions; any signage, makers' plates or graffiti which contribute to an understanding of the building. A transcription should be made wherever characters are difficult to interpret.
8 Any building contents which have a significant bearing on the building's history (for example, a cheese press or a malt shovel).
9 Copies of maps, drawings, views and photographs present in the building and illustrating its development or that of its site. The owner's written consent may be required where copies are to be deposited in an archive.

Taken from *Understanding Historic Buildings – a guide to good recording practice* (Historic England, 2016, p 19–20)

How much of the above coverage to include in your own record is clearly dependent on the quality of the building, the length of time you have available to make your record and any constraints imposed on time and access to the site by the owner of the site.

The following four case studies would all count as full photographic surveys under level 4 of the Historic England guidance on recording historic buildings.

Case study 1 Farnley Hey, West Yorkshire

The recent past of post-war architecture, built decades rather than centuries ago, enables records to be made more accurately, because as record-makers we are able to better understand and reflect the original intent of the architect, guided by our own sense of how something was intended to look, and by contemporary material around us.

Many owners of post-war buildings are passionately interested in the building they occupy and strive to maintain the original vision of the architect. The passing of time and changing use of the building will frequently distort the original vision, through modernisation and replacement of original construction materials. While this change over time is interesting in its own way, it is often possible with minimal physical effort (such as moving furniture and unwanted clutter, if the owner is willing) to return the building to some semblance of its original self.

317

318

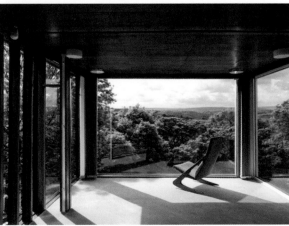

319

317 Designed in 1954 by Peter Womersley, Farnley Hey was awarded a bronze medal by the Royal Institute of British Architects (RIBA) in 1956, marked by a plaque over the house name.

318 A view of the entrance hall taken straight on, to illustrate the panelling with fitted door and glazed panels adjoining the main entrance.

319 The large floor-to-ceiling windows of the upper living room offer magnificent views over the countryside.

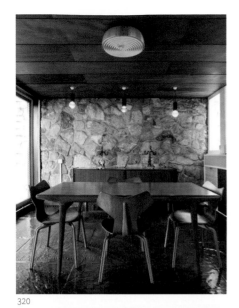

320

320 The dining room is given similar treatment to the living room, stripped of any unnecessary ornament to show the building materials and original dining furniture.

Stair and screen shown from two directions: from within the living room (321) and from the entrance hall (322), revealing the change in level between the two rooms.

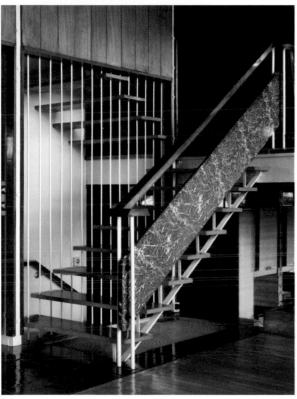

321

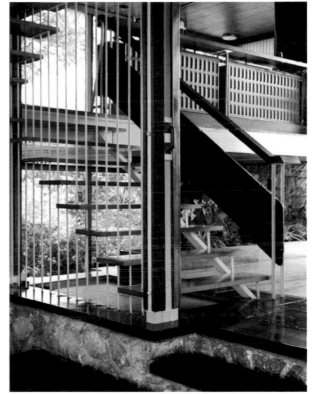

322

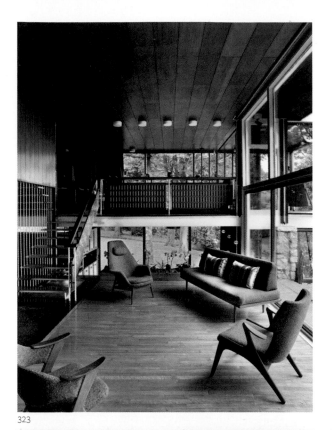

323

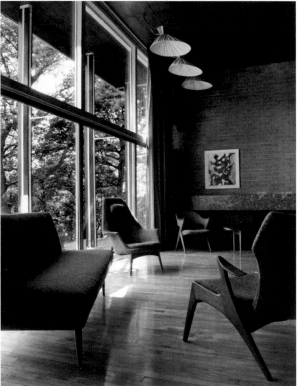

324

325

323 Wood used for floor and ceiling, but in different orientations, is emphasised by this straight-on view.

Two views of the living room that highlight the double-height glazing (324) and the original panelling and fitted cabinets (325).

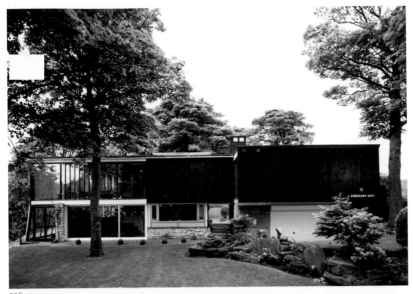

326 The flat light present during the day of the site visit made it difficult to get any shape and texture in the building, and the enormous glazed areas so important in the design are lost. However, had the building been shot in full sun, shadows from the trees would have created an unevenly lit elevation.

327 Waiting until twilight and lighting the exterior with electronic flash from various directions and the interior with tungsten light, the information of constructional materials and form are illustrated, while also negating too much shadow. The different colour temperature of the light sources emphasises the glazing and helps to separate the interior from the exterior.

326

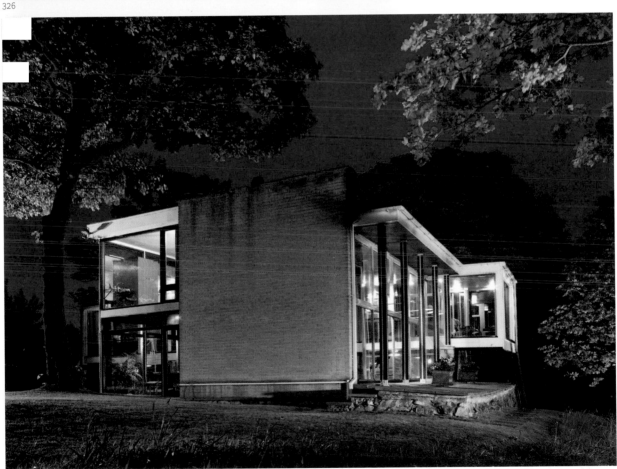

327

Case Study 2 Oxgate Farm, London

Oxgate Farm is a rare survival of a timber-framed farmhouse in the north-western suburbs of London. The condition of the building had deteriorated over many years and a photographic record of its condition was required before a substantial repair programme commenced. The building is formed of two ranges (north and south) and contains two main rooms on each of its three floors.

328

329

330

331

328, 329 Views showing the location of the building in the now suburban street and all elevations were required.

330–332 Parked cars are always going to create a problem in showing a complete elevation. However, opportunities come and go as traffic moves over a period of time. An additional view was taken at the same time to reveal the right corner of the building in its entirety.

332

333

334

335

333–335 A viewpoint allowing a single complete view of the south elevation was not possible within the property boundary, or from beyond it due to trees.

With the camera mounted on a tripod and using a perspective control lens, two views with a large overlap were taken to show both the top and the bottom of the elevation. These two files were then stitched together (*see* Stitching an image, chapter 7).

336

337

338

336–338 Views are taken connecting the side elevations (south and north) with the rear elevation (west), from available viewpoints.

339, 340 Other parts of the north elevation hidden in the general views from the street and garden were captured as details.

339

340

Views of the ground-floor rooms were taken to show both the layout and other elements.

341

342

343

344

341 A view from north-east at the entrance doorway of the ground-floor room of the south range gives the location of a stair with cupboard underneath and also the doorway to the entrance lobby on the south elevation.

342 Looking south gives the location of the window as seen in the exterior shot of the south elevation.

343 Looking east gives the location of the doorway and window on the east elevation.

344 The view from the south locates the stair and shows a niche and the doorway to the east room of the north range.

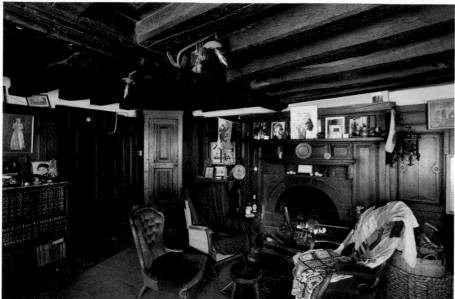

345

346

345 A view of the ground-floor east room of the north range was taken looking towards the fireplace from the south-east. However, the low ceiling height of the timber-framed building necessitated a viewpoint to show more of the joists and moulded crossbeam.

346 The lower viewpoint here, about equidistant between floor and ceiling, gives a better proportional representation to the floor and the ceiling.

347

348

347 Opening the door to the north-west room beyond provides visual navigation through the building.

348 Opening the door to another stair better explains the location of the stair and its direction of travel.

349

350

349 A view in the opposite direction reveals both the window and the doorway from the entrance hall.

350 For the view towards the window, a large reflected light source was used to create a soft and even illumination over the panelling and ceiling.

351

351 A view looking up to the ceiling using reflected flash light back towards the camera from a large reflector creates highlights and shadows in an otherwise monochrome ceiling, giving shape to the joists and moulded beam.

352 A large, white reflector was used to provide a large light source to give an even illumination to the ceiling.

353 A strong cross light from a flash light positioned to the right of camera creates shadows and highlights to bring out the scratched numbering system of the joists.

352

353

354

354 The view from the ground-floor west room of the north range looking south to the west room of the south range continues visual navigation via features seen through the open doorway.

The other end of this room has an interesting feature (355) that is worth a detailed view (356) to show the moulded wall post and inserted brace.

355

356

357 Interesting features often survive in cupboards. Opening the doors to the one in the kitchen (north range, ground-floor west room) reveals a door with strap hinges and two circular openings which may have been viewing portals, vents or just lights. If the doorway is *in situ*, it suggests an earlier or at least different arrangement of access between the east and west rooms of the north range. The photographic lighting possibilities are limited due to the recess of the cupboard. A soft reflected light to the left of camera casts some shadow to reveal the recess in the circular openings.

358

360

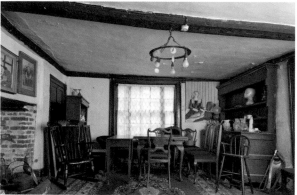
359

361

358 A view from the south in the south range ground-floor west room connects it with the west room of the north range (kitchen).

359 A view from the north locates the window visible on the south elevation and another doorway leading to the entrance lobby on the south side.

360 A view from the west locates the fireplace.

361 A view from the east locates a doorway to the outside that is visible on the exterior elevations.

First floor

Clutter in the south range first-floor east room prevents any meaningful diagonal views. Views looking at each wall present enough of an overlap of features to navigate from one view to the other, and also serve to show any significant features.

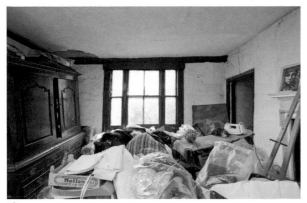

362

364

363

365

362 A view from the north locating a window visible on the south elevation.

363 A view from the east showing a doorway and fireplace.

364 A view from the south showing the timber frame.

365 A view from the west locating corner posts and window visible on the east elevation.

The south range first-floor west room needs the same treatment
as the east room, whereby views looking at each wall present
enough of an overlap to navigate from one view to the other
and show the significant features, or lack of them.

366

368

367

369

366 A view from the west.

367 A view from the east.

368 A view from the north.

369 A view from the south.

The west room of the north range again requires four views in order to show the access, lighting, heating and timber framing. This can often be achieved with two shots taken from the corners of the room, but here clutter prevented this.

370

372

371

373

370 A view from the west.

371 A view from the east.

372 A view from the north.

373 A view from the south.

374

374 The junctions of the north and south ranges at first-floor level reveal a complicated arrangement of stairs, doors and levels.

375 Interesting structural details can be found in the smallest of rooms.

376 The very restricted space on the stair necessitated the use of a very wide-angle lens and the placing of the camera in the doorway of a room. The stair was also dark, requiring lighting by flash light from below and above on the stair and also from a position close to the camera, in order to light the foreground to give an idea of the complicated levels in this space.

375

376

377

378

Viewpoint is often a compromise! Adaptation and flexibility are always needed. The first-floor east room of the north range was greatly given over to storage. Views looking (377) south and (378) north just give the arrangement of door and window.

379 A small area of space allowed a less cluttered view of the timber frame

379

Second floor

The roof is often the least altered space in a building. Attempts should always be made to view and record it in timber-framed buildings.

Here, the roof over the south range gives little indication of what lies beneath the plaster.

380

381

380 A view of the east room from the east.

381 A view of the east room from the west.

382

383

382 A view of the west room from the east.

383 A view of the west room from the west.

The roof over the north range provides some information about its construction, including evidence in the view of the west room from the west of removed posts from a partition in the tie-beam nearest to the camera.

The purlins and wind brace are more easily viewed in the north range, where it is possible to see a complete view of one bay with wind braces at the west end of the room.

384 A view of the west room from the west.

385 A view of the west room from the east.

384

385

386

387

388

386 A view of the east room from the west.

387 A view of the east room from the north-east.

388 A view of the east room (west end) from the south.

Case study 3 Ponsanooth Methodist Church, Cornwall

389

389 A location view is taken to show the dominant setting of the chapel high up on the hill, as seen on the entry to the village.

390 A view from the same viewpoint but using a telephoto lens to give a larger image of the chapel itself.

391 A view from the east nearer the building gives some additional locational information and, by showing more than one elevation, both size and fenestration details are recorded.

390

391

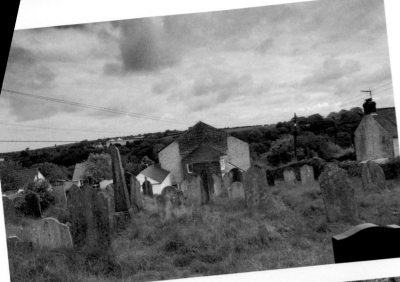

392 A rear (south-west) view shows the apsidal bay and the graveyard.

393 An additional view of the tombstones gives a general impression of the quality and age of the stones.

392

393

394 The interior of the church is simple, with a beautiful oval gallery. It was not possible to capture this in its entirety with a straight-on view, so a view from off-centre in the aisle was chosen.

395 A straight-on view, while not showing the complete oval of the gallery, does provide useful information about the pulpit and the organ.

394

395

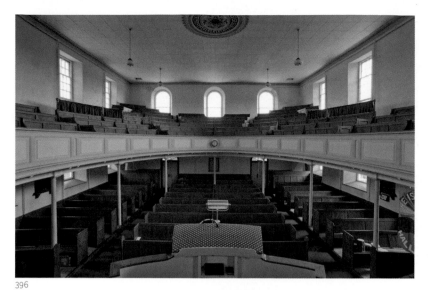

396

396 Using the pulpit to gain height gives additional information about the layout of the pews and also an insight into the view that the minister has of the church.

397 A view of the pulpit from an angle emphasises the semicircular shape and shows the stair to it.

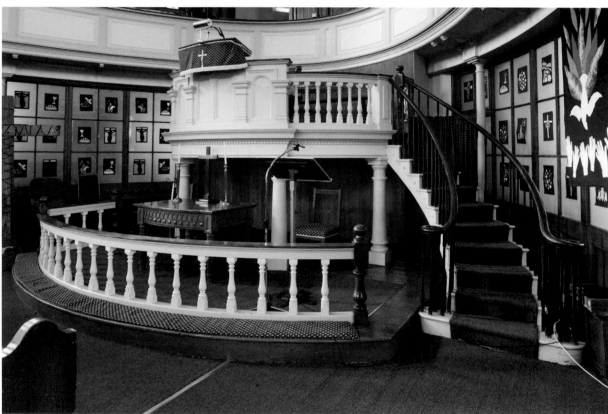

397

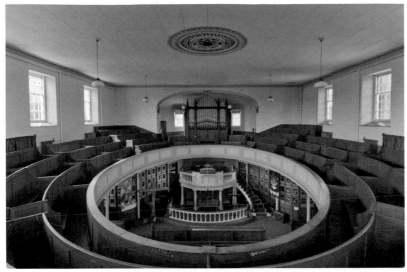

398 A straight-on view in the gallery portrays the symmetry of the gallery and the arrangement and partitioning of the seating.

399 A view from higher up in the gallery gives additional information about the pews and shows all of the windows lighting it on the north-west side.

398

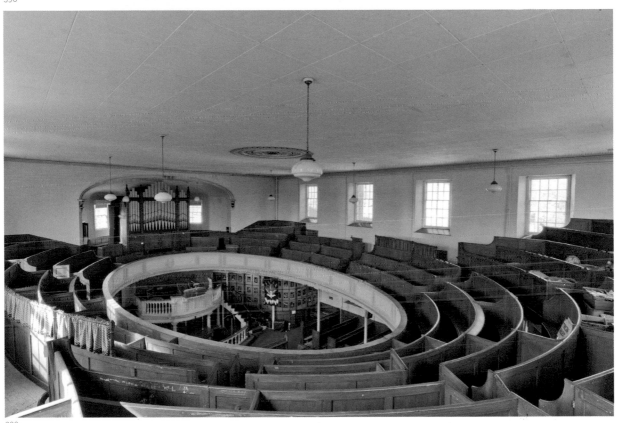

399

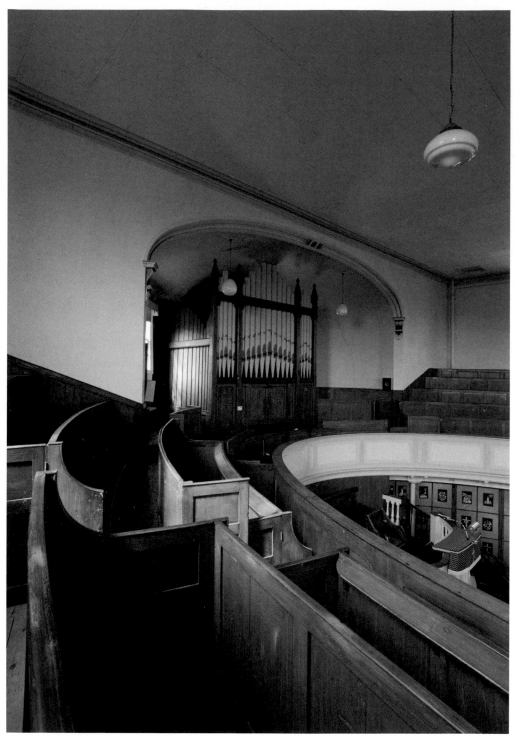

400

A detail from in the gallery provides good
information about the form of the gallery
seating and the organ beyond.

401

402

The chapel has a few other items of interest: (401) the ceiling rose and (402) the brackets to the gallery. This detail shows them and the capital to the column supports.

403 This book, written by a famous former minister of the church, was on display in a case within the chapel. Significant items of historical interest such as this should be recorded.

404 War memorials can suffer from neglect or damage, so it is useful to record them. The off-centre view here serves two purposes, first to show the form of the monument and second to pick up the reflected light on the brass insert, giving it a highlight and the appearance of brass.

403

404

Case study 4 The Air House, National Gas Turbine Establishment, Hampshire

The National Gas Turbine Establishment at Pyestock, near Farnborough in Hampshire, was a world-class facility in the 1950s where gas turbines (jet engines) were designed, built and tested. As part of the Royal Aircraft Establishment (RAE), access was restricted under the Official Secrets Act until its closure in 2000. The Air House, completed in 1961, was at the centre of the site functionally and almost geographically. Here, air — fast, slow, dry or humid — was generated via eight massive turbines and sent through a network of pipes to various test cells around the site. The site was visited in 2009 when it was threatened with demolition to make way for a distribution centre or business park.

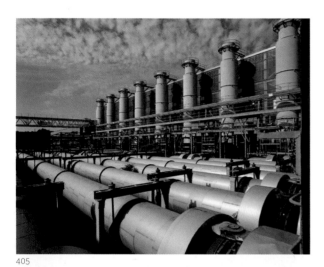

405

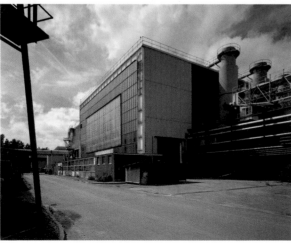

406

405–407 Views of the exterior were taken to convey the mass and massive number of pipes that lead to and from the building, and the necessity of various gantries to allow servicing of the pipes and valves.

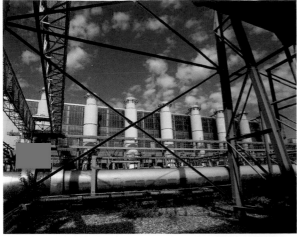

407

408

409

A view from above a gantry (408) and on a gantry (409), help to tell the story of flow and access.

410

410 Access to the top of the building allowed for views out across the rest of the site. A river of pipes flows away from the building towards the various test cells where the jet engines were mounted for testing.

411 The roof also gave the opportunity to look down on to the pipework, showing the complexity of feed and flow.

411

412

412 Inside, a view from a high-level gantry displays the layout of the Compressor Hall and the various pieces of plant and switchgear. To the left, picked out in a different colour, are the windows of the building's control room.

From the same elevated gantry, a view into the service bay (413) and a more general view (414) to indicate the multi-level construction with a floor for an additional plant below the Compressor Hall.

413

414

415 A bay between the compressors shows the control room and also the lifting gear used in the servicing of plant.

416 Safety information intended for staff provides interesting statistical information for us.

417, 418 It was not necessary to show every piece of plant, but rather to give a flavour of what is there.

415

416

417

418

419–422 Much useful information can be gained about equipment suppliers by noting details of various controls and makers' plates.

419

420

421

422

423

424

425

426

427

428

429

430 A telltale of the systems once used to ensure safe working. Keys to switches could not be taken without a permit plate being issued.

Various views to show additional parts of the building: access corridors (431), instrumentation arrays (432) and access panels to the rear of instrument panels in the control room (433).

431

430

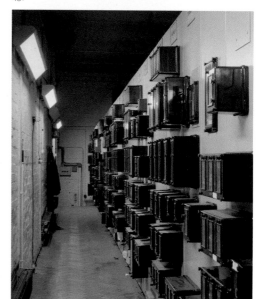

432

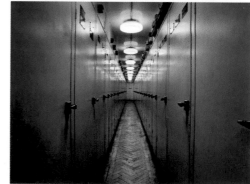

433

434

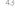

434–436 Buildings and plant do not function without staff, and some indication of the occupancy by humans and their needs should be captured.

435

436

Here Lyeth Interred The Body
Of FRANCES LUCK The Eldest Daughter o[f]
S[r]. SAMUEL CLARKE Baronet, and Wife
Of THOMAS LUCK Esq[r]. of Grey's Inn
Barrister At Law: By Whom He Had Issu[e]
Three Sons, and One Daughter MARY
The Wife of THOMAS HARRISON D.D.
Buried Within The Chancel: The Sons
Dyed In Their Infancy & Lye Here Interr[ed]
She Departed This Life Nov[r]. 1: MDCCXVIII. Æt: xL
Here Also Lyeth The Body of ELIZABETH Lu[ck]
His Second Wife Daughter of The Right Hon[.]
S[r]. WILLIAM ASHHURST K[t]. Who was Lord May[or]
Of The City of London In The Year MDCXCIV.
She Dyed Oct[br]. III[d]. MDCCXLVIII. Æt: LxiV.
The last here interred is the Body of THOMAS Luc[k]
[E]sq[r]. Son of M[r]. THOMAS LUCK who lyes buried in th[e]
Parish Church of Broxbourn in Hertfordshire.
[A]s mentioned in S[r]. HENRY CHAUNCEY's History o[f]

7 | Post-production

Many people are surprised that there is a need to do anything to their images after they have been captured other than download them and store them and maybe print them out. Taking a photograph has always been just the start of the process. Previously, how a film was developed, what chemical was used and for how long it was processed would be the initial stages that photographers used to determine how their image would look. Once the negative was produced, more time was spent in the dark room at the enlarger exposing the negative image onto the printing paper. This involved manipulating the light projected onto the printing paper (itself chosen for its surface qualities and colour and tonal reproduction) to lighten some parts of the image by reducing the exposure (dodging) or alternatively darkening other parts by giving more exposure (burning). These skills were needed to produce an exposure of the paper to reflect the tones or colours that the photographer envisioned when the photograph was taken. The printing paper was then processed through another set of chemicals, their constituents carefully chosen to produce the tones, contrast and colours desired. The final result was a combination of all these skills and choices.

With digital images the chemical element is removed but the manipulation of the image to produce the envisioned outcome is still a skill that needs to be learned, practiced and perfected.

The image manipulation computer program now takes the place of the developer and enlarger as the route to the image we want or need.

There are many image manipulation programs available for the purposes of the post-production of digital images. Adobe Photoshop is the industry standard imaging software. This massively powerful and versatile program allows sophisticated after-treatment of the files produced in the camera to enable reproduction to established standards. Other professional programs include DxO Optics, Capture One from Phase One and Phocus from Hasselblad. Many other consumer-oriented programs will also allow you carry out the necessary post production to the captured image files. Gimp and Pixir.com, which is an online editor, give the basics for free and Adobe Elements will provide much of the functionality of its bigger relative for about a tenth of the price. A program capable of processing RAW image files greatly enhances the post-production techniques available. The free applications may not open RAW files and therefore the advantages of shooting in this file format will be lost, so choose your program carefully.

This is not a book about image editing programs; there are plenty of those available (*see* Suggested reading). The following is a guide about what can and should be done to an image before it is saved as an archive file or sent for reproduction. Where it is appropriate to explore a certain process I have used Photoshop as an example; however, most image manipulation program follow similar methodologies.

The light room

Before you start work on any image manipulation, it is necessary to ensure that what you see on your computer monitor accurately reflects what your image really looks like. As the only means of telling this is via what you see on your computer screen, it is good practice to choose a suitable working environment and monitor. The monitor must be adjusted so that it reproduces the image correctly (*see* Monitor calibration).

The monitor should be viewed in a stable working environment, one that presents consistent viewing conditions, such as lighting conditions, background colour and tone. A room that is not influenced by external lighting conditions (daylight) should be the goal for any critical colour assessment and adjustment. Professional establishments have rooms with ideal viewing conditions with a plain white or grey coloured wall behind the screen and daylight-balanced artificial light sources for illumination. For viewing prints a special box is used to provide light at the right colour temperature and standard level of luminance known as D50, which provides daylight viewing conditions at 5000K.

In practice, a room with window blinds and a controllable light source will likely be the best that most will achieve. All computer workstations need to be set up correctly to be able to work in comfort. Further information about suitable working set-ups can be found at http://ergo.human.cornell.edu/ergoguide.html or http://www.wikihow.com/Set-Up-an-Ergonomically-Correct-Workstation.

Many hours may be spent looking at your computer screen, so money spent on a high-quality screen is money well spent. Working at the screen, especially the sort of work required for producing images, can cause problems for our eyes and our backs, arms and wrists. Work at the screen should be interspersed with time spent away from the screen to give the body time to recover from the time spent sitting staring at it. For advice on how to set up your workstation and safe working periods and conditions visit http://www.hse.gov.uk/msd/dse/guidance.htm.

The computer

Apple and Windows operating systems both have their supporters and either system will successfully support various editing programs for the post-production of the captured image. The wide availability and affordability of Windows hardware and the extensive range of image-editing programs written for the Microsoft system offer the cheapest route to a finished image. However, paying a premium for the Apple hardware may result in a faster post-production process as the combination of the operating system and the hardware produced by Apple is more finely tuned, hence the widespread adoption of 'Macs' in the imaging industry.

Whichever system is adopted, the sheer size of the data being manipulated necessitates fast processing units and as much random access memory (RAM) as you can afford, typically 8–16Gb

The monitor

Choosing a colour monitor will be influenced by a number of factors, not all of them technical. How much room and how much cash you have will place limits on any purchase. From a technical standpoint it is important that your monitor should have a wide colour gamut, so that a wide range of colours can be displayed. It should provide an even illumination across the whole of the screen area and should be free of reflections. It should also provide ergonomic adjustments so that it can be viewed at the correct height and angle to provide a comfortable working position. The screen will need to be adjustable for colour temperature, brightness and contrast and allow a consistency of illumination from a wide variety of viewing angles so that decisions can be made about image contrast density and colour.

If space allows, a screen of at least 22 inches in size is desirable for carrying out post-production work.

Standard laptop computer screens rarely offer the qualities outlined above and are particularly difficult to set up for image assessment due to the many variables of viewing height and angle that arise from opening and closing the screen. In addition, a laptop computer may be used in many various positioning and environmental configurations. A desktop mounted monitor should be used for assessing image quality and for making adjustments to images. As technology moves on, the shortcomings of laptop screen technology will no doubt be overcome, but the ergonomic considerations will continue.

Computer screen technology

Computer screens use different display technologies: Cathode Ray Tube (CRT) – which is now largely obsolete – and Liquid Crystal Display (LCD). LCD monitors have three main types of technology: twisted nematic (TN), patterned vertical alignment (PVA) and in-plane switching (IPS), each offering differing quality.

Twisted nematic panels are most commonly found in laptop computers and suffer from a limited colour gamut or range. In addition, severe shifts of colour, brightness and contrast are evident with minor changes of viewing angle.

Patterned vertical alignment panels are better than TN panels for displaying more colours but suffer from the same drawbacks as TN panels with minor changes of viewing angle.

In-plane switching is currently considered the best technology for image display as it offers the potential for displaying a wide range of colours and a wide range of viewing angles without noticeable shift in colour and contrast display. Unsurprisingly they cost more money.

A new generation of screens capable of very high resolutions containing great pixel density (many more than the 72–90 ppi that are used in the display of most current screens) are appearing on mobile telephones, tablet computers, desktops and in the domestic viewing technology of television screens. These '4K' devices offer a rich and vibrant viewing experience but at desktop monitor sizes, 20 inches and above, make great demands on the other elements in the display screen apparatus, the computer graphics card and processor. The screen interconnects also need to be current, HDMI or Display port (best), to provide a sufficient refresh rate to give flicker free display. The very high resolution also reproduces desktop icons and menus at small sizes that may lead to eye-strain. The Graphical User Interface (GUI) of the computer operating system currently lags behind the display technology.

Monitor calibration

The computer monitor is the primary way to see the pixels that you have captured in your camera. It is therefore important that you can be sure that your monitor is showing you those pixels as the right colour, the right contrast and at the right level of brightness. Almost all uncalibrated monitors are set to display too brightly and at the wrong colour temperature, usually too cold (blue).

The way to ensure that your monitor is giving an accurate reproduction is to measure the brightness, the contrast or gamma and the colour and compare them to a known standard. Measurement is made using a device called a colorimeter, more commonly known as a spider. This is an optical device which is placed on the screen to measure, via software, colour,

contrast and brightness. Once measured, a profile (a small program that describes your device, in this case a monitor) is produced within a standard colour space and highlights any differences in the measured device to the standard. The profile adjusts the display to compensate for its deficiencies.

Checking that your monitor is showing you an accurate representation of your image should take place at regular intervals (anywhere from 30 days to 3 months depending on the quality of your monitor) and if possible in consistent viewing conditions. The consistent viewing environment described earlier (*see* The light room) offers the best conditions to calibrate a monitor. This is for the most colour critical work and may be beyond your budget. Don't worry too much; a window blind and a monitor hood that prevents light from reaching the screen will be a good start. Some screens and calibration devices will take into account the ambient lighting conditions as part of the calibration process.

A colorimeter and profiling software for regular screen measurement will cost from £70 upwards. For profiling additional devices such as printers and scanners, a spectrophotometer should be added to your standard equipment. Spectrophotometers are more sophisticated measuring devices costing considerably more money at around ten times the price of a colorimeter.

Work flow
Transferring digital image files from camera to computer
It is advisable to download the files from the camera memory card onto a computer hard drive as soon as possible after taking photographs. Using a card reader for this is safer than connecting the camera directly to the computer, as a direct connection requires dual functionality of the camera to read and transfer the files at the same time.

Hard disk drives are susceptible to failure and valuable data needs to be stored on more than one drive and preferably in more than one location in case of a disaster occurring in the place where the data are normally kept. The storage drives themselves need to be regularly backed up so that the changes made to files on one drive are reflected on the other drives. Losing a day or a week of post-production work is worth avoiding. Some computer programs – Adobe Photoshop Lightroom and Capture One from Phase One, for instance – offer the facility to download and back up at the same time, saving time and alleviating the need to copy the files manually.

Backup can be simplified by the use of programs purchased or downloaded free from the internet which will compare the drive being backed up from with the drive or drives being backed up to and only transfer the files that have changed. Many programs come free with the plug-in backup hard drive.

The downloaded files should be placed into folders preferably named by site or alternatively by date or better still by site and date. Metadata as outlined below should be added to the files.

Image editing program basic settings

It is necessary to set some preferences in the program in which you are going to edit, most importantly colour space. As with the colour space setting on the camera (*see* chapter 1), the use of the Adobe RGB 1998 will offer a wide gamut of colours and take advantage of the setting that you have already used in the camera.

Other preferences you may be able to set are printing resolution and what information about your image you would like to have displayed on screen while you are in the editing process. These might range from a levels display to a measurement scale around the image or a display of the history of your adjustments to a graphical readout of the section of the image you are working on. Other personal choices about how your interface looks and acts can usually be specified but these will not be crucial to how your image will be edited.

All programs are updated from time to time to improve and enhance functionality and also to fix bugs and glitches in the program. It is useful to make periodic visits the website of the program maker to take advantage of these.

Dealing with your image
Using RAW

If you are using camera RAW files as your file source there is a pre-stage to undertake via the RAW file converter before your image is loaded into the image editing program. This initial stage is where the benefits of using RAW files really demonstrate their superiority over other file formats The RAW file converter allows an interface with the data the camera captured so that adjustments can be made to the exposure, colour, tone, contrast and also the white balance setting that was selected in the camera, so if it was set incorrectly it can be remedied. The RAW file converter also allows corrections to be made for lens aberrations (distortions of the image introduced by the lens). Even more wonderfully, it is possible to recover detail in the highlight and shadow areas of the image that would otherwise be lost. The image may also be cropped, straightened, have any blemishes caused by dust on the sensor removed and if desired can be converted to black and white. Saving the image into a new format such as TIFF, JPEG or DNG format can also be performed by the RAW file converter. All of these adjustments can be made working with a file in the equivalent of 16 bit so that a greater range of tones is available to adjust.

Perhaps the most useful part of the RAW process is the creation of a 'sidecar' or buddy file, which records all the changes that have been made

437

438

437 A RAW file of the interior of a church before any adjustment in the RAW file converter. Notice the loss of detail in the highlight areas near the window and shadow areas in the roof.

438 The same file after being adjusted in the RAW file converter without any other post-production work in an image editor.

to the image file and applies them to the image. The result is the creation of two files, the original photographic image and the second, a complete record of all changes made to the file. This means changes to the file can also be undone and you always retain the original photograph.

In fact, the RAW file converter is capable of such extensive adjustments to the image that many photographers manage all their post-production work just via the converter without the need to use the image editing program.

Cropping the image

Ideally, the composition of the images should be done in camera, but this is not always practical. The need to crop out unwanted portions of the image to concentrate on the subject matter or to remove unwanted distractions will be frequent. Cropping the image early on is useful as it saves the editing program from having to deal with pixels that won't be needed and will speed up any other processes applied later.

Many programs will also allow the setting of an image size when cropping. This is useful for getting the size of image you require and also for creating a consistency of image size for publication or printing.

Cropping the image removes pixels, producing smaller file sizes. Ensure that your file is still a suitable size for its intended reproduction or for any standard file size required by an archive.

Levels adjustment

A comprehensive way of changing the image brightness and contrast is by using the levels dialogue. The levels, which are displayed as a graph (histogram), show all the different brightness levels within your image, and are the same as those that may have been displayed on your camera when you took the photograph. On the left side are the dark to black levels, on the right are the light to white levels and in the middle, grey (*see* Understanding the histogram).

In Photoshop, you make adjustments to the levels histogram by moving the little arrows at the base of the graph to alter the image. Sliding the left arrow to the right will darken an image and sliding the right arrow to the left will lighten an image. Sliding the middle arrow to the left or right will lighten or darken the mid-tones of the image. The reduction in the light or dark tones brought about by moving the arrows at either end of the graph will also have the effect of increasing the contrast of the image.

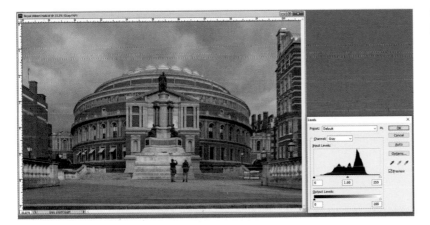

Image before adjustment of contrast in the Levels dialogue.

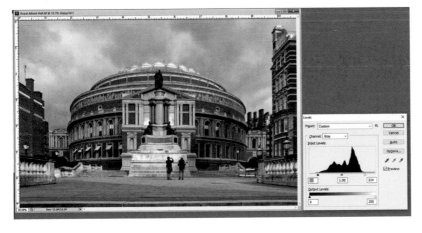

Image after adjustment of contrast in the Levels dialogue.

Photoshop tip

You can keep control of your highlight and shadow brightness levels by holding down the Alt key on the keyboard and moving the left arrow (shadows) as detailed above. This process turns the image area white except for any pixels that do not contain detail, which show up as dark-coloured pixels. Using the right arrow (highlights) turns the image area black except for pixels that do not contain detail, which show up as bright-coloured pixels. To make an adjustment to the highlights, slide the right arrow to the left until some pixels begin to show, which indicates where information is being lost. Once this is found, move the arrow back to the right until just after the bright pixels disappear so as to keep maximum highlight detail but achieve maximum brightness in the highlight areas of the image. Use the same technique with the left arrow for shadow areas. Releasing the Alt key at any point in the process will reproduce the image normally on the screen so that the effect of the process can be seen.

It is not necessary to maintain detail in all areas of an image. It is usual to try and achieve this in highlight areas, but you may decide to sacrifice some detail in either the shadow or highlight areas of the image to get the best result. Using this method will help you make this decision.

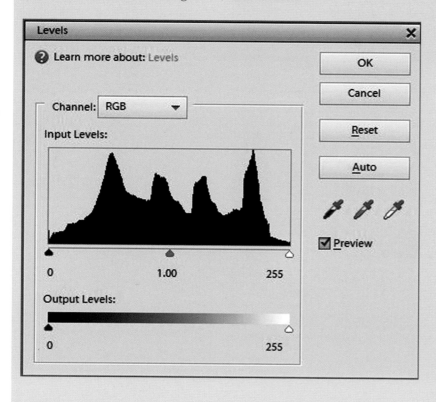

Curves adjustment

The curves dialogue is a different way of showing the same information as the histogram. It does take a little more investment to get the results you want, but offers the ability to make more accurate adjustments to the contrast and tonality of the image. Light areas of the image are towards the top of the diagonal line and dark at the bottom; unsurprisingly, mid-tones are in the middle as the grey point. Changing the diagonal from a straight line into a shallow 'S' shape by clicking and dragging on the line above and below the grey point will lighten the highlights and darken the shadow area of an image, thereby increasing its contrast. It is also possible to make minor adjustments to specific tones within the images by finding where they are represented on the line (usually indicated by placing the curser at the chosen point within the image) and then moving the line at this point to make the adjustment.

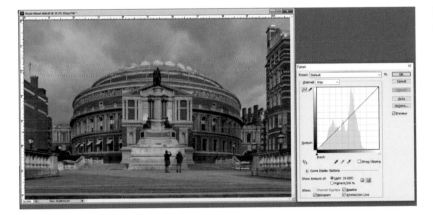

Image before adjustment of contrast in the curves dialogue.

Image after adjustment of contrast in the curves dialogue.

Adjustment layers

Newer versions of some of photographic software platforms have introduced adjustment layers; these, much like the RAW sidecar process, allow adjustments to the curves and levels of the image within a layer, which can be switched on and off. The advantage of applying these adjustments in layers is that the adjustments are nondestructive and can be removed easily if they are not required, or changed later if necessary. If any adjustments are applied in layers it will be necessary to flatten the file (in effect apply them permanently to the image before saving it) before saving it as a TIFF or JPG.

Saving the flattened adjusted image as a copy of the original file is good practice as the original can be returned to and readjusted as required.

Selecting parts of an image

Being able to select subsections or smaller areas of the image is essential for applying any special treatments such as lightening, darkening and colour adjustments. An invaluable tool for making selections and other post-production adjustments is a graphics tablet, which is an alternative to a mouse and allows finer control. Tablets vary in size and price; they take a little time to get used to, but in a short while you will wonder how you ever managed without one. There are a number of different ways of selecting different areas of the image, the most powerful of which are described below.

The lasso tool

This allows you to select areas of an image simply by drawing around the area you want with the cursor. The selection is made when the cursor is returned to the starting point. The accuracy of the selection will depend on your drawing skills and mouse control.

Polygonal or freeform lasso tool

This works in a similar way to the lasso tool but allows you to put anchor points in your selection by clicking the mouse, thereby providing a number of 'stopping off' points while making the selection. The selection is made when the cursor is returned to the starting point.

Magic wand/fuzzy selection tool

This is simple to use, though a somewhat haphazard way of selecting parts of an image. It works on the basis of selecting pixels that are the same colour and tone, usually across the whole of the image area, and will, for instance, select a uniform area of sky where all the pixels are similar. The problem is that it would also select the same colour pixels reflected in water or pixels in a blue car that just happen to be the same colour and tone. Some programs allow you to add and subtract pixels to the selection.

Correcting distortion

Even with the most expensive cameras and the highest quality lenses there will be distortions in the images produced, which fall into two categories, perspective and lens distortion. Most image software allows you to correct these distortions by using a lens correction or perspective filter, which is widely available in most software.

Correction of verticals

Images of building exteriors (and some interiors) taken without the aid of a perspective control lens or rising front camera movement are likely to exhibit converging verticals due to the tilting of the camera out of the parallel plane with the building to include its upper parts (*see* chapter 2 for more information).

In Photoshop correction of verticals can be undertaken by selecting the lens correction filter from the list under the Filter menu. This loads the image that is currently open in PhotoShop into a new dialogue box for lens correction.

Within this dialogue you can make a number of adjustments. Corrections for lens aberrations may be made automatically under the 'Auto Correction' tab, made possible because of the EXIF data stored by the camera within the image file at the time of taking (*see* EXIF data). This gives the program information about the lens and camera used to take the photograph, from which it is able to apply corrections to the image from a database of known faults (profiles) of various lens and camera combinations.

Correction of distortion

To a lesser or greater extent the camera and lens will produce a number of distortions of the image, the result of capturing the 3d world onto a 2d plane. These distortions include

▶ Geometric distortions. This is an overall term to describe barrel distortion, where the image appears to bulge towards you, or pincushion distortion where the image sinks away from you.

▶ Chromatic aberration, also known as colour or purple fringing. This is the result of the dispersion of different wavelengths of light by the lens and shows as fringes of colour around edges of objects and the edge of the image.

▶ Vignetting. This is the reduction of image illumination at the edges compared to the centre of the image.

Lens correction filter dialogue, image imported without any auto adjustments. Camera and lens information from EXIF data listed at the base of the screen and profiles offered to the right within white box.

Lens correction filter dialogue with lens and camera profiles chosen and auto adjustments made for geometric distortion, chromatic aberration and vignetting which are inherent in all lenses.

Within this section of the dialogue make sure that the Preview and Show Grid boxes at the base of the dialogue box image are ticked. Both will be needed to make effective vertical corrections.

Use the Transform section at the bottom of the dialogue box (outlined in red below) to apply corrections to the vertical planes of the image. Adjustments/corrections can be made to the horizontal plane as well as the vertical and the image may also be rotated here around 360 degrees using controls in this section. The rotation adjustment can be used to level the horizon of the image

Beware! Old buildings can lean at funny angles! Using this method of vertical correction may lead you to correct verticals that were not 'vertical' in the first place. Optical correction at the time of image capture using rising front or a perspective control lens is a preferable solution.

The area outlined in yellow has controls to adjust geometric distortion, chromatic aberration and vignetting, also available in the auto section. Automatic adjustments already made can be fine tuned if necessary.

439 The image after the verticals have been corrected and the image cropped to remove the blank areas created during the image correction process.

408

Stitching images

The ease with which images can be combined using digital technology in post-production (or at the time of taking using apps to create panoramas on some cameras and other capture devices) is another great benefit to working with a digital medium.

The ability of the computer program to match pixels from one image with pixels in another image enables photographers to extend the field of view of any one lens to be many times more than its original focal length. This extension can be used not only to show the complete width of an elevation, but also used to capture other things like ledger stones without the use of ladders and thereby avoid the risks of injury from falls.

440

441

442
443

444

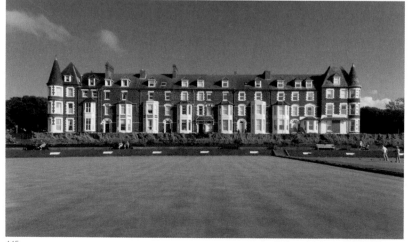

445

440, 441 The two original images to be combined are loaded into the stitching program, which compares the pixels in the two images and creates edges that will join together seamlessly.

442, 443 The two images and their irregular joining points are produced by the stitching program.

444 The two images are merged together producing an irregularly shaped image with some distortion of the perspective.

445 Using the lens correction tool it is possible to correct the distortion of the perspective, after which the image is cropped to remove the irregular shape.

A ledger stone photographed in sections (446–449) and joined together (450) enables capture of the complete stone without the need for an elevated viewpoint.

446

447

448

449

450

The successful stitching of images depends on providing enough information in the series of images to be stitched to enable the computer program to make comparisons of the pixels in each image and match those of the same colour tone and brightness with each other. It works most accurately with subjects that have little variation depth, ie a flat surface. Subjects that have great variation in depth are likely to be distorted. Although not a flat surface, the image of the seaside terrace has stitched with only minor distortion due to the relatively distant viewpoint, which minimises the differences in depth of the bay windows and dormers, etc.

The stitching of the images below showing a range of buildings along a street has produced very different results! This is due to the change of viewpoint for each image capturing very different views of the same part of the building so that parts of the building that are not in the same plane as the main elevation are shown from very different angles (451).

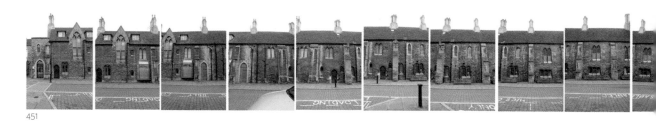
451

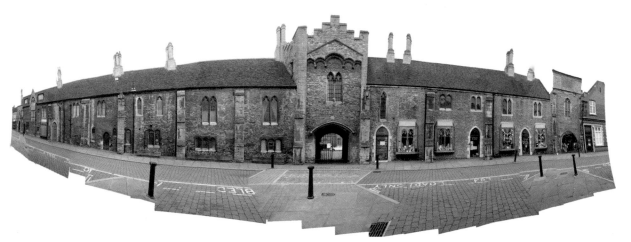
452

The stitched image (452) shows how it can all go horribly wrong. The elevation has acquired a curved appearance and several additional chimney pots have been created. This is all due to the scale of the reproduction of parts of the building that are not in the same plane as the main façade. An accurate representation of this range requires the use of photogrammetric techniques using scaled measurements taken from known and measurable points on the façade (targets) of the building, known characteristics of the lens and camera and a whole different level of software.

More information about photogrammetry and metric survey can be found here: https://content.historicengland.org.uk/images-books/publications/measured-and-drawn/measured-and-drawn.pdf.

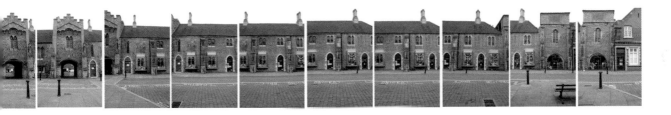

453 The façade of this building is difficult to photograph even with a wide angle lens due to the narrowness of the street and the width of the building. Could it be a suitable candidate for multi-image capture and stitching?

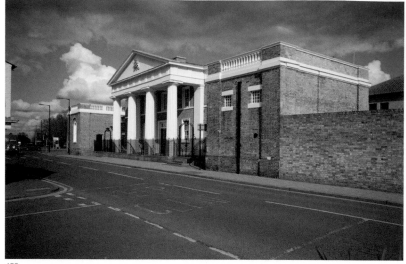

453

454

454 With knowledge of what can happen, the elevation was photographed carefully choosing very specific viewpoints to try and avoid including too many planes in any one of the images that would be making up the composite.

455 Even with careful choice of viewpoint the original stitch from all the images was unsuccessful.

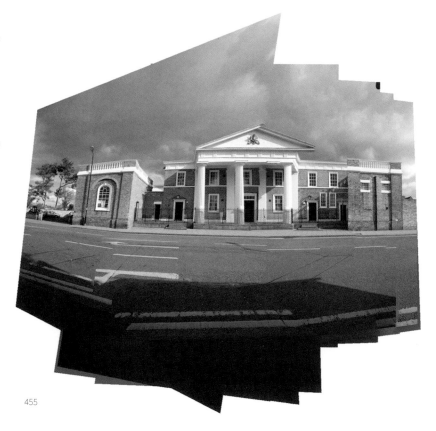

455

456

457

458

459

456–458 However, experimentation of stitching various combinations of images from the original set produced three composite images.

459 Placing the three images made from combining various combinations of the originals back into the stitching program produced a successful stitching.

460 The irregular outline produced during the stitching process is cropped out to produce a finished image. It is not perfect. There are some misaligned sections of the pavement, but the stitch is otherwise successful in presenting the façade in one image. An additional bonus to stitching images is the creation of a larger file than can be produced in camera from one image with a resultant increase in the digital information gathered.

460

Sharpening an image

Sharpening works by increasing the contrast at the junction of each pixel, giving the impression of sharper edges between them and greater overall contrast. For scanned images as opposed to camera images it is usually necessary to apply a degree of sharpening as some sharpness is lost during the scanning process. Sharpening is also applied in-camera as part of the capture process. Care should be exercised on the application of any additional image sharpening. In general, sharpening should not be applied to any archive image as sharpening is dependent on the size at which the image is going to be reproduced. The future reproduction size of any archive image cannot be known.

Images for reproduction can be sharpened (if necessary) once created at their reproduction size as copies of the original archive image. Beware of overuse of the sharpening tool as it can produce unreal effects.

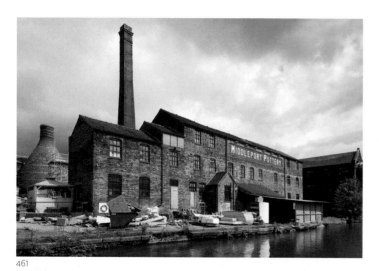
461

463

462

461 The original image of Middleport Pottery, Stoke-on-Trent.

462 and 463 The same image oversharpened in post-production, exhibiting tell-tale signs of halo around boundaries of dark and light areas.

464 The original image of the floor slab.

465 The excessively sharpened image resulting in the production of artefacts in the smooth areas of tone within the black areas of the stone slab.

464

465

Don't tell lies

The point of making a building record is that it should truthfully represent what is or was there. The power and ease with which images can be manipulated in editing programs is an ever-increasing temptation to modify what the camera saw. Post-production techniques should not fundamentally change reality; they should be used to enhance the image in terms of contrast, composition and correct colour rendition as photographers have always done.

Files that are changed significantly for presentational purposes should clearly indicate in the metadata that this is the case, perhaps with the phrase 'image derived from (reference no:)'. The original image without the significant changes should also be submitted to the archive.

466

467

466 The ledger stone commemorating George Warren has over the years been damaged; however, in about two minutes I was able to 'fix' this damage in Photoshop to make it much more presentable.

467 The stone looks much better and I am sure that George would be delighted. Historians and the diocesan archivist would be less pleased as their expectations are that the image represents the condition of what was there at the time of taking.

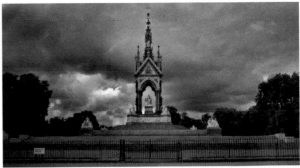

468

469

The two images above are in fact the same image. 468 is the original image with people scattered about the surrounds of the Albert Memorial in Kensington Gardens.

469 is the image produced without much effort – about 10 minutes' work – in Adobe Photoshop with people removed. It is all too easy to make changes in post-production!

There are arguments that the removal of the people makes for a better image and it is the same as if I had taken the photograph after asking the people to move or alternatively waiting for them to disappear.

The camera data for the image indicates that I took it at 14.30.59. The image with people is the truthful representation of how the scene looked at 14.30.59 on that day. Had I waited or managed to get the people to move from the scene the camera would have recorded a very different time. The image without people misrepresents what was there at 14.30.59 as much as the fixed ledger stone to George Warren.

I may also have been able to produce an image without people by taking many images of the scene over a period of time and then combining them all together in post-production software which would have produced an image without people or alternatively with the same people in many different places within the image depending on how I chose to merge the images. Is this misrepresenting the scene? It would be more representative of how the scene looked over the period of time taken to produce the many images without people, as they would have moved during that time and not blocked the particular part of the memorial that they are blocking at 14.30.59.

Both may be valid images for particular reasons but as with George Warren's ledger stone, if submitting to an archive both should be included, with an explanation of what has been done as part of the metadata of the altered image.

Metadata

Metadata is described as 'data about data', but it is much more important than that. Adding some words to a digital file (or appending it to any photographic print) makes the image very much more valuable. It also greatly increases the possibilities of finding it again when performing a search on any computer or the internet. There are two forms of metadata: the exchangeable image file (EXIF) data, which is automatically added by the camera, and the additional data added manually.

EXIF data

A digital file contains information placed into its metadata by the camera, which is known as EXIF data. The EXIF data provides information about the image size, the colour space within which it is captured and the white balance setting (light source setting used). In addition, the camera make and model and the lens used, as well as the lens aperture and shutter speed settings used at the time of capture are included. All of this information is needed to describe the image to a computer program that will open it. More recently this information about camera and lens is used in the post-production of the captured image to correct distortions in the image produced by the lens. In fact, many lenses are manufactured in the knowledge that faults will be remedied using the algorithms of a computer program to correct these inherent faults. EXIF data also provide one of the essentials required, the date and time the photograph was taken. It will only do this accurately if the camera has been set up to record the correct date and time. This information is demanded by the camera when it is first switched on, usually before any other operation can take place. Having accurate information about the date and time of a photograph is massively valuable for records, investigative work and making comparisons. How a building appears in a photograph and how a building has changed over time and when those changes took place is fundamental to telling the story of any building.

Adding information about 'where' our image is can be applied in two ways. As previously mentioned in the equipment section, geographical information can be added at the time of capture using a Global Positioning System logger or later by using computer programs such as Google Earth, or Google Maps to show exactly where the photograph was taken from or where the building is. It is worth remembering that the GPS records the position of the camera and not the co-ordinates of the building. This may be significant if the building is distant from the viewpoint. If geographical position is not indicated by the addition of 'geotagging', this information can be given by the addition of a National Grid Reference in the description box of the metadata dialogue box (*see* opposite).

Manually added metadata

The description box in the Metadata dialogue of the computer program is the place to write additional information about the image. The IPTC (International Press Telecommunications Council) defines three groupings of data.

1 Administrative – identification of the creator, creation date and location, contact information for licensors of the image, and other technical details.

2 Descriptive – information about the visual content. The standard UK archiving information should include:

> Building name and or street number
> Street name
> Parish name
> County name
> Postcode
> National Grid Reference. Information about how to provide a six figure reference number is provided on an Ordnance Survey 1:50 000 map or a reference can be obtained at http://www.getamap.ordnancesurveyleisure.co.uk/

Description (free text field)

A description of what part of the building is shown in the image. This may take the form of 'View from south west' or 'ground floor south east room from south east' or 'Nave, interior from west'. Be careful when naming parts of a building; for example, a room may currently be used as the dining room, but it might have previously been the kitchen. Better to stick to compass points unless it is obviously the Great Hall or Chancel. In addition, you may wish to add information about a significant event or specific reason why the photograph was taken such as, 'photographed prior to new extension being added to the west wing' or 'taken to show roof after storm damage'. Any additional information added to the caption makes the photograph valuable as a historical record.

Keywords

The addition of key words will assist searches for the subject matter. Provide a list of at least three keywords that describe the subject matter captured within the image. Thesauri of controlled vocabularies that are commonly used in the heritage sector are available from Historic England.

HE Monument Types Use this thesaurus if your project includes specific monument types: http://thesaurus.historicengland.org.uk/thesaurus.asp?thes_no=1

HE Evidence Use this thesaurus if the project recovered specific types of evidence: http://thesaurus.historicengland.org.uk/thesaurus.asp?thes_no=92

HE Maritime Craft Types Use this thesaurus if your project includes marine evidence: http://thesaurus.historicengland.org.uk/thesaurus.asp?thes_no=143

HE Event Types Use this thesaurus if the project involved a particular event or process: http://thesaurus.historicengland.org.uk/thesaurus.asp?thes_no=566

You should record information about when the photograph was taken. If the camera was correctly set up this will be already completed, and if not or you need to change it, a date and time can be inserted.

Also in the Origin dialogue box is an area to indicate what the credit line should be if the photograph is reproduced.

A job or reference number can also be added under Transmission Reference for later searching to find the complete set of images taken of the building or at one point in time.

3 Rights – copyright information and underlying rights in the visual content including model and property rights, and rights usage terms.

The metadata dialogue allows the input of other essential information, such as the name of the photographer (author), what the position of the photographer is (Author Title), such as freelance photographer or staff photographer, and also information about who is writing the description.

Metadata input can be speeded up by creating metadata templates which contain all the basic information about author, copyright, credit etc. Once created and saved, this information can be selected and applied to one or many images at the click of a mouse.

The great thing about adding metadata to an image is that it goes with it wherever the image goes unless it is deliberately removed.

More detailed and thorough information about metadata standards can be found at http://dublincore.org/ and http://www.jiscdigitalmedia.ac.uk/guide/metadata-standards-and-interoperability.

Glossary of photographic terms

additive colour If we are working on a computer, the colours we see on the screen are created with light using the additive colour method. Additive colour mixing begins with black and ends with white; as more colour is added, the result is lighter and tends to white.

Adobe® Photoshop® An image manipulation computer program widely used throughout the photographic industry and regarded as the 'standard' software for the post-production of images.

aliasing Jagged edges between different elements of the image, particularly noticeable in circular objects when insufficient pixel numbers prevent the smooth representation of a curve by the square pixel; often referred to as jaggies.

aperture The size of the opening in the diaphragm placed in front of the sensor to control how much light is transmitted through to the sensor. It is expressed as a ratio of the focal length of the lens in terms of f numbers or f stops. The higher value f numbers (F:8, F:11, F:16) are smaller openings and pass less light through to the sensor. Lower value f numbers (F:2, F:4, F:5.6) are wider openings and pass more light through to the sensor.

app Short for application. A computer program that is designed to run on a smartphone or tablet computer.

blinking highlights Areas of an image that 'blink' black to white on a camera or computer screen to indicate over-exposure of an area. Used to indicate loss of information recorded in any bright area of an image.

bounced lighting Any light source bounced off a reflector such as the ceiling or walls or other neutral photographic reflector.

CCD Charge-coupled device: an image sensor.

card reader A device for reading information from a camera memory card and transferring it to a computer hard drive.

camera A device for capturing images made by light on to a medium capable of reproducing the image. Film cameras capture the image on a silver-based sensitive emulsion and digital cameras capture the images using an array of pixels forming a sensor that transfers electrical signals to a computer processing unit and then on to a storage device (memory card).

camera shake Movement of camera during the exposure. Prevalent in images taken without camera support at slow shutter speeds. Results in a blurred image.

CMOS Complementary Metal Oxide Semiconductor: an image sensor.

clipping A term used to describe the inability of a camera sensor to accommodate all of the levels of brightness contained within a scene or subject being photographed. This results in several different brightness levels being merged into one, being a black or a white depending whether the level of brightness is a shadow (dark) or highlight (bright) area.

colour chart A card of standard colours that is included in an image to provide a standard for measurement at later stages of the image post-production and reproduction.

colour cast An unwanted shift in the colour of an image due to a mismatch of the colour temperature of light source or sources with the colour temperature setting of the camera.

colour profile A description of how a device is reproducing colour within a defined colour space.

colour space The space in which computers and cameras store the information that describes the colour of an image. The three most widely used choices of colour space are Adobe® RGB 1998, sRGB and CMYK. The size of these spaces, and therefore the colour information that can be contained within them, vary.

colour temperature A method defined by William Thompson Kelvin for measuring the colour of light at different wavelengths. Measured in kelvin (K).

compact camera A camera of small size, usually able to fit into a coat pocket or handbag, that lacks the capability to change lenses, as the lens is integral to the camera.

contrast The range of difference in the light to dark areas of an image.

curves dialogue A graphical display and means of adjusting the contrast of an image in post-production. Initially, the image's tonality and contrast is represented as a straight diagonal line on a graph. Moving any point within the graph to change the shape of the straight line to non-straight or curved changes the tonal value (contrast) of the image. Moving a point in the upper-right area of the graph represents changing the highlights and moving a point in the lower-left area represents changing the shadows of the image. Adjustment can be made to any tone in the image by selecting the point on the line that represents it and moving left or right to lighten or darken it.

cut-off An area of less illumination at the edges of an image caused either by the lens failing to illuminate the whole area of the image evenly or alternatively by the use of a lens hood not designed for the lens or being incorrectly fitted.

dynamic range The ratio between the maximum and minimum measurable levels of light: white and black, respectively.

depth of field How much of the image is in focus in front of and behind the object focused on. Dependent on three factors: the focal length of the lens, the aperture used and distance of the subject focused on from the camera. A greater range of sharpness is achieved with smaller apertures using wide-angle lenses and a distant subject focused on. A shorter range of sharpness is produced using larger apertures, telephoto lenses and a near subject focused on.

distortion image Inaccurate representation of the subject matter due to misuse of camera, for example distortion of parallel lines causing convergence or divergence.

distortion lens Camera lenses, particularly wide-angle lenses, have characteristics that produce distortions in the way the image is produced, most notably in the bending of elements of the scene which should be straight. These are reproduced either as bending outwards (barrel distortion) or bending inwards (pin cushion distortion). Using the right software in post-production will enable the removal or reduction of this unwanted distortion.

DX sensor Sensor sizes are often defined in ratio to the size of a 35mm film frame. DX sensors are smaller (by various amounts) than a 35mm frame, while FX sensors are about the same size as a 35mm frame.

electronic flash A light source of very short duration produced on an electrical discharge across two electrodes in a gas-filled tube. The light produced is usually close to the colour temperature of daylight at 5,500K. May be mains or battery operated.

EXIF Exchangeable image file format: data embedded into an image at the time of capture that describes the image and the camera settings to a computer.

exposure The quantity of light allowed to fall on a photosensitive sensor. It is the product of the amount of light (controlled by the aperture) and the duration of its falling (controlled by the shutter speed).

exposure meter An instrument with a light-sensitive cell that measures the light reflected from or falling on a subject. May be integral to or independent of the camera.

F: numbers The numbers on the lens aperture ring that indicate the relative size of the lens aperture opening. The number series is a geometric progression based on changes in the size of the lens aperture, as it is opened and closed to allow more or less light to pass through to the sensor. Each change in number results in a doubling or halving of the amount of light transmitted to the sensor. Standard numbers for calibration are 1.0, 1.4, 2, 2.8, 4, 5.6, 8, 11, 16, 22, 32, and so forth. While they are not physically the same size, they are relative to the lens being used and allow the same quantity of light to pass.

file format A standard way that information is encoded for storage in a computer file. It specifies how bits (units of information) are used to encode information in a digital storage medium. File formats may be either proprietary or open for free use. File formats widely used in photography are TIFF (Tagged Image File Format), JPEG (Joint Photographic Experts Group) or RAW (data straight from the camera with minimal processing having taken place).

flash synchronisation Timing of the shutter opening to coincide with the firing of the flash light. Limited to a higher speed of 1/250 second or lower.

focal length The power of a lens to bend light. In a simple lens it is the distance from the centre of the lens to where it focuses a sharp point of light. In practice, no camera lenses are simple, but instead are a combination of lenses within a mount to produce an image. The focal length of a lens determines its angle of view, how wide or how narrow an area can be seen or how much the subject will be magnified for a given viewpoint. Wide-angle lenses have short focal lengths, while telephoto lenses have longer corresponding focal lengths. Focal length is based on format, which is measured across the diagonal: for 35mm, lenses of 24mm, 28mm and 35mm are considered wide angle, and lenses of 80mm, 135mm and 200mm are telephoto, while the standard lens based on the diagonal is 55mm.

focus An adjustment of the distance of the lens from the focal point (usually the sensor) to produce a point of light. More practically, the adjustment of the combination of lenses within a lens housing or camera to produce a sharp image of subjects at varying distances from the camera.

focus (auto) A mechanism within the camera or lens housing to make the adjustment of the combination of lenses within a lens housing or camera to produce a sharp image of subjects at varying distances from the camera.

FX sensor Sensor sizes are often defined in relation to the size of a 35mm film frame. FX sensors are about the same size as a 35mm frame, while DX sensors are smaller (by various amounts) than a 35mm frame.

guide number A number supplied with flash guns as an indication of their power. Used as a basis to calculate the aperture for an exposure.

grey card (also known as 18% grey card) Coloured card or material that reflects light containing equal amounts of red, green and blue light. Used for assessing exposure or alternatively for colour balance. For the latter it may be left in the image area to allow measurement of it in post-production. Readings taken from it can be applied to another image of the same scene taken without the grey card.

Global Positioning System (GPS) A satellite system capable of determining the precise position on earth of any device able to contact four or more satellites. The system provides location and time information in all weather conditions, anywhere on or near the earth where there is an unobstructed line of sight to the GPS satellites. Created by the government of the United States, it is freely accessible to anyone with a GPS receiver. The receivers may be built-in or attached to a camera to provide geographical information to images.

hard light A light from a source that will cause hard shadows.

highlights Used to describe the lightest tones of a picture, those that are reflecting or transmitting the greatest amount of light.

hot shoe Fitting on the top of a camera with electrical contacts that allow the camera to communicate with an external device such as a flash gun or remote triggering device.

hue The description of the colour of the light within a colour space.

image Two-dimensional (or sometimes three-dimensional) reproduction of a subject formed by a lens and captured by the camera sensor.

IPTC metadata The IPTC Photo Metadata standard is the most widely used standard because of its universal acceptance among photographers, distributors, news organisations, archivists and developers. The schema defines metadata structure, properties and fields, so that images are optimally described and easily accessed later.

ISO The International Organization for Standardization is an independent, non-governmental international organisation whose members develop voluntary, consensus-based, market-relevant international standards that ensure quality, safety and efficiency for products, services and systems.

ISO speed The sensitivity of a sensor (that is, how much it reacts to light) can be increased or decreased electronically by adjustment. The sensitivity of the sensor is expressed by the use of a standard numerical setting issued by the International Organization for Standardization (ISO). Low numbers such as 50, 100 and 200 are considered low sensitivities. High numbers such as 1,000, 1,600, 2,500 and up are considered high sensitivity settings.

JPEG (Joint Photographic Experts Group) A file format that compresses the image by discarding some bits of information (described as 'lossy') and grouping pixels of similar colour, brightness and saturation together to produce a smaller file. This loss of information is why the alternative TIFF file format is favoured as an archive file. The JPEG is an open format, widely available and it provides a useful format for viewing, storing and exchanging images.

LCD (Liquid Crystal Display) panel An electronically generated display of text, numbers and symbols found on many cameras to indicate the setting in use on the camera.

LED (Light Emitting Diode) Light-producing transistors used to display images and information on the rear of cameras or alternatively used in an array to produce a light source.

lens One or more pieces of optical glass that bend light rays to a point (or points) of focus.

lens hood or shade A shade or hood placed at the front of a lens to prevent unwanted light from acute angles from striking the lens and causing image flare. Should be appropriately sized and shaped to the particular lens to avoid being seen in the captured image area.

levels dialogue A graphical display and means of adjusting the contrast of an image in post-production. The brightness levels contained within the image are displayed along the x axis as 256 points of variation, where 0 is black and 255 is white. The amount of any one brightness is displayed along the y axis. Greater amounts of any one brightness or tone display as a higher point on the axis. By moving 'sliders' located along the x axis changes can be made to the highlight, shadow and midtones of the image.

luminence How bright light is. Measured in candela.

megapixel One million pixels.

memory card A storage medium used by most digital cameras. More specifically, it is a flash memory card that stores the electronic information about the image to allow it to be reconstructed and reproduced. There are many different formats of memory card; the most common in cameras are CF (compact flash) and SD (secure digital).

metadata Information or data about data, used to describe the information contained in a computer file.

noise Unwanted interference and degrading of the image caused by a number of factors during the processing of the image at the time of capture. One of the main causes of noise in images results from increasing the sensitivity of the image sensor (increasing the ISO setting) to obtain images in low levels of light or shooting in low levels of light.

noise reduction A built-in system within cameras to reduce the noise produced in an image during exposure. The ability to reduce or remove this degrading of the image greatly depends on the algorithms of the camera manufacturer. Additional noise reduction can also be applied during post-production. Overzealous noise reduction in post-production can result in smeary looking images. Using lower ISO sensitivity settings and turning off any automatic facility on the camera to increase the sensitivity at low light levels will avoid or reduce this.

overexposure A condition in which too much light reaches the sensor to record information in the light areas of the subject.

pan and tilt (head) A mechanical means of moving the camera in the vertical and horizontal planes and in a 360-degree axis.

perspective The rendition of how objects appear in relation to each other; determined by viewpoint only. Also refers to the distortion of an image if the camera is used incorrectly: parallel lines will appear to converge or diverge if the camera is not set to view them in the same vertical and horizontal planes. Most prevalent in buildings when the camera is tilted back from the vertical axis.

perspective control Keeping the perspective of parallel lines and preventing the appearance of convergence or divergence by setting the camera to view them in the same vertical and horizontal planes. This is impractical for most buildings due to the inability to capture the upper parts of them when the camera is not tilted back. To maintain control of the perspective, camera movements (rising front) or a perspective control (shift) lens are used to alter the capture area of the image.

perspective control lens Used in architectural photography mainly to correct the distortion of perspective that becomes apparent when the camera is used in a plane that is not parallel to the walls of the building, which changes the representation of the relationship or proportion of the parts of a building, making parallel lines appear to converge. This distortion of the perspective within the image makes a building appear as if it is leaning backwards or falling over. A perspective control lens eliminates this distortion. The lens has mechanical movements that allow the camera to be set in a parallel plane to a building's vertical axis, and using the mechanical adjustments on the lens casing enables capture of the uppermost elements without the need to tilt the camera. This advantage is only gained if the camera is set up accurately so that it is vertical to the plane being focused on, which is usually achieved by mounting the camera on a tripod.

pixel Picture element: the smallest point in a light-sensitive array or sensor in a digital camera or the smallest addressable point in a display screen.

post-production Applying changes to an image in a computer program after it has been produced in the camera.

raking light A light that shines across a subject from an oblique angle.

RAM (Random Access Memory) A type of memory used in a computer to store data on a temporary basis to speed up the computer's immediate performance in undertaking tasks.

RAW file format Data as captured by the camera, showing 'what the pixel saw', with minimal processing applied. This allows the 'pixel' data to be taken into a computer program for interpretation and processing by the photographer or other competent person. The RAW data offer the widest manipulation of the file without loss of quality. It is not an 'open' format and is subject to change by the owner of the format. Its relatively large size (although smaller than a TIFF file) makes it less suitable for electronic transmission. Its use as an archive file is an issue for debate due to its proprietary nature.

reflector Any device used to reflect light on to a subject to enhance the existing lighting of the subject.

RGB (red, green and blue) The primary colours of light that can be mixed together in different quantities to produce any colour of light. Digital cameras, computer screens and digital projectors are RGB devices, using this system to reproduce colour.

saturation The intensity of a colour. Highly saturated means lots of colour while desaturated means little colour and is sometimes referred to as 'washed out'.

sensor An array of light-sensitive cells able to record light transmitted to it by a camera lens and pass this information on as electrical signals to a processing unit and memory card.

shutter A mechanical system for controlling the time that light reaches the image sensor. May utilise metal blades, a blind of adjustable width or a plate to achieve the control.

shutter release A mechanical or electronic means of firing the shutter without having to touch the camera itself. Used to ensure stability of the camera at the time of exposure.

single-lens-reflex (SLR) camera A type of camera that allows the photographer to see through the camera's lens as they look in the camera's viewfinder.

soft light Light that does not produce hard shadows.

standard lens A lens that has a focal length that is the same as the diagonal measurement of the sensor.

stitching The combination of several images to form a new one.

subtractive colour When we mix colours using paint, or through the printing process, we are using the subtractive colour method. Subtractive colour mixing means that one begins with white and ends with black; as one adds colour, the result gets darker and tends to black.

telephoto lens (or long lens) Any lens with a focal length greater than the standard lens for the size of the image sensor. The focal length of the standard lens is based on the measurement across the diagonal of the sensor, typically between 50mm and 55mm on an FX-sized sensor. (Using these focal length lenses on the smaller DX sensor typically multiplies their focal length by a factor of 1.5, making them telephoto.) The effect of this greater focal length is to magnify the image and to narrow the angle of view. They also give a shorter depth of field. Long or telephoto lenses are useful for capturing distant or small subjects that cannot be approached.

TIFF (Tagged Image File Format) A widely available, uncompressed ('non-lossy') open file format used to store image files. A standard archive file format, yet its large size makes it less suitable for transmission via the Internet.

tripod A three-legged supporting stand used to hold the camera steady. Especially useful when using slow shutter speeds and/or telephoto lenses. The use of a tripod also facilitates a considered viewpoint.

tungsten light Incandescent light from regular room lamps and photographic lights; not fluorescent. A light source with a colour temperature between 2,700 and 3,500K.

underexposure A condition in which too little light reaches the sensor to record information in the dark areas of the subject.

viewfinder Device or system indicating the field of view seen by the camera lens. It may actually be able to see what the lens sees, as with a single lens reflex camera, or alternatively offer an approximate view of what the lens sees, hence the term 'viewfinder camera'.

viewpoint The point from where the subject is viewed, comprising distance, angle and height from the subject matter.

wide-angle lens A lens that has a shorter focal length and a wider field of view (so it includes more subject area) than a standard lens. A lens whose focal length is shorter than the diagonal of an FX-sized sensor (50–55mm). It is also referred to as a 'short' lens. A wide-angle lens is one that will enable a view of a whole building elevation or most of a room.

white colour balance How the camera is set to receive different colours of light produced by different light sources (*see* colour temperature).

zoom lens A lens which combines the wide-angle and telephoto lenses into one; also known as a lens of variable focal length. The quality of a zoom lens is always inferior to that of a lens of fixed focal length; however, modern zoom lenses offer very acceptable quality and the convenience of being able to vary the focal length will likely outweigh the loss of quality. Beware zoom lenses that offer a very great range of focal lengths as these are less likely to provide acceptable image quality throughout the range, even using modern software techniques.

Further reading

Andrews, Philip 2008 *The Complete Raw Workflow Guide: How to Get the Most from Your Raw Images in Adobe Camera Raw, Lightroom, Photoshop and Elements*. Oxford: Focal Press

Buchanan, Terry 1984 *Photographing Historic Buildings for the Record*. London: Her Majesty's Stationery Office

Evening, Martin 2014 *Adobe Photoshop CC for Photographers: A professional image editor's guide to the creative use of Photoshop for the Macintosh and PC*. New York: Focal Press

Kopelow, Gerry 2007 *Architectural Photography the Digital Way*. New York: Princeton Architectural Press

Langford, Michael 1979 *Basic Photography* (4 edn). London: Focal Press

Langford, Michael 1972 *Advanced Photography* (2 edn). London: Focal Press

Web sources

Archaeology Data Service/Digital Antiquity Guides to Good Practice: http://guides.archaeologydataservice.ac.uk/g2gp/

Digital Preservation Coalition: http://www.dpconline.org/

DxO cameras: http://www.dxo.com/us

Envato tutorials – bit depth explained: http://photo.tutsplus.com/articles/post-processing-articles/bit-depth-explained-in-depth/

Fredmiranda, a photography news, equipment review, and fine art presentation website: http://www.fredmiranda.com/

Hasselblad cameras: http://www.hasselblad.com/

Image Composite Editor: http://research.microsoft.com/en-us/um/redmond/groups/ivm/ice/

International Colour Consortium: http://www.color.org/chardata/rgb/srgb.xalter

International Press Telecommunications Council photo metadata standard: http://www.iptc.org/cms/site/index.html?channel=CH0099

International Press Telecommunications Council – Schema for XMP metadata: http://www.iptc.org/std/Iptc4xmpCore/1.0/specification/Iptc4xmpCore_1.0-spec-XMPSchema_8.pdf

Jisc, the UK higher education, further education and skills sectors' not-for-profit organisation for digital services and solutions: http://www.jisc.ac.uk

Joint Photographic Experts Group: http://www.jpeg.org/jpeg2000/

Lynda, an online learning platform that helps anyone learn business, software, technology and creative skills: www.lynda.com

Nikon cameras: http://imaging.nikon.com

Panoramic image stitching software for Windows and Mac OS X: www.ptgui.com

Phase One cameras: http://www.phaseone.com/

Photoshop image essentials: http://help.adobe.com/en_US/photoshop/cs/using/WSfd1234e1c4b69f30ea53e41001031ab64-7949a.html

Picture credits

All illustrations by John Vallender. © Historic England Archive.

Front cover Cantilevered staircase, 1 Lewes Crescent, Brighton. Photographer James O Davies. © Historic England Archive, DP035434.

Inside front cover St Mary's Church, Warmington, Northamptonshire. Photographer Steve Cole. © Historic England Archive, DP160863.

001 The author. Photographer Alun Bull.

002, 003 St Leodegarius Church, Ashby St Ledgers, Northamptonshire. Photographer Steve Cole. © Historic England Archive, BB84/03007, DP161533.

004 Latticed window, Lacock Abbey, 1835. Photographer William Henry Fox Talbot. National Media Museum/Science & Society Picture Library. All rights reserved. 10421201.

005 John Rennie's Waterloo Bridge, *c* 1854. Photographer Roger Fenton. © Historic England Archive, AA44/01353.

006 Carlton Club on Pall Mall, 1872. Photographer Bedford Lemere & Co. © Historic England Archive, BL00111.

007 The Great Hall, Mentmore House (1880–1920). Photographer Bedford Lemere & Co. © Historic England Archive, AL0174/029/01.

008 The Brewers Hall (built 1670–3 and destroyed by bombing in 1940), 1941. Photographer Bedford Lemere & Co. © Historic England Archive, BL/WP/05947/005.

009 Deanery next to Rochester Cathedral. Photographer Bill Brandt. © Historic England Archive, AA43/00206.

010 The Regnum Club, 45 South Street, Chichester. Photographer Bill Brandt. © Historic England Archive, AA42/02533.

011 Horse Guards Parade c 1865. Photographer Roger Fenton. © Historic England Archive, BB83/01019.

012 Arab Hall. Photographer Bedford Lemere & Co. © Historic England Archive, BB83/00708.

013 Drummond Street with Euston Arch in the foreground and booking offices at Euston Station beyond (1892–95). Photographer Bedford Lemere & Co. © Historic England Archive, BL/P051.

014 Stonehenge at first light. Photographer James O Davies. © Historic England Archive, DP149784.

015 Peterborough Cathedral, Peterborough, Cambridgeshire. Photographer Steve Cole. © Historic England Archive, DP160811.

016 Antenna One, 'Arthur' Goonhilly Satellite Earth Station, Cornwall. Photographer Steve Cole. © Historic England Archive, DP035734.

017 Didcot 'A' Power Station, Power Station Road, Didcot, Oxfordshire. Photographer Steve Cole. © Historic England Archive, DP157316.

018 Effigy (detail) of Alethea Talbot, Countess of Arundel, FitzAlan Chapel, Arundel Castle, West Sussex. Photographer Steve Cole. © Steve Cole.

019 Plaque of 'Healing the Hemorrhaging woman' (detail), Furness Abbey, Cumbria. Photographer Peter Williams. © Historic England Archive, DP045095.

020 Roof over Great Chamber, Kirby Hall, Kirby, Northamptonshire. Photographer Patricia Payne. © Historic England Archive, DP152940.

021 Pattern store, Middleport Pottery, Port Street, Burslem, Stoke-on-Trent, Staffordshire. Photographer Steve Cole. © Historic England Archive, DP157658.

022 Monument to Griffin, All Saints Church, Braybrooke, Northamptonshire. Photographer Steve Cole. © Historic England Archive, DP070549.

023 Preston Bus Station, Tithebarn Street, Preston, Lancashire. Photographer Alun Bull. © Historic England Archive, DP143108.

024 John Taylor & Co, The Bellfoundry, Freehold Street, Loughborough, Leicestershire. Photographer Steve Cole. © Historic England Archive, DP154455.

025 Armour-plated observation ports (detail) in Building J10, Atomic Weapons Research Establishment, Foulness, Essex. Photographer Steve Cole. © Historic England Archive, DP035948.

026 Esso Petrol Filling Station, A6 northbound carriageway, Red Hill Circle, Leicestershire. Photographer Steve Cole. © Historic England Archive, DP070109.

027 Stained glass by Peter Strong, Church of St Luke, Millom. Photographer Alun Bull. © Historic England Archive, DP066629.

028 St Nicholas's Church, Great Yarmouth, Norfolk. Photographer Steve Cole. © Historic England Archive, DP129846.

029 The Promenade, Blackpool, Lancashire. Photographer Steve Cole. © Historic England Archive, DP154755.

030, 031 Chancel arch, St John the Baptist Church, Wakerley, Northamptonshire. Photographer Steve Cole. © Historic England Archive, DP146410, DP146411.

032 48 St Mary's Street, Ely, Cambridgeshire. Photographer Steve Cole. © Steve Cole.

033 Tower Bridge, London. Photographer Steve Cole. © Steve Cole.

034 Lewes Bowling Green Society, Castle Precincts, Lewes, East Sussex. Photographer Steve Cole. © Historic England Archive, DP141880.

035 Roof, Apethorpe Hall. Photographer Steve Cole. © Historic England Archive, DP161680.

036 Gorse Industrial Estate (formerly RAF Barnham), Elveden Road, Barnham, Thetford, Norfolk. Photographer Steve Cole. © Historic England Archive, DP129996.

037 St Paul's Church, Holbeach Road, Fulney, Spalding, Lincolnshire. Photographer Steve Cole. © Historic England Archive, DP110113.

038 Church of The Holy Cross, Stuntney, Cambridgeshire. Photographer Steve Cole. © Steve Cole.

039 Spiral staircase, Beckford's Tower, Avon. Photographer James O Davies. © Historic England Archive, AA037576.

040 William Stone Building, Peterhouse, Cambridge. Photographer Steve Cole. © Historic England Archive, AA028487.

041 Former Woolworths building, Lister Gate, Nottingham. Photographer Steve Cole. © Historic England Archive, DP161681

042 Mill on the Norfolk Broads. Photographer Steve Cole. © Historic England Archive, EA15.

043 The Worshipful Company of Cutlers, Cutlers' Hall, Warwick Lane, London. Photographer Derek Kendall. © Historic England Archive, DP130375.

044 Wilkinson's car park, 34–40 Talbot Road, Blackpool. Photographer Steve Cole. © Historic England Archive, DP119539.

045 Granville Arcade (now called Brixton Village), Coldharbour Lane, Brixton, London. Photographer Nigel Corrie. © Historic England Archive, DP103078.

046 Goldsmiths' Hall, London. Photographer Derek Kendall. © Historic England Archive, DP130488.

047 Font, Church of the Good Shepherd, Mansel Way, Arbury Road, Cambridge, Cambridgeshire. Photographer Steve Cole. © Historic England Archive, DP119577.

048 Hasselblad camera with adapter. Photographer Steve Baker. © Historic England Archive, DP184504.

049 Mobile phone camera. Photographer Steve Cole. © Steve Cole.

050 Tablet camera. Photographer Steve Cole. © Steve Cole.

051 Church of St Mary, Church Close, Dullingham, Cambridgeshire. Photographer Steve Cole. © Steve Cole.

052–055 The Old Fire Engine House Restaurant, Church Lane, Ely, Cambridgeshire. Photographer Steve Cole. © Steve Cole.

056–061 Photographer Steve Cole. © Steve Cole.

062 Chapel ceiling, Humberside Trinity House, Hull. Photographer Bob Skingle. © Historic England Archive, DP071970.

063–065 Church of St Edmund, Hauxton, Cambridgeshire. Photographer Steve Cole. © Steve Cole.

066 Canon with CC lens. Photographer Steve Baker. © Historic England Archive, DP184495.

067 Church of St Mary, Westley Waterless, Cambridgeshire. Photographer Steve Cole. © Steve Cole.

068 Pan and tilt tripod head. Photographer Steve Cole. © Steve Cole.

069 Spirit level. Photographer Steve Cole. © Steve Cole.

070 GPS logger. Photographer Steve Cole. © Steve Cole.

071 Hot shoe adapter. Photographer Steve Cole. © Steve Cole.

072 Camera transmitter. Photographer Steve Cole. © Steve Cole.

073 Flash receiver. Photographer Steve Cole. © Steve Cole.

074 Bowens flash. Photographer Steve Cole. © Steve Cole.

075 Tungsten light. Photographer Steve Baker. © Historic England Archive, DP188924.

076 Lowel Prime™ LED light. http://lowel.tiffen.com/2011StudioLED.html.

077–079 Great Tower, Dover Castle, Dover, Kent. Photographer Steve Cole. © Historic England Archive, DP154725.

080–082 Monument to Robert Peyton, Church of St Andrew, Isleham, Cambridgeshire. Photographer Steve Cole. © Steve Cole.

083 Battery Observation Post Mural Painting, Pendennis Castle, Falmouth, Cornwall. Photographer Peter Williams. © Historic England Archive, DP114949.

084 Coombes Church, Coombes. Interior view of a medieval wall painting on the north wall of the nave. Photographer Steve Cole. © Historic England Archive, DP027372.

085 Copy of Audley End watercolour album 'In', c 1840s–50s. Great Hall and screen. Photographer Patricia Payne. © Historic England Archive, DP155873.

086–087 Staircase, Walton Hall, Warwickshire. Photographer Steve Cole. © Steve Cole.

088 Deeper Christian Life Ministry (formerly Granada Cinema), St John's Hill, Clapham, Battersea, London. Photographer Steve Cole. © Historic England Archive, DP153839.

089 Bromley House Library, 13–15 Angel Row, Nottingham, Nottinghamshire. Photographer Steve Cole. © Historic England Archive, DP046313.

090 Airship hangars, Cardington, Bedfordshire. Photographer Steve Cole. © Steve Cole.

091–092 The Rotunda, Ickworth House, Horringer, Bury St Edmunds, Suffolk. Photographer Steve Cole. © Steve Cole.

093–094 Waterside, Ely, Cambridgeshire. Photographer Steve Cole. © Steve Cole.

095 Chatsworth House, Chatsworth, Bakewell, Derbyshire. Photographer Steve Cole. © Steve Cole.

096 18 Cavendish Square, Marylebone, London. Photographer Christopher Redgrave. © Historic England Archive, DP165921.

097 Brierfield Mill, Brierfield, Lancashire. Photographer Steve Cole. © Historic England Archive, DP084242.

098 Remains of Mohopehead Mine, Mo Hope, West Allen, Northumberland. Photographer Steve Cole. © Historic England Archive, DP146222.

099 Signal Box 1741, Station Road, Littleport, Cambridgeshire. Photographer Steve Cole. © Historic England Archive, DP110656.

100 Former Unitarian Chapel, Stamford Street, Southwark, London. Photographer Derek Kendall. © Historic England Archive, DP150864.

101 Using a stepladder. Photographer Charles Walker. © Charles Walker.

102 Using a camera pole. Photographer Paul Backhouse.

103 Wimpole Street, London. Photographer Chris Redgrave. © Historic England Archive, DP165922.

104 Apethorpe Hall, Apethorpe, Northamptonshire. Photographer Greg Colley. © Historic England Archive, DP157415.

105–106 Mount Grace Priory, East Harlsey, North Yorkshire. Photographer Steve Cole. © Historic England Archive, DP160916, DP160917.

107 Oxgate Farm, Coles Green Road, Cricklewood, Brent, Greater London. Photographer Steve Cole. © Historic England Archive, DP157512.

108–109 Reconstructed World War I Military Hut at Cannock Chase Visitor Centre, Marquis Drive, Hednesford, Near Cannock, Staffordshire. Photographer Steve Cole. © Historic England Archive, DP160768, DP160766.

110–111 Mount Grace Priory, East Harlsey, North Yorkshire. Photographer Steve Cole. © Historic England Archive, DP160979, DP160978.

112–114 The Grand Hotel, Colmore Row, Birmingham, West Midlands. Photographer Steve Cole. © Historic England Archive, DP153971, DP153970, DP153975.

115 Long gallery with fireplace by Robert Adam, Croome Court, Croome D'Abitot, Worcestershire. Photographer James O Davies. © Historic England Archive, DP031165.

116 Font, Church of St Andrew, Wickmere, Norfolk. Photographer Steve Cole. © Steve Cole.

117–118 Ely Cathedral, Ely, Cambridgeshire. Photographer Steve Cole. © Steve Cole.

119–124 RAF Coltishall, Coltishall, Norfolk. Photographer Steve Cole. © Historic England Archive, DP029225, AA0543398, DP029247, DP029295, DP035653, DP936662.

125–128 Church of St Leodegarius, Ashby St Ledgers, Northamptonshire. Photographer Steve Cole. © Historic England Archive, DP161677, DP161678, DP161679, DP161531.

129–131 Ye Olde Trip to Jerusalem public house, Brewhouse Yard, Nottingham, Nottinghamshire. Photographer Steve Cole. © Historic England Archive, DP046293, DP046292, DP046294.

132 Longthorpe Tower, Longthorpe, Peterborough. Photographer Derek Kendall. © Historic England Archive.

133 Coombes Church, Coombes, West Sussex. Photographer Steve Cole. © Historic England Archive, DP027407.

134 Former Royal Aircraft Establishment, Bedford. Photographer Steve Cole. © Historic England Archive, AA051180.

135, 136 Oven, RAF Coltishall, Coltishall, Norfolk. Photographer Steve Cole. © Historic England Archive, AA054452, AA054453.

137 Well House donkey wheel, Carisbrooke Castle, Castle Hill, Newport, Isle of Wight. Photographer Steve Cole. © Historic England Archive, K021076.

138 Bayham Abbey, Clay Hill Road, Lamberhurst, Kent. Photographer Steve Cole. © Historic England Archive, DP147255.

139 Kirby Hall, Kirby, Northamptonshire. Photographer Patricia Payne. © Historic England Archive, DP155764.

140 Wealden House, Weald and Downland Open Air Museum, Singleton, Sussex. Photographer Steve Cole. © Steve Cole.

141 Decorative terracotta panelling, Watts Mortuary Chapel, Compton, Surrey. Photographer Steve Cole. © Steve Cole.

142, 143 Railway Mission, Ely, Cambridgeshire. Photographer Steve Cole. © Steve Cole.

144 Horsley Park, Ockham Road South, East Horsley, Surrey. Photographer Steve Cole. © Steve Cole.

145 Wharram Percy deserted medieval village, North Yorkshire. Photographer Steve Cole. © Historic England Archive, DP146526.

146, 147 Church of St Martin, Witcham, Cambridgeshire. Photographer Steve Cole. © Steve Cole.

148 The Old Rectory, Friars Lane, Lower Brailes, Warwickshire. Photographer Steve Cole. © Historic England Archive, DP154530.

149 Interior of Test Cell 4, National Gas Turbine Establishment, Pyestock, Fleet, Hampshire. Photographer Steve Cole. © Historic England Archive, DP070613.

150 20 Mansfield Street, Marylebone, London. Photographer Christopher Redgrave. © Historic England Archive, DP165754.

151 Hilton Hall, High Street, Hilton, Cambridgeshire. Photographer Patricia Payne. © Historic England Archive, DP084543.

152 Arthur's Hall, Dover Castle, Dover, Kent. Photographer Steve Cole. © Historic England Archive, DP154750.

153 Old Hall, Queens' College, Cambridge, Cambridgeshire. Photographer Steve Cole. © Historic England Archive, DP129948.

154, 155 Monument to Jane Cotton, Church of St Mary Magdalene, Madingley, Cambridgeshire. Photographer Steve Cole. © Steve Cole.

156, 157 Monument to Edward, 1st Lord North (1564), Church of All Saints, Kirtling, Cambridgeshire. Photographer Steve Cole. © Steve Cole.

158 Great Northern Warehouse, Manchester. Photographer Alun Bull. © Historic England Archive, DP143372.

159 Lilford Hall, Lilford cum Wigsthorpe, Northamptonshire. Photographer Steve Cole. © Historic England Archive, DP070546.

160 Former Regional Seat of Government (Dumpy level), Dover Castle, Dover, Kent. Photographer Christopher Redgrave. © Historic England Archive, DP154695.

161 Fireplace, Apethorpe Hall, Apethorpe, Northamptonshire. Photographer Patricia Payne. © Historic England Archive, AA052275.

162 Former Regional Seat of Goverment (Dumpy level), Dover Castle, Dover, Kent. Photographer Christopher Redgrave. © Historic England Archive, DP154693.

163 Auditorium ceiling, plasterwork (detail), Deeper Christian Life Ministry (formerly Granada Cinema), St John's Hill, Clapham, Battersea, London. Photographer Steve Cole. © Historic England Archive, DP153843.

164 Incised image of St Paul's Cathedral, City of London, before the Great Fire, St Mary's Church, Ashwell, Hertfordshire. Photographer Steve Cole. © Historic England Archive, DP119363.

165 Fireplace (detail), Apethorpe Hall, Apethorpe, Northamptonshire. Photographer Patricia Payne. © Historic England Archive, DP029601.

166, 167 Overmantel, Kenilworth Castle, Warwickshire. Photographer Steve Cole. © Historic England Archive, DP161793, DP161794

168 Staircase, Brodsworth Hall, Doncaster, South Yorkshire. Photographer Bob Skingle. © Historic England Archive, DP070927.

169 Cantilevered staircase, 1 Lewes Crescent, Brighton. Photographer James O Davies. © Historic England Archive, DP035434.

170 Main stair, officers' mess, RAF Henlow, Bedfordshire. Photographer Mike-Hesketh-Roberts. © Historic England Archive, DP004935.

171 Staircase, Luton Sixth Form College, Bradgers Hill Road, Luton, Bedfordshire. Photographer Steve Cole. © Historic England Archive, DP068385.

172 Staircase, Parkgate House School, 80 Clapham Common, Northside, London SW4 9SD. Photographer Steve Cole. © Historic England Archive, DP153811.

173 Staircase, 16 Lewes Crescent, Brighton, East Sussex. Photographer James O Davies. © Historic England Archive, DP035442.

174 Stairwell, Bevin Court, Islington, London. Photographer Derek Kendall. © Historic England Archive, AA056199.

175 Staircase, Apethorpe Hall, Apethorpe, Northamptonshire. Photographer Steve Cole. © Historic England Archive, DP161676

176 Staircase, Apethorpe Hall, Apethorpe, Northamptonshire. Photographer Patricia Payne. © Historic England Archive, DP029057.

177 Staircase, Byrne Avenue Baths, Byrne Avenue, Birkenhead. Photographer James O Davies. © Historic England Archive, DP031340.

178 Staircase, Tynemouth Priory, North Tyneside Castle. Photographer Mike Hesketh Roberts. © Historic England Archive, DP022833.

179 Staircase, Motor Carriage Houses, Salomons, David Salomons Estate, Tunbridge Wells, Kent. Photographer Steve Cole. © Historic England Archive, DP070059.

180 Stair, Barford Court, Princes Crescent, Hove, East Sussex. Photographer James O Davies. © Historic England Archive, DP035464.

181 Stair, Parkgate House School, 80 Clapham Common, Northside, London. Photographer Steve Cole. © Historic England Archive, DP153813.

182 Stair, Felsted School Chapel, Felsted, Essex. Photographer Steve Cole. © Historic England Archive, DP119561.

183 Stair, Clifton Hill House, Bristol. Photographer Peter Williams. © Historic England Archive, DP114703.

184 Stair, 55–57 Westgate Road, Newcastle, Northumberland. Photographer James O Davies. © Historic England Archive, DP059777.

185 Stair, 19–20 Sussex Square, Brighton, East Sussex. Photographer James O Davies. © Historic England Archive, DP035486.

186 Avon Staircase, Clifton Wood House, Clifton Wood Road, Bristol. Photographer Patricia Payne. © Historic England Archive, DP135983.

187 Plaster ceiling (detail), The Abbey, Beckington, Somerset. Photographer James O Davies. © Historic England Archive, DP082004.

188 Duke's Chamber, Apethorpe Hall, Apethorpe, Northamptonshire. Photographer Patricia Payne. © Historic England Archive, DP060066.

189 Oak Stair ceiling pendant, Apethorpe Hall, Apethorpe, Northamptonshire. Photographer Patricia Payne. © Historic England Archive, DP060087.

190, 191 The Old Merchant's House, South Quay, Great Yarmouth, Norfolk. Photographer Steve Cole. © Historic England Archive, DP088739, DP088741.

192 7 Mansfield Street, Marylebone, London. Photographer Christopher Redgrave. © Historic England Archive, DP165764.

193 Using an iPad to control the camera while photographing the ceiling at St Mary's Church, Studley Park, North Yorkshire. Photographer James O Davies. © Historic England Archive, DP184909.

194 St Mary's Church, Studley Park, North Yorkshire. Photographer James O Davies. © Historic England Archive, DP184910.

195 Dining room frieze, Wrest Park, Silsoe, Bedfordshire. Photographer Steve Cole. © Historic England Archive, DP141972.

196 Great Chamber ceiling (detail), Apethorpe Hall, Apethorpe, Northamptonshire. Photographer Steve Cole. © Historic England Archive, DP060091.

197 Turret, Brierfield Mill, Brierfield, Lancashire. Photographer Steve Cole. © Historic England Archive, DP084239.

198 Rainwater head, Apethorpe Hall, Apethorpe, Northamptonshire. Photographer Patricia Payne. © Historic England Archive, DP060102.

199 Date stone, Hartwell House stables, Aylesbury, Buckinghamshire. Photographer Steve Cole. © Steve Cole.

200 Bell and date stone on the south gatehouse, The Garrison, St Marys, Isles of Scilly. Photographer Mike Hesketh-Roberts. © Historic England Archive, DP116030.

201 Date stone, Bullhouse Chapel, Bull Lane, Penistone, Sheffield. Photographer Alun Bull. © Historic England Archive, DP143294.

202 War Memorial, Hertford, Hertfordshire. Photographer Steve Cole. © Historic England Archive, DP002703.

203 Foundation stone, Former Railway Mission, Silver Street, Ely, Cambridgeshire. Photographer Steve Cole. © Steve Cole.

204 Hilton Hall, High Street, Hilton, Cambridgeshire. Photographer Patricia Payne. © Historic England Archive, DP084503.

205 Cropple How Farmstead, Ravenglass, Cumbria. Photographer Bob Skingle. © Historic England Archive, DP117574.

206 Britons Arms, 9 Elm Hill, Norwich, Norfolk. Photographer Steve Cole. © Historic England Archive, DP160565.

207–208 Chalgrove Manor, Oxfordshire. Photographer Steve Cole. © Historic England Archive, DP161795, DP161796.

209 Weaver's Triangle, Burnley, Lancashire. Photographer Steve Cole. © Historic England Archive, DP110537.

210 John Taylor & Co, The Bellfoundry, Freehold Street, Loughborough, Leicestershire. Photographer Steve Cole. © Historic England Archive, DP154450.

211 Plant House, National Gas Turbine Establishment, Pyestock, Fleet, Hampshire. Photographer Steve Cole. © Historic England Archive, DP161648.

212 Barford Brothers Ltd, 111 North Street, Luton, Bedfordshire. Photographer Steve Cole. © Historic England Archive, DP110770.

213–215 Barford Brothers Ltd, 111 North Street, Luton, Bedfordshire. Photographer Steve Cole. © Historic England Archive, DP110740, DP110703, DP110686.

216–231 Boon and Lane Ltd, 7–11 Taylor Street, Luton, Bedfordshire. Hat block making sequence. Photographer Steve Cole. © Historic England Archive, DP153605, DP153609, DP153610, DP153614, DP153617, DP153619, DP153650, DP153651, DP153652, DP153653, DP153657, DP153668, DP153672, DP153673, DP153674, DP153675.

232 Hounds Gate, Nottingham. Photographer Alun Bull. © Historic England Archive, DP081516.

233 Bridge (dated 1795), Bridge End, Wansford, Peterborough. Photographer Steve Cole. © Historic England Archive, DP129983.

234 Bridge over the M1 motorway at Milton Malsor, Northamptonshire. Photographer Steve Cole. © Historic England Archive, DP130294.

235, 236 Scarisbrick Hall School, Scarisbrick Hall, Southport Road, Ormskirk, Lancashire. Photographer Steve Cole. © Historic England Archive, DP110505, DP110503.

237 Stewart's Lane Depot, Dickens Street, Battersea, London. Photographer Steve Cole. © Historic England Archive, DP153864.

238 A1 road bridge over the river Nene at Wansford, Peterborough. Photographer Steve Cole. © Historic England Archive, DP129973.

239 St Lawrence's Church, The Street, Mereworth, Kent. Photographer Steve Cole. © Historic England Archive, DP084410.

240 Jamia Ghousia Mosque, 406 Gladstone Street, Peterborough. Photographer Steve Cole. © Historic England Archive, DP147359.

241 Baptist Chapel, Wheal Busy, Chacewater, Truro, Cornwall. Photographer Steve Cole. © Historic England Archive, DP160700.

242 Glasgow Central Mosque, 1 Mosque Avenue, Gorbals, Glasgow. Photographer Alun Bull. © Historic England Archive, DP143533.

243 The Free Church, Central Square, Hampstead Garden Suburb, Greater London. Photographer Patricia Payne. © Historic England Archive, DP088318.

244 St Mary's Church, Helmingham, Suffolk. Photographer Steve Cole. © Historic England Archive, DP035792.

245 Friends Meeting House, Come to Good, Nr Kea, Cornwall. Photographer Steve Cole. © Historic England Archive, DP160689.

246 St Paul's Church, Holbeach Road, Fulney, Spalding, Lincolnshire. Photographer Steve Cole. © Historic England Archive, DP110128.

247 Central Synagogue, Great Portland Street, Marylebone, London. Photographer Christopher Redgrave. © Historic England Archive, DP155339.

248 Birmingham Central Synagogue, Speedwell Road, Birmingham, West Midlands. Photographer James O Davies. © Historic England Archive, DP055933.

249 Chancel, St Joseph's Roman Catholic Church, Moreton Road, Upton, Wirral. Photographer James O Davies. © Historic England Archive, DP162871.

250 Faizan E Madina Mosque, 175 Gladstone Street, Peterborough. Photographer Steve Cole. © Historic England Archive, DP153505.

251 Baptist Chapel, Regent Place, Rugby, Warwickshire. Photographer Steve Cole. © Historic England Archive, DP160644.

252 Church of St John, Stamford, Lincolnshire. Photographer Steve Cole. © Steve Cole.

253 Church of St Andrew, Isleham, Cambridgeshire. Photographer Steve Cole. © Steve Cole.

254 Church of St Mary, Wiggenhall, Norfolk. Photographer Steve Cole. © Steve Cole.

255 Chancel ceiling, St Simon and St Jude Church, Quendon, Essex. Photographer Steve Cole. © Historic England Archive, DP119427.

256 Twidde tomb, Church of St Andrew, Wickmere, Norfolk. Photographer Steve Cole. © Steve Cole.

257 Walpole tomb, Church of St Andrew, Wickmere, Norfolk. Photographer Steve Cole. © Steve Cole.

258 John Harrison tomb, Church of St John, Leeds, West Yorkshire. Photographer Steve Cole. © Steve Cole.

259–262 Sir Thomas and Lady Mary Fane tomb, St Lawrence's Church, The Street, Mereworth, Kent. Photographer Steve Cole. © Historic England Archive, DP084431, DP084432, DP084434/ DP084441, DP084437.

263 Monument to Lionel Tollemache, St Mary's Church, Helmingham, Suffolk. Photographer Steve Cole. © Historic England Archive, DP035794.

264 Monument to Richard Thornton, Church of St John, Leeds. Photographer Steve Cole. © Steve Cole.

265, 266 Monument to Elizabeth Stewkely, dated 1636, Church of St Mary Magdalene, Madingley, Cambridgeshire. Photographer Steve Cole. © Steve Cole.

267 Font, Church of St Margaret, Bacton Road, Paston, Norfolk. Photographer Steve Cole. © Historic England Archive, DP110261.

268 Font, Church of St Paul, Fulney, Spalding, Lincolnshire. Photographer Steve Cole. © Historic England Archive, DP110142.

269 Font, Church of All Saints, Lullington, North Somerset. Photographer James O Davies. © Historic England Archive, DP081792.

270 Font, St Mary's Church, Hawkswood Avenue, Hawkesworth Wood, Leeds, West Yorkshire. Photographer Steve Cole. © Historic England Archive, DP027037.

271 Font and cover, Church of St Michael, Headlam Street, Byker, Newcastle, Northumberland. Photographer James O Davies. © Historic England Archive, DP058455.

272, 273 Font, Church of St Martin, Witcham, Cambridgeshire. Photographer Steve Cole. © Steve Cole.

274 Baptistery, Marychurch, Salisbury Square, Hatfield, Hertfordshire. Photographer James O Davies. © Historic England Archive, DP162258.

275 Baptistery, St Paul's Church, Raynel Drive, Ireland Wood, Leeds, West Yorkshire. Photographer Steve Cole. © Historic England Archive, DP027059.

276 Bemah (detail), Central Synagogue, Great Portland Street, Marylebone, London. Photographer Christopher Redgrave. © Historic England Archive, DP155346.

277 Pulpit, St Paul's Church, Holbeach Road, Fulney, Spalding, Lincolnshire. Photographer Steve Cole. © Historic England Archive, DP110143.

278 Pulpit, Church of St Wilfrid, Ribchester, Lancashire. Photographer Steve Cole. © Steve Cole.

279 Mimbar (detail), Aziziye Mosque, 117–119 Stoke Newington Road, Hackney, London. Photographer Derek Kendall. © Historic England Archive, DP132048.

280 Pulpit, Lutheran Chapel, 55 Alie Street, Whitechapel, Greater London. Photographer Patricia Payne. © Historic England Archive, DP155964.

281 Pulpit, Church of St Martin, Witcham. Cambridgeshire. Photographer Steve Cole. © Steve Cole.

282 Lectern, St Paul's Church, West Street, Brighton, East Sussex. Photographer James O Davies. © Historic England Archive, DP054076.

283 Lectern, St Paul's Church, Holbeach Road, Fulney, Spalding, Lincolnshire. Photographer Steve Cole. © Historic England Archive, DP110145.

284 Chancel screen (detail), St Paul's Church, Holbeach Road, Fulney, Spalding, Lincolnshire. Photographer Steve Cole. © Historic England Archive, DP110137.

285 Lectern (detail), Church of St Andrew, Isleham. Photographer Steve Cole. © Steve Cole.

286, 287 Brass to Sir John de Creke (died 1325) and his first wife Alyne Clopton, Church of St Mary, Westley Waterless, Cambridgeshire. Photographer Steve Cole. © Steve Cole.

288 Memorial stone showing indent for brass, Church of St John the Baptist, Inglesham, Wiltshire. Photographer Peter Williams. © English Heritage Archive, DP031910.

289, 290 Memorial to Papworth, Church of St Martin, Witcham, Cambridgeshire. Photographer Steve Cole. © Steve Cole.

291 Camera screen. Photographer Steve Cole. © Steve Cole.

292 Chancel screen, St Simon and St Jude Church, Quendon, Essex. Photographer Steve Cole. © Historic England Archive, DP119428.

293 Misericord, Church of St Andrew, Isleham, Cambridgeshire. Photographer Steve Cole. © Historic England Archive.

294 Ark, Sunderland Synagogue, Ryhope Road, Sunderland. Photographer Bob Skingle. © Historic England Archive, DP020517.

295, 296 Bench end, Church of St Mary the Virgin, Wiggenhall, Norfolk. Photographer Steve Cole. © Steve Cole.

297 Choir stalls, Church of All Saints, Margaret Street, Marylebone, London. Photographer Steve Cole. © Historic England Archive, DP183160.

298 Benches (detail), Baptist Chapel, Regent Place, Rugby, Warwickshire. Photographer Steve Cole. © Historic England Archive, DP160648.

299 Reading desk. Photographer Steve Cole. © Steve Cole.

300 South door furnishing, St Paul's Church, Holbeach Road, Fulney, Spalding, Lincolnshire. Photographer Steve Cole. © Historic England Archive, DP110147.

301 East window, Church of St Peter, Cambridge. Photographer Steve Cole. © Steve Cole.

302 Arts & Crafts stained glass by J Edgar Mitchell (1904), Laing Art Gallery, New Bridge Street, Newcastle upon Tyne. Photographer Steve Cole. © Steve Cole.

303 Stained glass by David Hillman, St John's Wood Synagogue, 37–41 Grove End Road, London. Photographer Nigel Corrie. © Historic England Archive, DP042813.

304 Stained-glass panel, Oxburgh Hall, chapel of St Margaret and Our Lady, Oxburgh, Norfolk. Photographer Steve Cole. © Steve Cole.

305, 306 Stained glass, St Paul's Church, Holbeach Road, Fulney, Spalding, Lincolnshire. Photographer Steve Cole. © Historic England Archive, DP110141.

307–311 Stained glass, east window, Church of St Peter, Babrham, Cambridgeshire. Photographer Steve Cole. © Steve Cole.

312, 313 Stained glass, Church of St Peter, Snailwell, Cambridgeshire. Photographer Steve Cole. © Steve Cole.

314–316 Stained glass, Church of St Michael the Archangel, Booton, Norfolk. Photographer Steve Cole. © Steve Cole.

Case Study 1: 317–327 Farnley Hey, Farnley Tyas, West Yorkshire. Photographer James O Davies. © Historic England Archive, 317 DP137974; 318 DP137987; 319 DP137980; 320 DP137983; 321 DP137984; 322 DP137986; 323 DP137981; 324 DP137988; 325 DP137985; 326 DP137976; 327 DP137978.

Case Study 2: 328–388 Oxgate Farm, Coles Green Road, Cricklewood, Brent, London. Photographer Steve Cole. © Historic England Archive, 328 DP157466; 329 DP157475; 330 DP157464; 331 DP157476; 332 DP157477; 333–335 DP157467; 336 DP157470; 337 DP157469; 338 DP157471; 339 DP157472; 340 DP157473; 341 DP157525; 342 DP157523; 343 DP157526; 344 DP157524; 345 DP157515; 346 DP157514; 347 DP157521; 348 DP157520; 349 DP157517; 350 DP161792; 351 DP157513, 352 DP161791, 353 DP157522; 354 DP157539; 355 DP157538; 356 DP157537; 357 DP157540; 358 DP157534; 359 DP157533; 360 DP157531; 361 DP157532; 362 DP157482; 363 DP157484; 364 DP157483; 365 DP157485; 366 DP157487; 367 DP157488; 368 DP157489; 369 DP157490; 370 DP157494; 371 DP157493; 372 DP157492; 373 DP157491; 374 DP157495; 375 DP157496; 376 DP157511; 377 DP157500; 378 DP157501; 379 DP157502; 380 DP157478; 381 DP157479; 382 DP157480; 383 DP157481; 384 DP157506; 385 DP157507; 386 DP157508; 387 DP157509; 388 DP157510.

Case Study 3: 389–404 Methodist chapel, Rye Hill, Ponsanooth, Cornwall. Photographer Steve Cole. © Historic England Archive, 389 DP160728; 390 DP160729; 391 DP160730; 392 DP160732; 393 DP160734; 394 DP160736; 395 DP160735; 396 DP160737; 397 DP160741; 398 DP160738; 399 DP160739; 400 DP160740; 401 DP160744; 402 DP160742, 403 DP160745; 404 DP160743.

Case Study 4: 405–436 Airhouse, National Gas Turbine Establishment, Pyestock, Fleet, Hampshire. © Historic England Archive, 405 DP088662; 406 DP161616; 407 DP161637; 408 DP161641; 409 DP161639; 410 DP070612; 411 DP161631; 412 DP088660; 413 DP161617; 414 DP161618; 415 DP161623; 416 DP161644; 417 DP161619; 418 DP161620; 419 DP161625; 420 DP161627; 421 DP161622; 422 DP161626; 423 DP161647; 424 DP161633; 425 DP161634; 426 DP161645; 427 DP161646; 428 DP161636; 429 DP088663; 430 DP161632; 431 DP161643; 432 DP161635; 433 DP088664; 434 DP161642; 435 DP161629; 436 DP161630.

437, 438 Church of the Holy Cross, Stuntney, Cambridgeshire. Photographer Steve Cole. © Steve Cole.

439 Winter Gardens, Cedar Square Blackpool, Lancashire. Photographer Steve Cole. © Historic England Archive, DP154788.

440–445 14–22 Cliff Parade, Hunstanton, Norfolk. Photographer Steve Cole. © Steve Cole.

446–450 Ledger stone to Frances Luck, Church of St Peter, Snailwell, Cambridge. Photographer Steve Cole. © Steve Cole.

451, 452 North Range, High Street, Ely, Cambridgeshire. Photographer Steve Cole. © Steve Cole.

453–460 Court house, Lynn Road, Ely, Cambridgeshire. Photographer Steve Cole. © Steve Cole.

461–463 Middleport Pottery, Port Street, Burslem, Stoke-on-Trent, Staffordshire. Photographer Steve Cole. © Historic England Archive, DP157645.

464, 465 Ledger stone to Sharpe and Norman, Church of St Martin, Isleham, Cambridgeshire. Photographer Steve Cole. © Steve Cole.

466, 467 Ledger stone to George Warren, Church of St Peter, Snailwell, Cambridgeshire. Photographer Steve Cole. © Steve Cole.

468, 469 Albert Memorial, Kensington Gardens, London. Photographer Steve Cole. © Steve Cole.

Inside back cover Church of St Wandresgesilius, Bixley, Norfolk. Photographer Steve Cole. © Historic England Archive, DP089004.

Back cover Preston bus station, Tithebarn Street, Preston, Lancashire. Photographer Alun Bull. © Historic England Archive, DP143108.

Index